EUROPEAN PAINTINGS IN THE METROPOLITAN MUSEUM OF ART

by artists born in or before 1865

A SUMMARY CATALOGUE

by Katharine Baetjer

Associate Curator, Department of European Paintings

VOLUME TWO

The Metropolitan Museum of Art
New York

Copyright © 1980 by The Metropolitan Museum of Art

LIBRARY OF CONGRESS CATALOGING IN PUBLICATION DATA

New York (City). Metropolitan Museum of Art.
 European paintings in The Metropolitan Museum of Art.

 Includes index.
 1. Painting, European—Catalogs. 2. Painting—New
York (City)—Catalogs. 3. New York (City). Metropolitan
Museum of Art—Catalogs. I. Baetjer, Katharine.
II. Title.

ND450.N45 1980 759.94′074′01471 80–17747
ISBN 0–87099–250–3

PUBLISHED BY

The Metropolitan Museum of Art, New York

Bradford D. Kelleher, Publisher
John P. O'Neill, Editor in Chief
Ellen Shultz, Editor
Peter Oldenburg, Designer

Photographs by the Photograph Studio, The Metro-
 politan Museum of Art
Composition by Graphic Composition, Inc., Athens,
 Georgia
Printed by Murray Printing Company, Westford,
 Massachusetts
Bound by American Book-Stratford Press, Inc.,
 Saddle Brook, New Jersey

CONTENTS

VOLUME ONE: Text

Preface vii

Note to the Catalogue ix

Catalogue 1

Index 201

VOLUME TWO: Illustrations

Italian Paintings

 Florentine 1

 Sienese 43

 Central and South Italian 77

 Venetian 107

 North Italian 145

 XIX century 179

Spanish Paintings (including Portuguese
and Peruvian) 183

Icons (including Byzantine, Post-Byzantine,
and Russian) 221

Russian Paintings 239

British Paintings 245

German Paintings (including Austrian,
Czechoslovakian, Danish, Hungarian,
Swedish, and Swiss) 287

VOLUME THREE: Illustrations

Flemish Paintings (including Dutch and
Portuguese) 325

Dutch Paintings, XVII and XVIII century 393

Dutch and Belgian Paintings, XIX century 459

French Paintings

 middle XV–XVII century 467

 XVIII century 493

 XIX century 535

ITALIAN PAINTINGS

FLORENTINE, XIII–XVII CENTURY

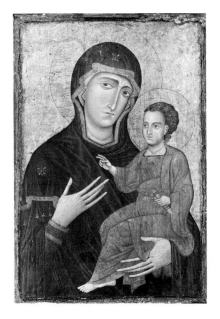

60.173 Berlinghiero

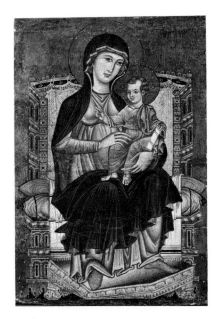

69.280.4 Florentine, last quarter XIII century

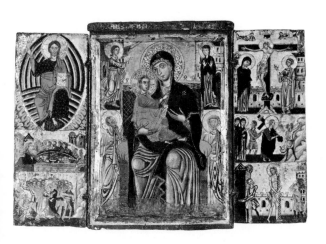

41.100.8 Master of the Magdalen

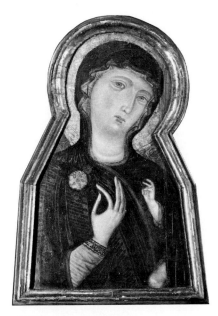

64.189.1 Master of the Magdalen

Italian/Florentine

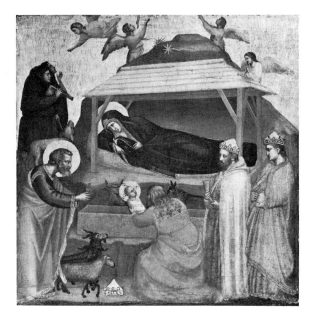

11.126.1 Giotto

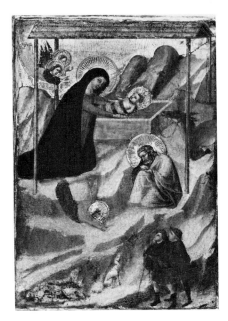

1975.1.60 Follower of Giotto

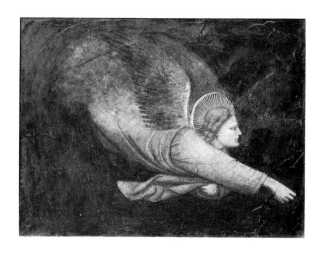

1971.115.1a Follower of Giotto

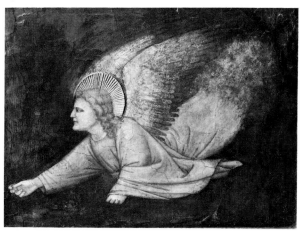

1971.115.1b Follower of Giotto

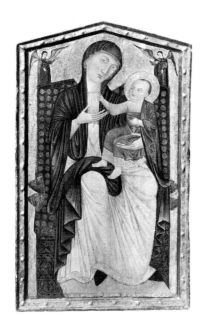

41.100.21 Florentine, late XIII century

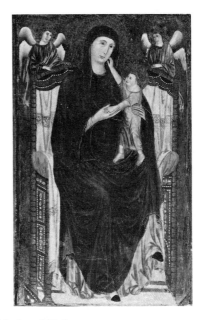

49.39 Master of Varlungo

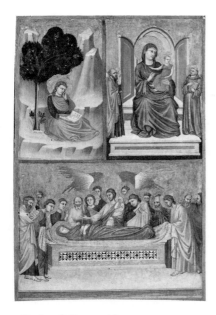

64.189.3a Pacino di Bonaguida

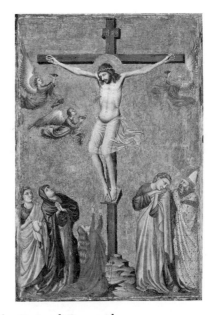

64.189.3b Pacino di Bonaguida

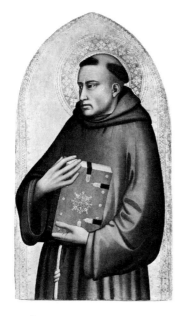

43.98.13 Maso di Banco

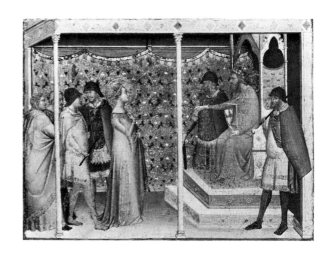

43.98.3 Bernardo Daddi

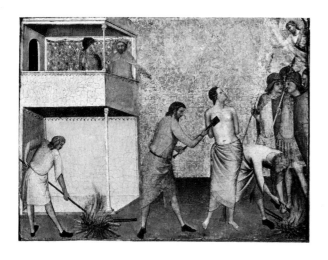

41.190.15 Bernardo Daddi

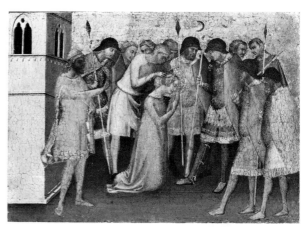

43.98.4 Bernardo Daddi

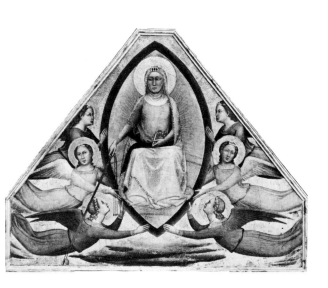

1975.1.58 Bernardo Daddi

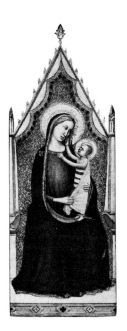

1975.1.59 Bernardo Daddi

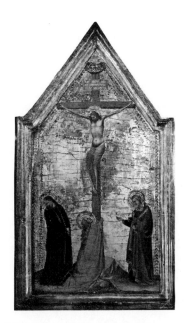

41.190.12 Workshop of Bernardo Daddi

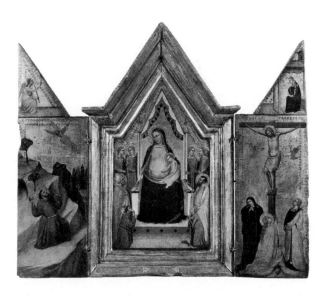

32.100.70 Workshop of Bernardo Daddi

7

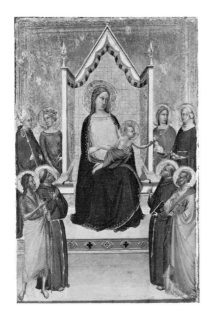

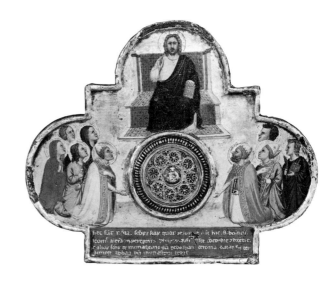

41.100.15 Workshop of Bernardo Daddi

1974.217 Follower of Bernardo Daddi

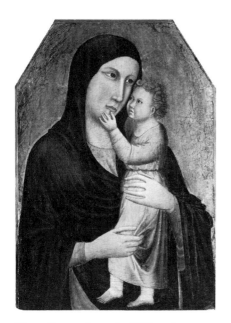

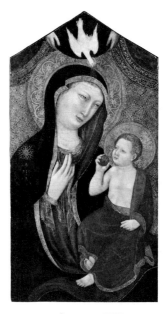

47.143 Florentine, 2nd quarter XIV century

63.203 Florentine, 2nd quarter XIV century

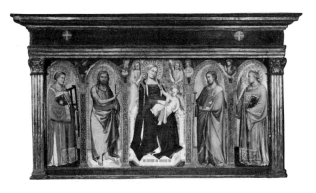

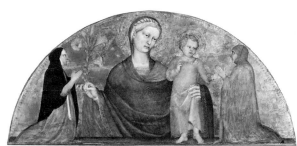

10.97 Taddeo Gaddi

07.200 Giovanni da Milano

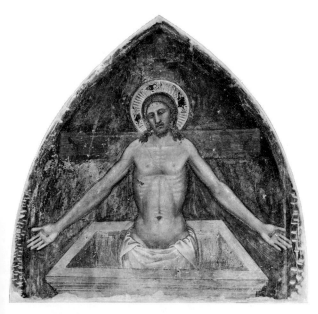

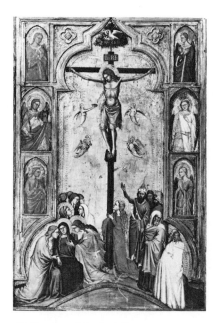

25.120.241 Niccolò di Tommaso

1975.1.65 Followers of Andrea Orcagna

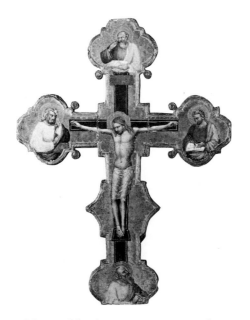

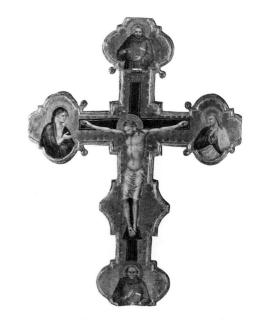

27.231a Master of the Orcagnesque Misericordia

27.231b Master of the Orcagnesque Misericordia

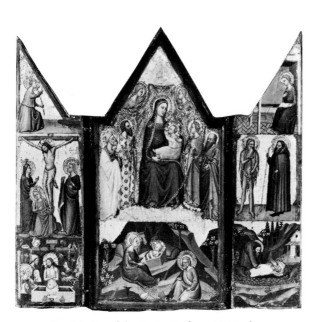

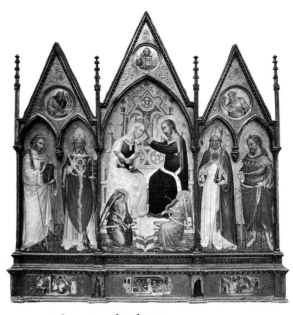

1975.1.69 Master of the Santa Verdiana Triptych

50.229.2 Florentine, dated 1394

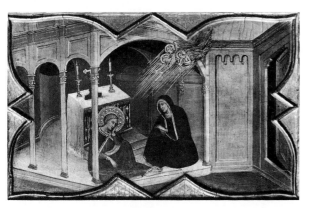

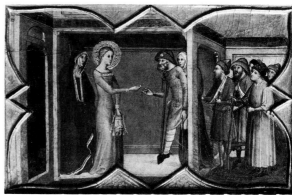

12.41.4 Giovanni di Bartolommeo Cristiani

12.41.3 Giovanni di Bartolommeo Cristiani

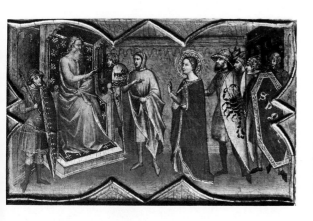

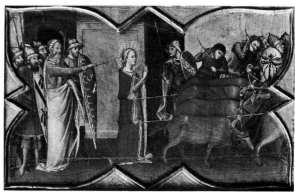

12.41.1 Giovanni di Bartolommeo Cristiani

12.41.2 Giovanni di Bartolommeo Cristiani

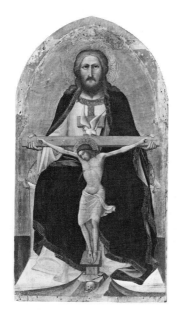

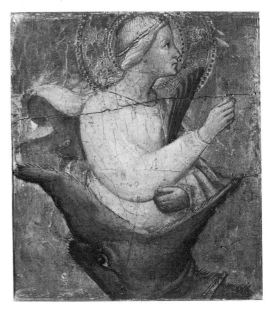

41.100.33 Agnolo Gaddi

41.190.23 Workshop of Agnolo Gaddi

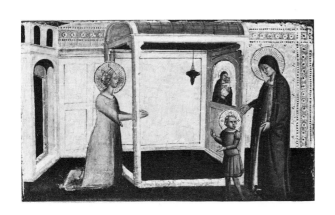

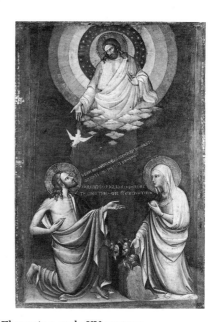

1975.1.62 Follower of Agnolo Gaddi

53.37 Florentine, early XV century

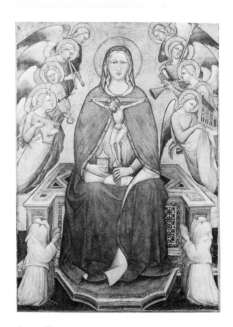

13.175 Spinello Aretino

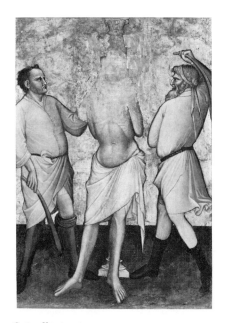

13.175 Spinello Aretino

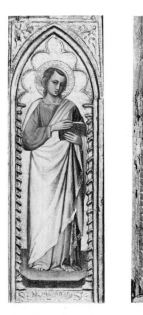

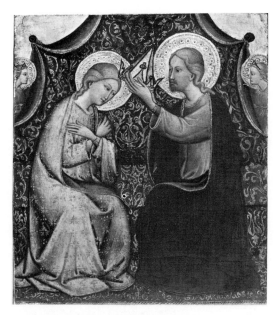

1975.1.63- 64 Spinello Aretino

88.3.77 Florentine, early XV century

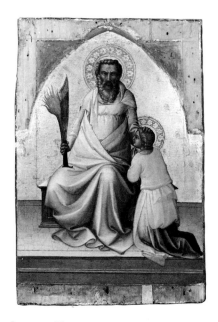

65.14.1 Lorenzo Monaco

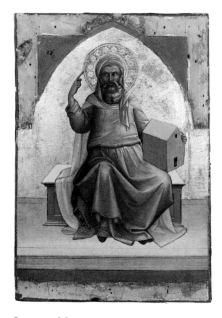

65.14.2 Lorenzo Monaco

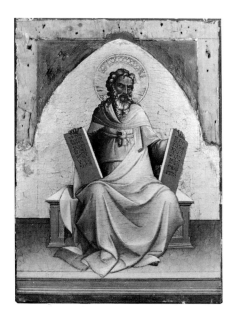

65.14.3 Lorenzo Monaco

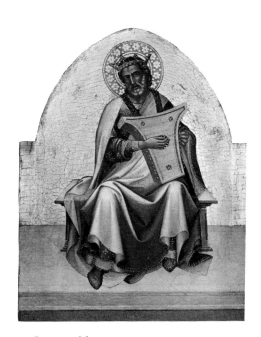

65.14.4 Lorenzo Monaco

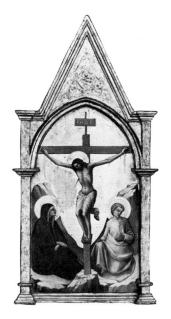

1975.1.67 Lorenzo Monaco

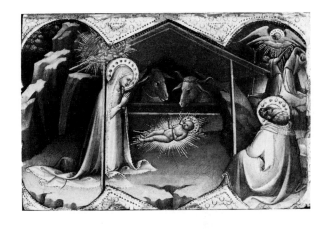

1975.1.66 Lorenzo Monaco

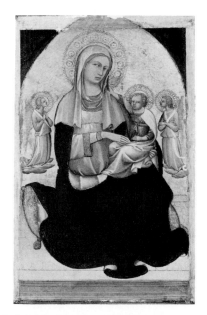

09.91 Workshop of Lorenzo Monaco

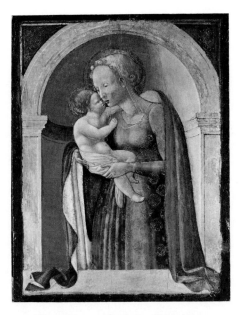

30.95.254 Florentine, 2nd quarter XV century

15

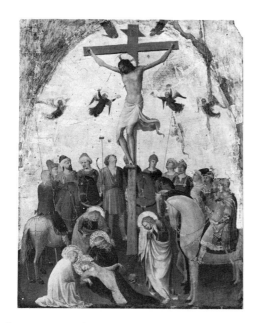

43.98.5 Giovanni di Francesco Toscani

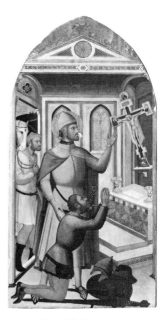

58.135 Lorenzo di Niccolò di Martino

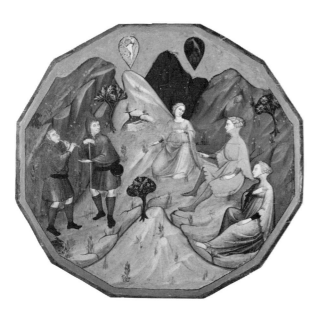

26.287.1 Workshop of Lorenzo di Niccolò di Martino

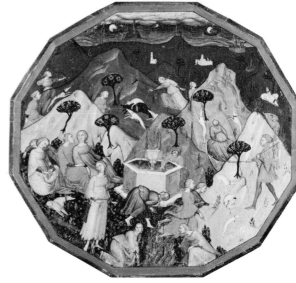

26.287.2 Workshop of Lorenzo di Niccolò di Martino

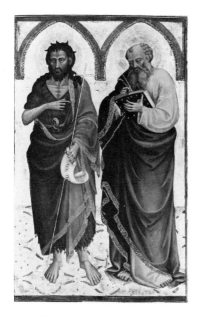

1975.1.68 Bicci di Lorenzo

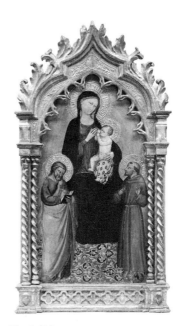

41.100.16 Bicci di Lorenzo

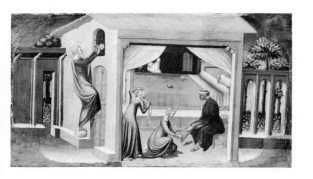

88.3.89 Bicci di Lorenzo

16.121 Bicci di Lorenzo

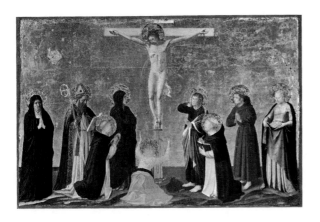

14.40.628 Fra Angelico

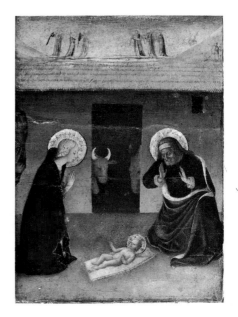

24.22 Workshop of Fra Angelico

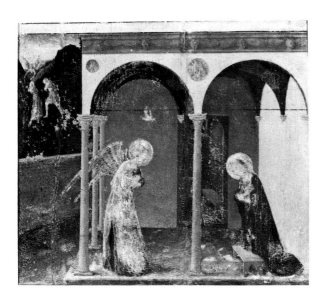

41.190.8 Workshop of Fra Angelico

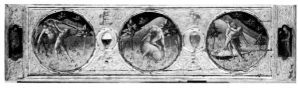

1971.115.4 Paolo di Stefano Badaloni

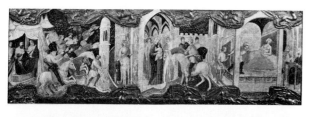

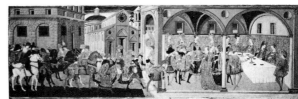

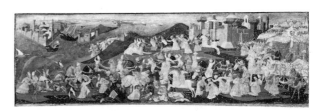

32.75.2a – c Florentine, 1st quarter XV century

18.117.2 Marco del Buono and Apollonio di Giovanni
14.39 Marco del Buono and Apollonio di Giovanni

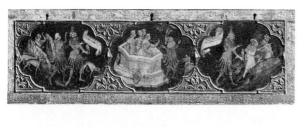

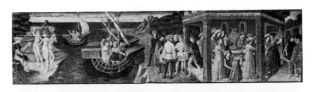

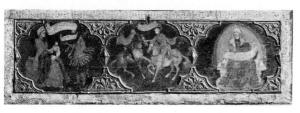

41.190.129, 130 Florentine?, 2nd quarter XV century

32.75.1a – c Marco del Buono and Apollonio di Giovanni

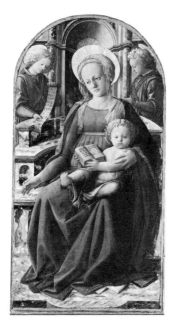

49.7.9 Fra Filippo Lippi

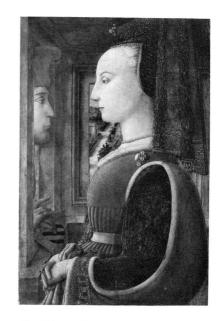

89.15.19 Fra Filippo Lippi

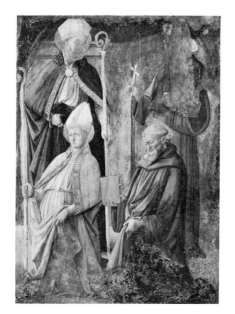

17.89 Fra Filippo Lippi

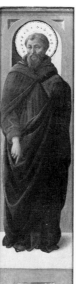
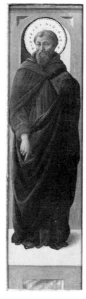

1975.1.70ab Fra Filippo Lippi

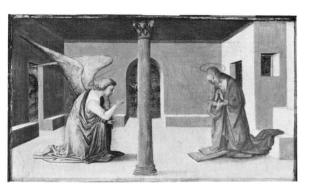

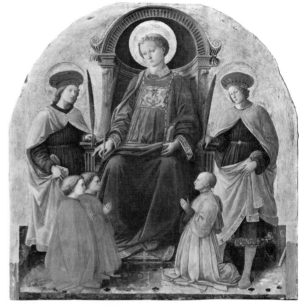

43.98.2 Fra Filippo Lippi

35.31.1a Fra Filippo Lippi

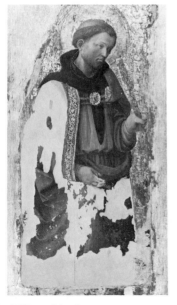

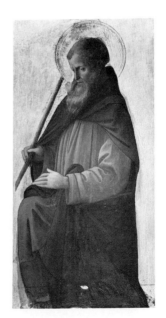

35.31.1c Fra Filippo Lippi

35.31.1b Fra Filippo Lippi

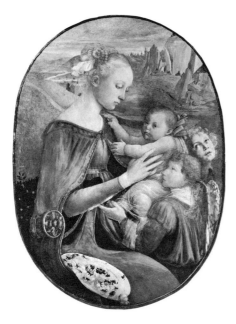

29.100.17 Follower of Fra Filippo Lippi

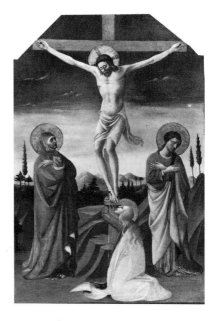

19.87 Domenico di Michelino

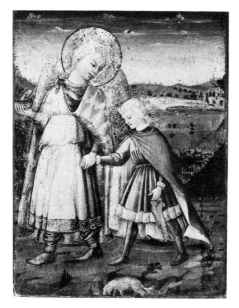

1975.1.71 Neri di Bicci

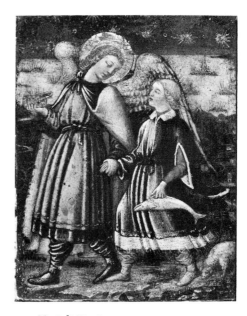

1975.1.72 Neri di Bicci

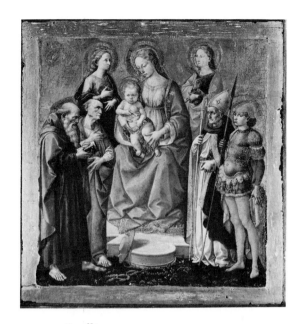

50.145.30 Pesellino

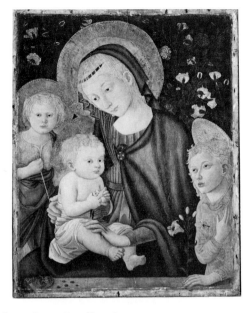

65.181.4 Lippi-Pesellino Imitators

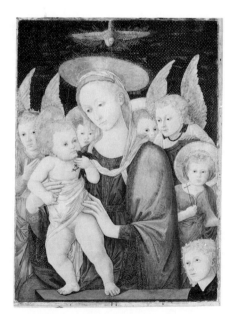

32.100.79 Lippi-Pesellino Imitators

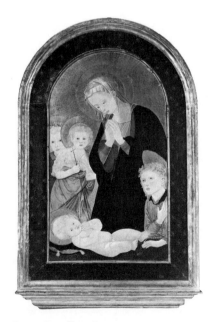

41.100.9 Lippi-Pesellino Imitators

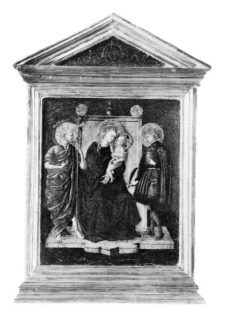

06.1048　Florentine, 2nd quarter XV century

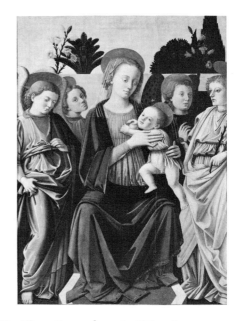

64.288　Florentine, 3rd quarter XV century

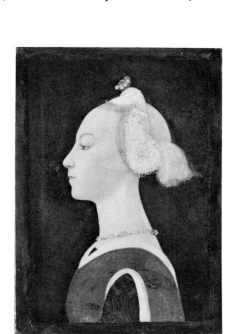

49.7.6　Master of the Castello Nativity

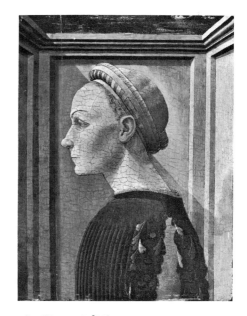

32.100.98　Giovanni di Francesco

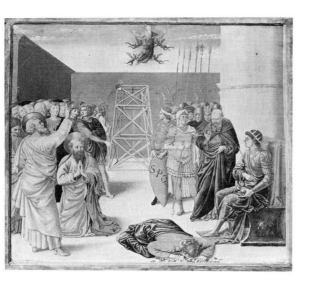

15.106.1 Benozzo Gozzoli

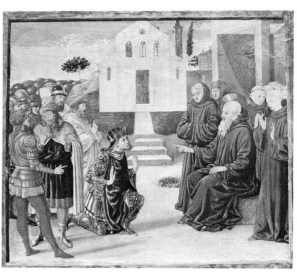

15.106.2 Benozzo Gozzoli

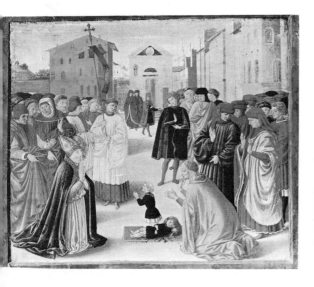

15.106.3 Benozzo Gozzoli

15.106.4 Benozzo Gozzoli

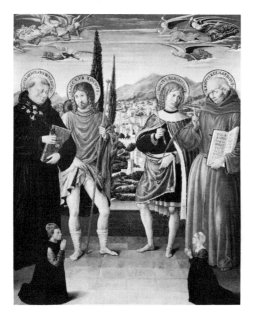

1976.100.14 Benozzo Gozzoli

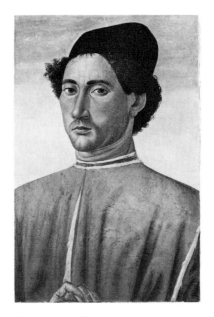

50.135.1 Cosimo Rosselli

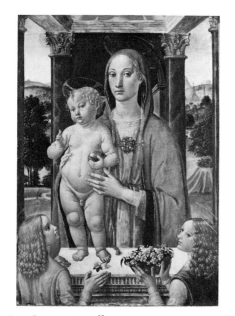

32.100.84 Cosimo Rosselli

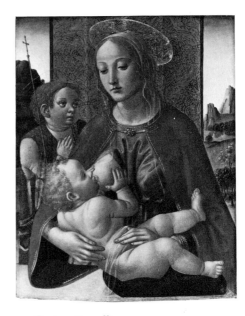

1975.1.73 Cosimo Rosselli

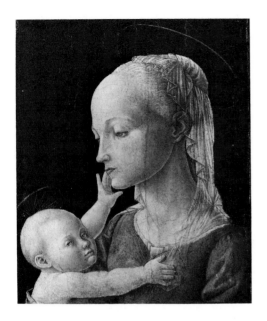

41.100.6 Master of San Miniato

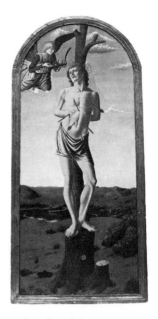

48.78 Follower of Andrea del Castagno

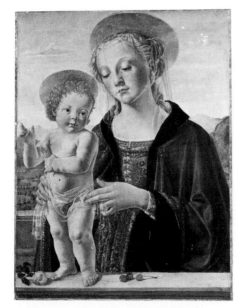

14.40.647 Workshop of Andrea del Verrocchio

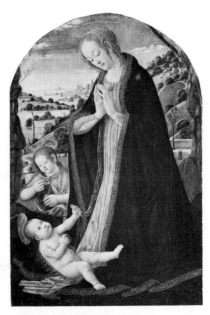

41.100.10 Jacopo del Sellaio

Italian / Florentine

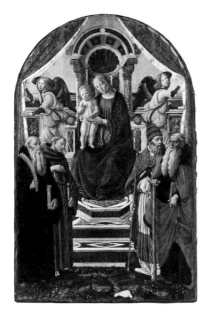

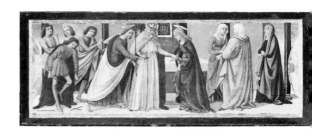

61.235　Francesco Botticini

13.119.1　Domenico Ghirlandaio

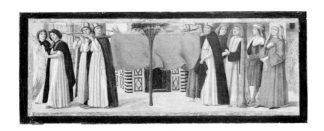

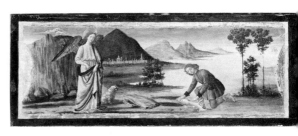

13.119.2　Domenico Ghirlandaio

13.119.3　Domenico Ghirlandaio

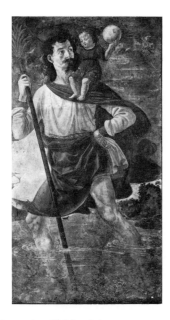

80.3.674 Domenico Ghirlandaio

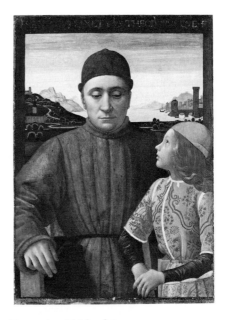

49.7.7 Domenico Ghirlandaio

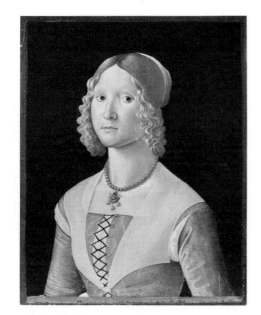

32.100.71 Domenico Ghirlandaio

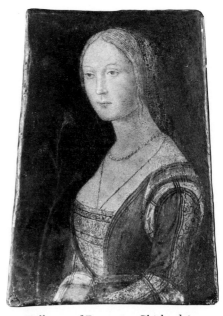

41.190.24 Follower of Domenico Ghirlandaio

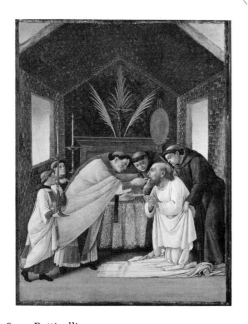

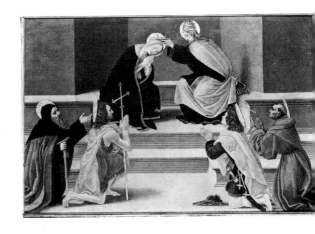

14.40.642 Botticelli

49.7.4 Follower of Botticelli

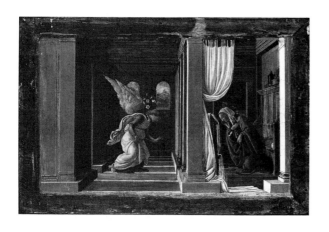

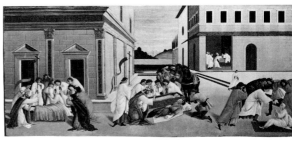

1975.1.74 Botticelli

11.98 Botticelli

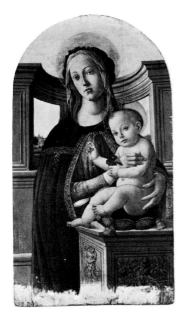

41.116.1 Follower of Botticelli

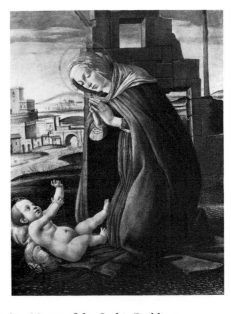

1975.1.61 Master of the Gothic Buildings

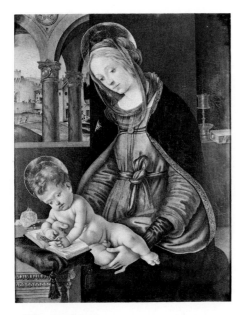

49.7.10 Filippino Lippi

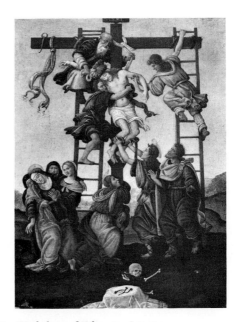

12.168 Workshop of Filippino Lippi

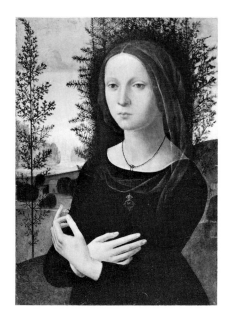

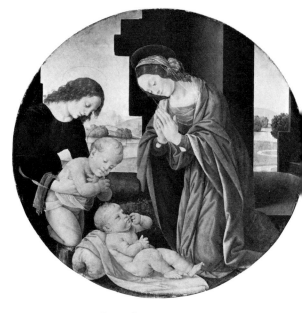

43.86.5 Lorenzo di Credi

09.197 Lorenzo di Credi

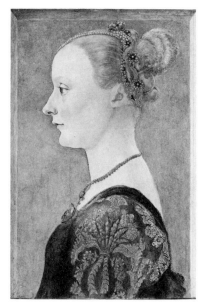

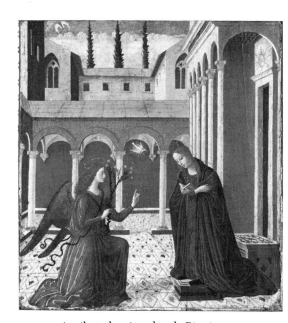

50.135.3 Piero del Pollaiuolo

1975.1.77 Attributed to Amadeo da Pistoia

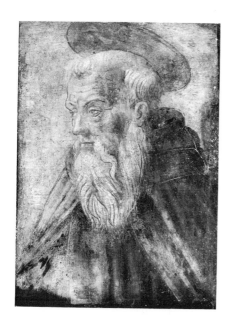

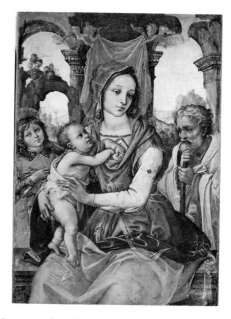

80.3.679 Florentine, last quarter XV century

14.40.641 Attributed to Raffaellino del Garbo

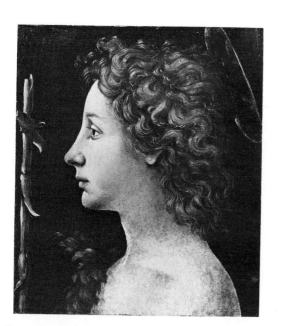

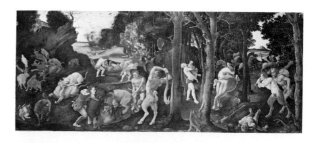

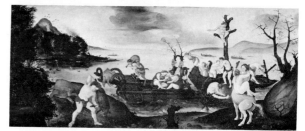

22.60.52 Piero di Cosimo

75.7.2,1 Piero di Cosimo

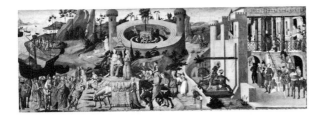

09.136.1 Biagio di Antonio

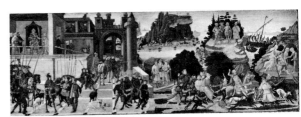

09.136.2 Workshop of Biagio di Antonio

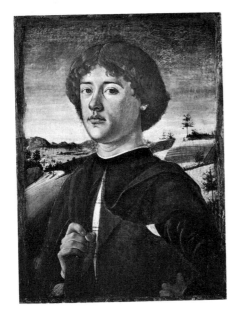

32.100.68 Biagio di Antonio

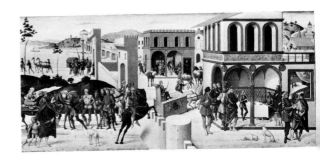

32.100.69 Biagio di Antonio

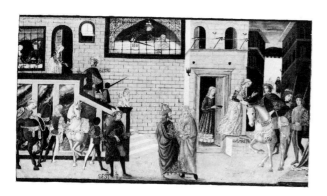

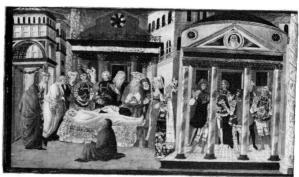

1975.1.75 Florentine, late XV century

1975.1.76 Florentine, late XV century

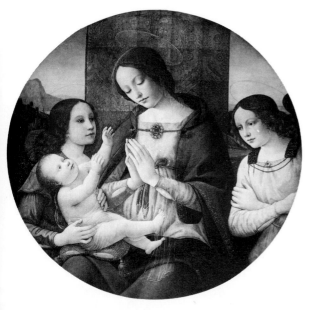

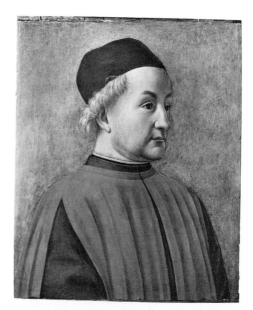

14.40.635 Sebastiano Mainardi

32.100.67 Sebastiano Mainardi

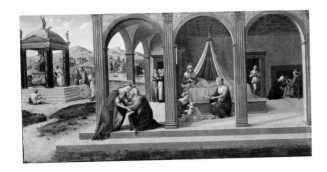

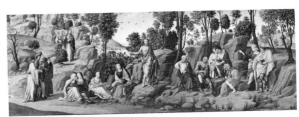

1970.134.1 Francesco Granacci

1970.134.2 Francesco Granacci

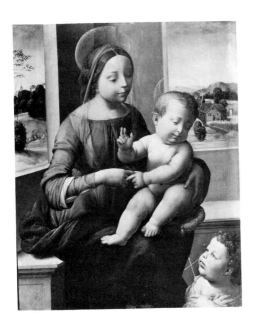

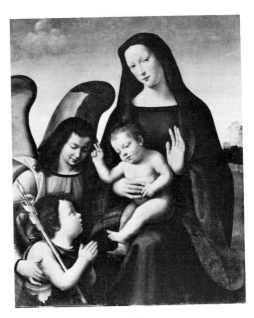

06.171 Fra Bartolomeo

30.95.270 Mariotto Albertinelli

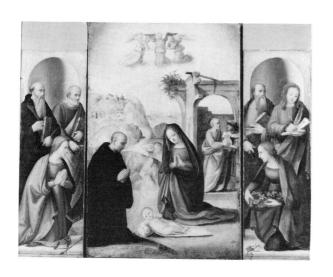

32.100.80 Ridolfo Ghirlandaio

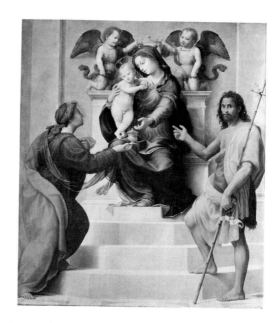

30.83 Giuliano Bugiardini

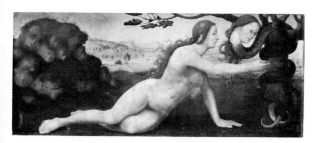

1971.115.3a Giuliano Bugiardini

1971.115.3b Giuliano Bugiardini

Italian / Florentine

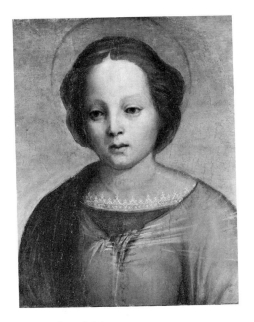

32.100.89 Andrea del Sarto

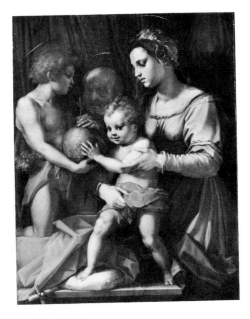

22.75 Andrea del Sarto

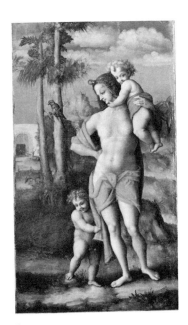

38.178 Bacchiacca

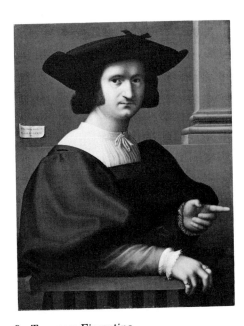

17.190.8 Tommaso Fiorentino

38

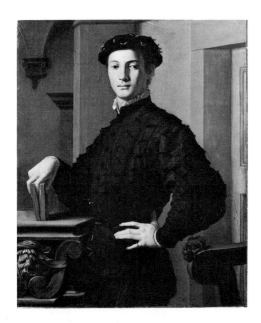

29.100.16 Bronzino

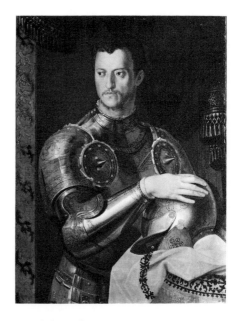

08.262 Workshop of Bronzino

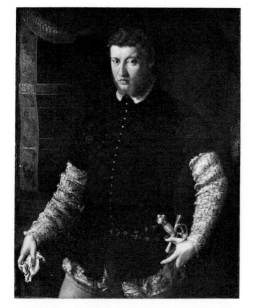

55.14 Francesco Salviati

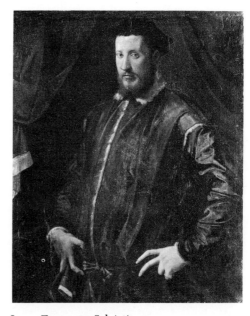

45.128.11 Francesco Salviati

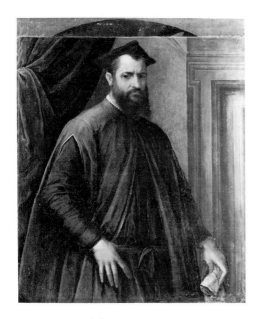

30.95.236 Jacopino del Conte

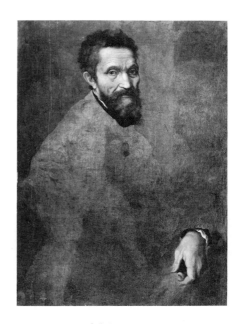

1977.384.1 Jacopino del Conte

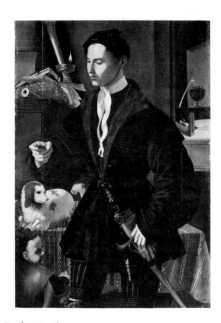

56.51 Paolo Zacchia

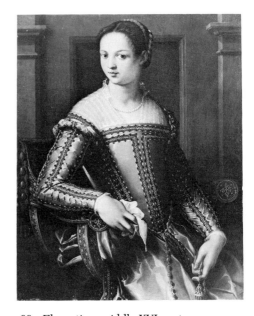

32.100.66 Florentine, middle XVI century

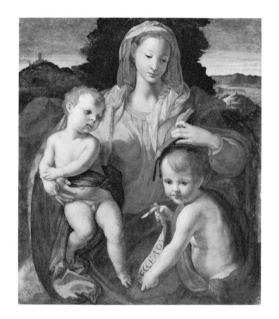

53.45.1 Florentine, middle XVI century

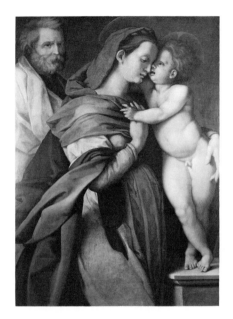

1976.100.15 Florentine, XVI century

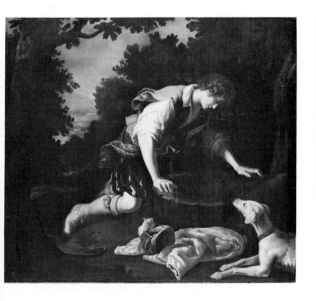

1978.554.1 Francesco Curradi

80.3.245a Aurelio Lomi

69.283 Cesare Dandini

80.3.673 Volterrano

68.162 Florentine, 2nd quarter XVII century

ITALIAN PAINTINGS

SIENESE, XIV–XVI CENTURY

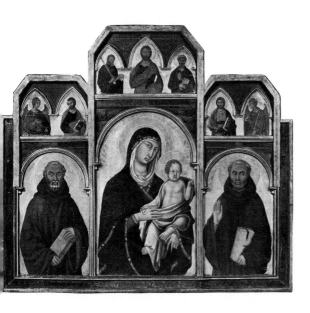

24.78 Segna di Buonaventura

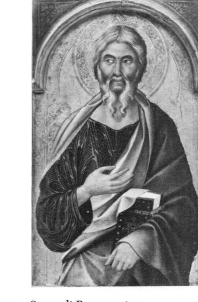

41.100.22 Segna di Buonaventura

1975.1.3 Segna di Buonaventura

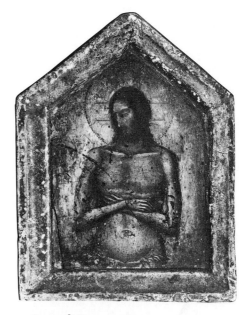

1975.1.4 Segna di Buonaventura

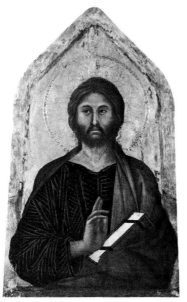

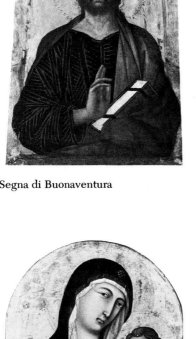

65.181.2 Segna di Buonaventura

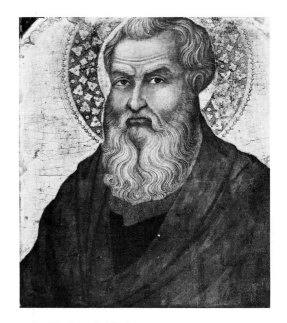

1975.1.6 Ugolino da Nerio

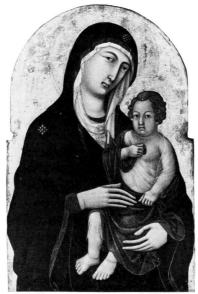

1975.1.5 Ugolino da Nerio

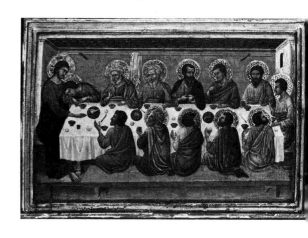

1975.1.7 Ugolino da Nerio

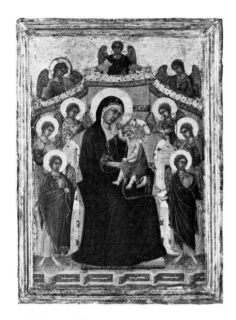

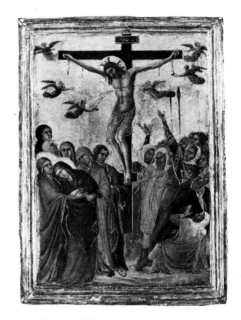

1975.1.1 Follower of Duccio

1975.1.2 Follower of Duccio

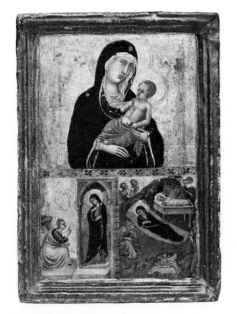

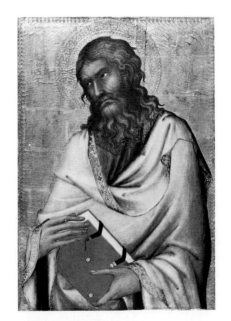

20.160 Goodhart Ducciesque Master

41.100.23 Simone Martini

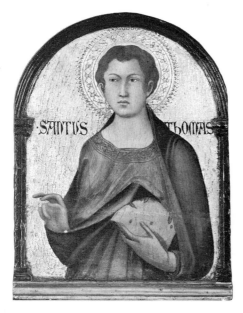

43.98.9 Workshop of Simone Martini

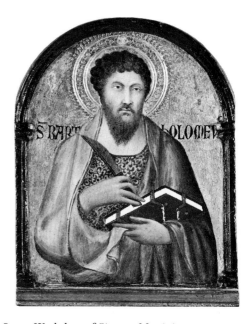

43.98.10 Workshop of Simone Martini

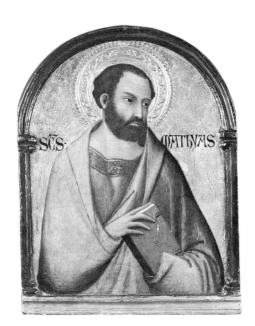

43.98.11 Workshop of Simone Martini

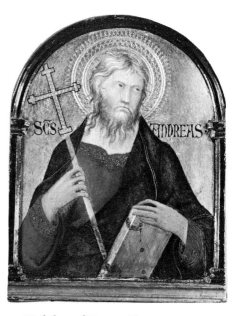

43.98.12 Workshop of Simone Martini

Italian / Sienese

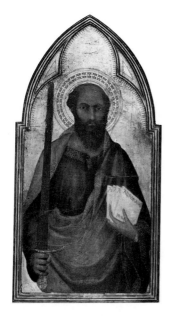

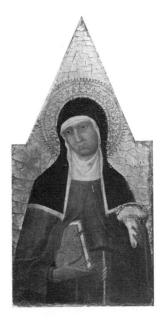

88.3.99 Lippo Memmi

64.189.2 Lippo Memmi

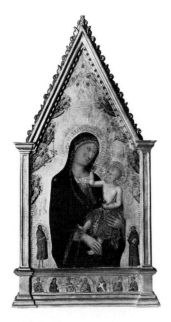

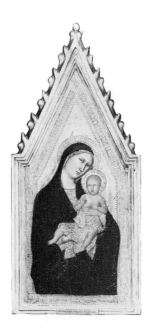

43.98.6 Lippo Memmi

1975.1.10 Follower of Lippo Memmi

49

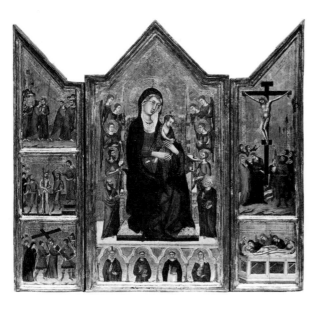

18.117.1 Master of Monte Oliveto

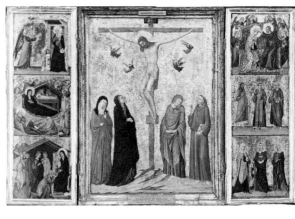

41.190.31a–c Master of Monte Oliveto and a Sienese
Painter

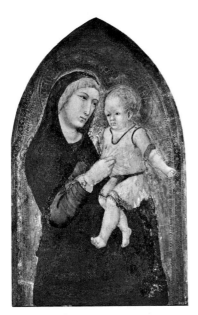

41.190.26 Ambrogio Lorenzetti

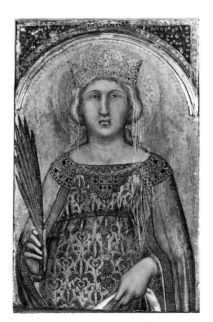

13.212 Pietro Lorenzetti

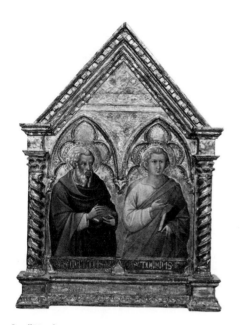

1975.1.8 "Ugolino Lorenzetti"

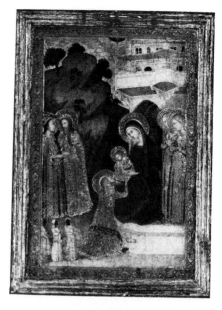

1975.1.9 Sienese, active in Avignon, 1st half XIV century

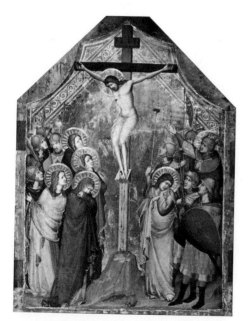

61.200.1 Master of the Codex of Saint George

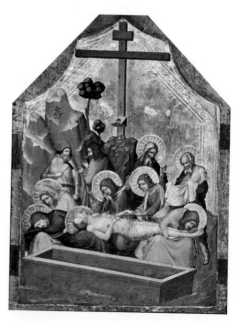

61.200.2 Master of the Codex of Saint George

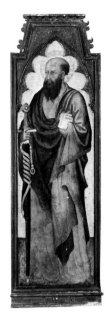

41.190.531 Francesco di Vannuccio

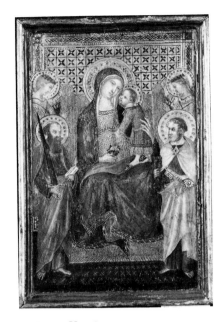

32.100.100 Lippo Vanni

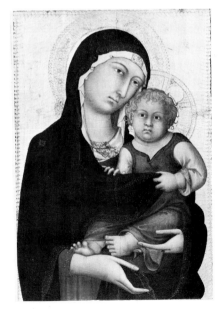

1975.1.12 Lippo Vanni

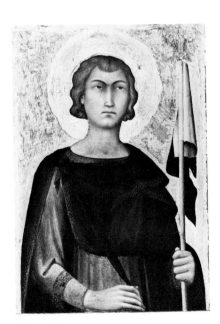

1975.1.13 Lippo Vanni

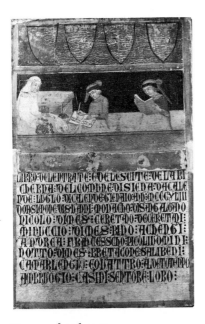

10.203.3 Sienese, dated 1343

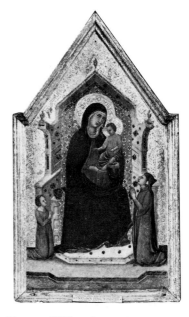

1975.1.24 Sienese, XIV century

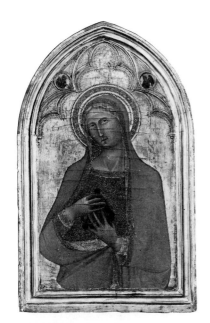

1975.1.14 Barna da Siena

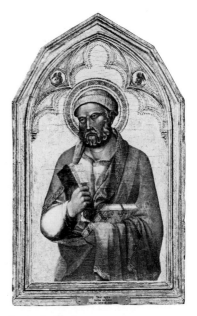

1975.1.15 Barna da Siena

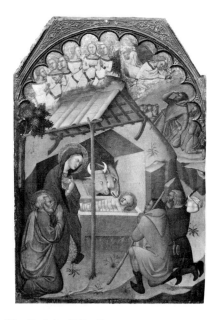

25.120.288 Bartolo di Fredi

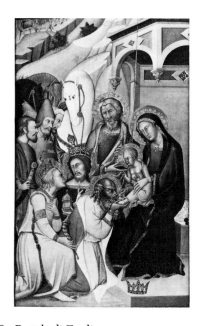

1975.1.16 Bartolo di Fredi

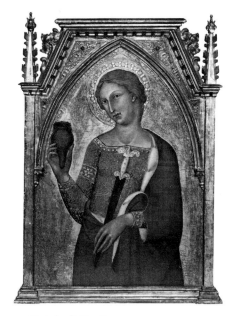

41.100.14 Bartolo di Fredi

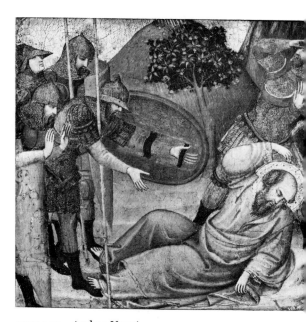

1975.1.11 Andrea Vanni

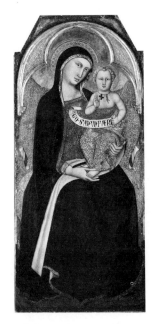

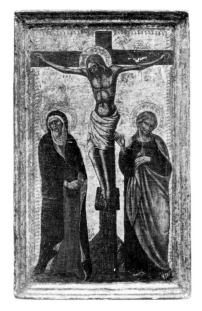

41.100.34 Luca di Tommè

25.79 Italian, Style of XIV century, XX century

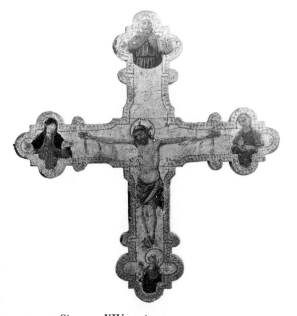

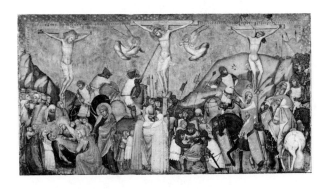

1975.1.25 Sienese, XIV century

12.6 Andrea di Bartolo

55

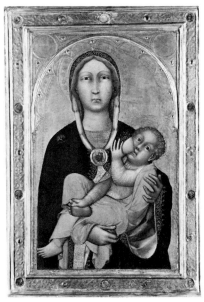

41.190.13 Paolo di Giovanni Fei

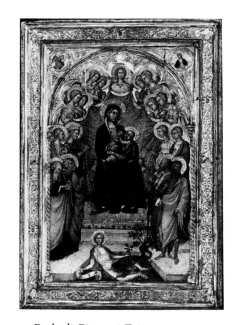

1975.1.23 Paolo di Giovanni Fei

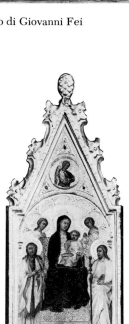

1975.1.22a Paolo di Giovanni Fei

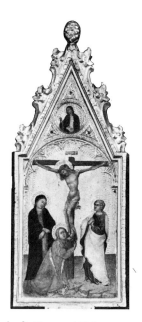

1975.1.22b Paolo di Giovanni Fei

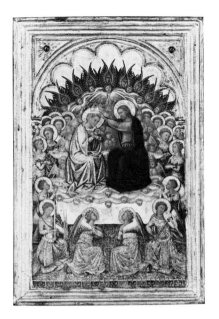

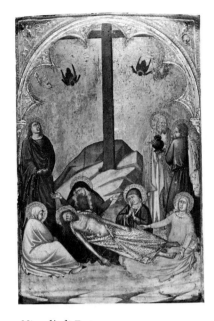

1975.1.21 Niccolò di Buonaccorso

1975.1.20 Niccolò di Buonaccorso

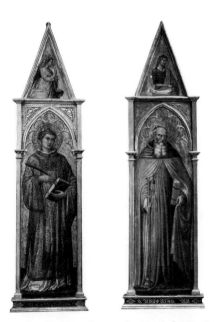

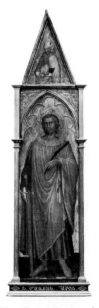

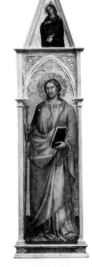

30.95.263, 265 Martino di Bartolommeo di Biagio

30.95.266, 264 Martino di Bartolommeo di Biagio

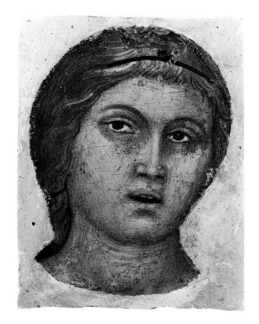

1975.1.17 Taddeo di Bartolo

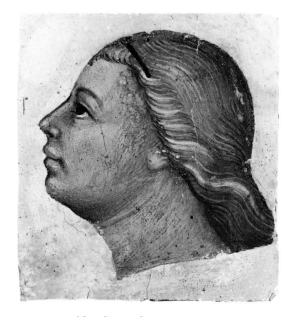

1975.1.19 Taddeo di Bartolo

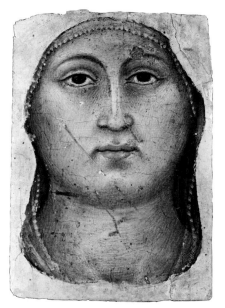

1975.1.18 Taddeo di Bartolo

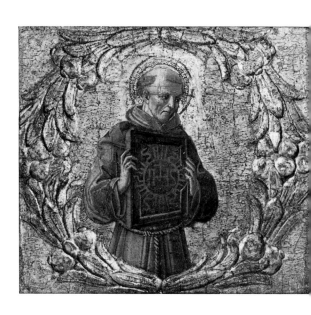

1975.1.53 Benvenuto di Giovanni

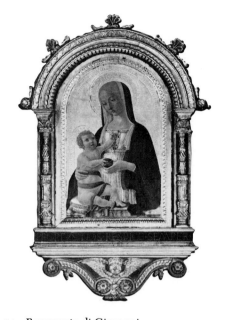

1975.1.54 Benvenuto di Giovanni

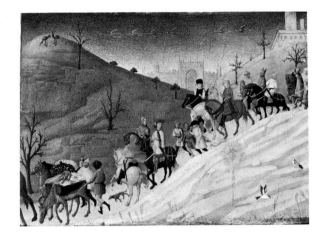

43.98.1 Sassetta

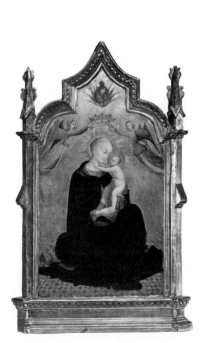

41.100.20 Sassetta

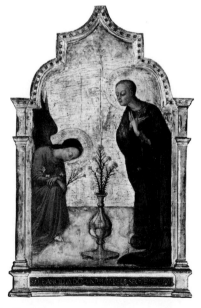

1975.1.26 Sassetta

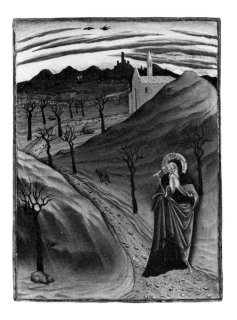

1975.1.27 Sassetta

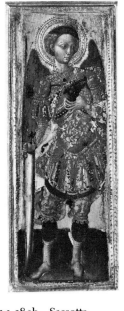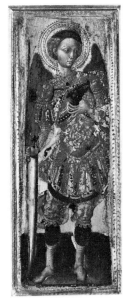

1975.1.28 ab Sassetta

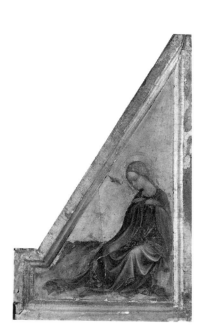

1975.1.29 Sassetta

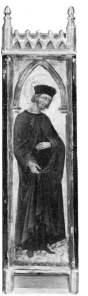

1975.1.55–56 Pellegrino di Mariano

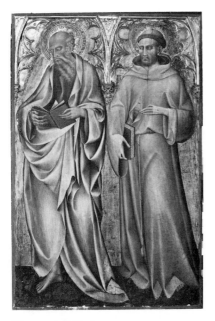

38.3.111 Giovanni di Paolo

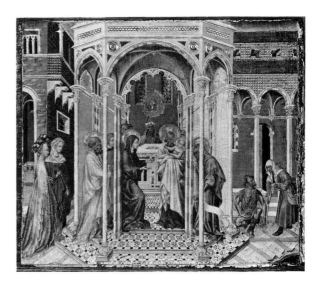

41.100.4 Giovanni di Paolo

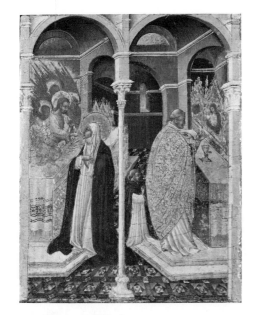

32.100.95 Giovanni di Paolo

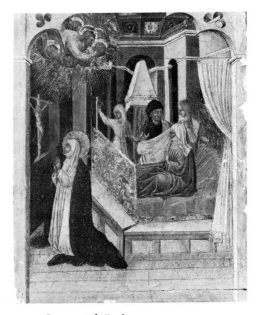

1975.1.33 Giovanni di Paolo

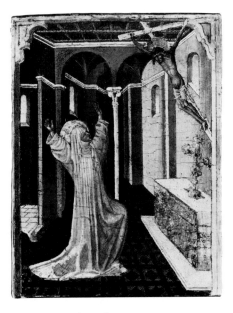

1975.1.34　Giovanni di Paolo

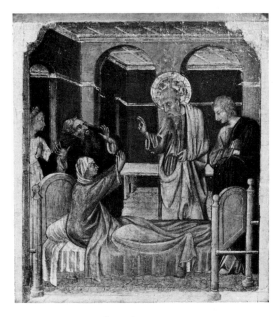

1975.1.36　Giovanni di Paolo

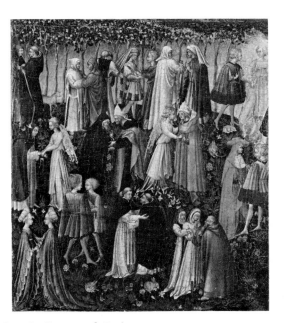

06.1046　Giovanni di Paolo

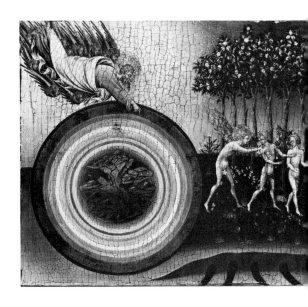

1975.1.31　Giovanni di Paolo

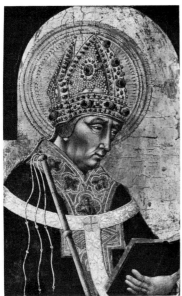

1975.1.30 Giovanni di Paolo

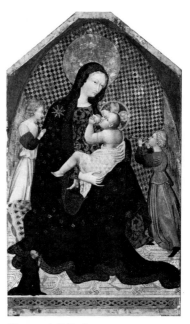

41.190.16 Giovanni di Paolo

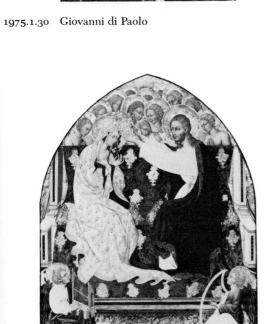

1975.1.38 Giovanni di Paolo

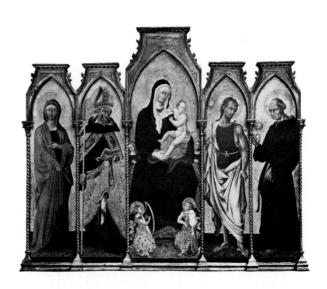

32.100.76 Giovanni di Paolo

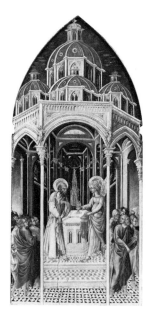

1975.1.37 Giovanni di Paolo

1975.1.37 Giovanni di Paolo

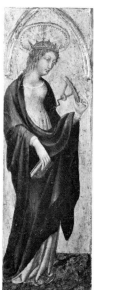

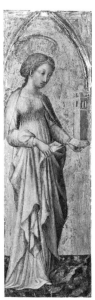

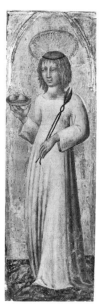

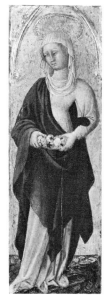

32.100.83ab Giovanni di Paolo

32.100.83cd Giovanni di Paolo

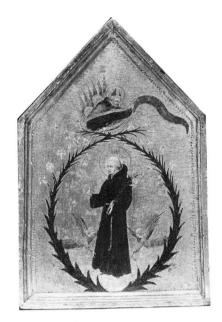

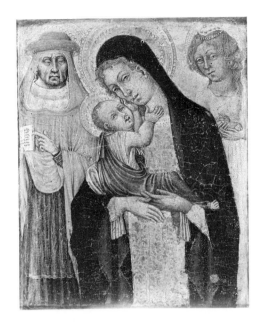

975.1.35 Giovanni di Paolo

1975.1.32 Giovanni di Paolo

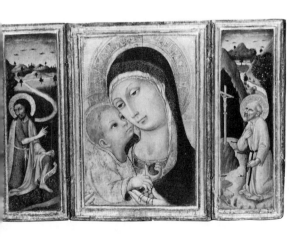

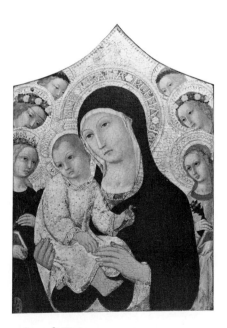

4.189.4 Sano di Pietro

41.100.19 Sano di Pietro

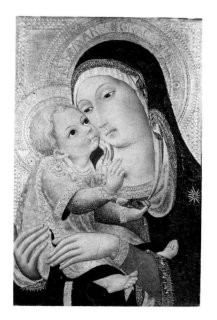

1975.1.39 Sano di Pietro

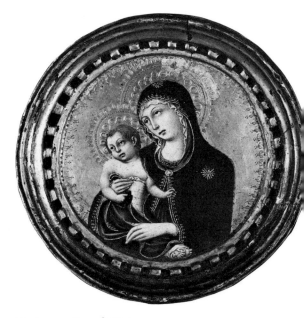

1975.1.40 Sano di Pietro

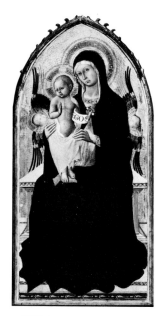

1975.1.41 Sano di Pietro

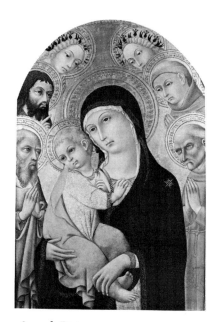

1975.1.42 Sano di Pietro

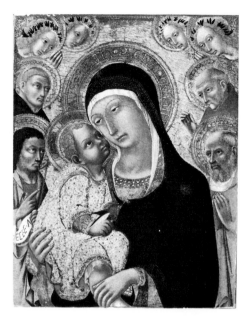

1975.1.43 Sano di Pietro

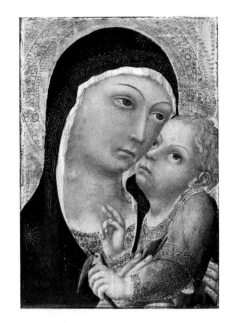

1975.1.51 Sano di Pietro

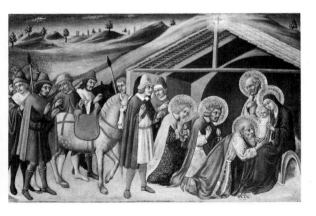

58.189.2 Sano di Pietro

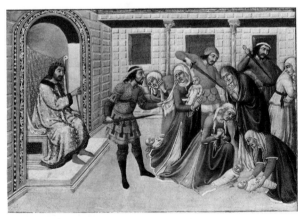

58.189.1 Sano di Pietro

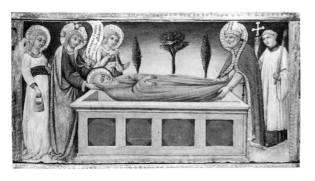

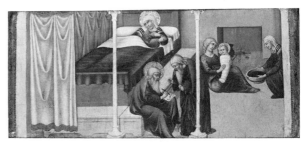

65.181.7 Sano di Pietro

1975.1.44 Sano di Pietro

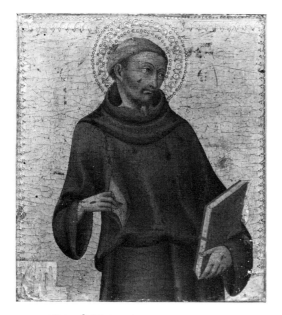

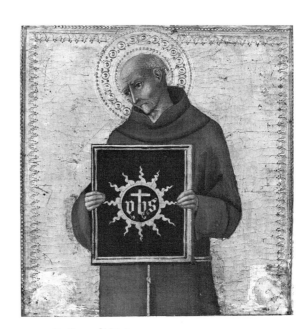

1975.1.50 Sano di Pietro

1975.1.46 Sano di Pietro

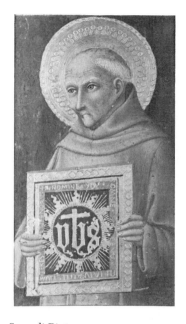

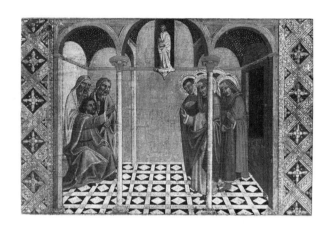

1975.1.45 Sano di Pietro

1975.1.47 Sano di Pietro

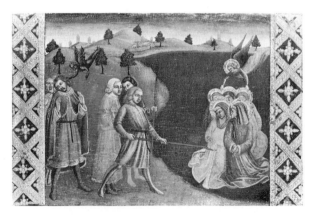

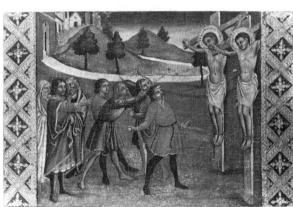

1975.1.48 Sano di Pietro

1975.1.49 Sano di Pietro

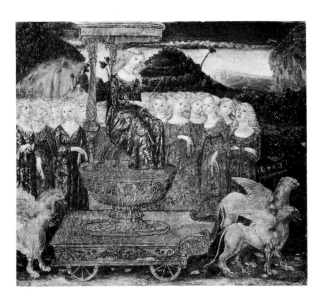

20.182 Francesco di Giorgio

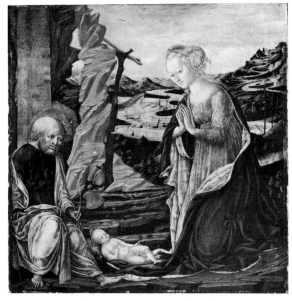

41.100.2 Francesco di Giorgio

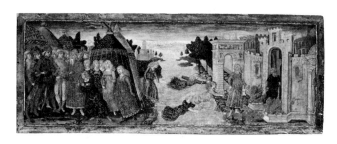

11.126.2 Guidoccio di Giovanni Cozzarelli

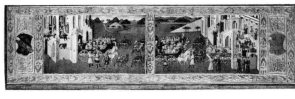

14.44 Sienese, 3rd quarter XV century

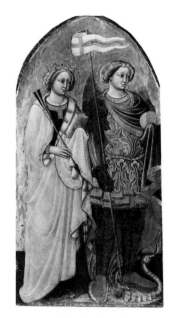

41.100.37 Priamo della Quercia

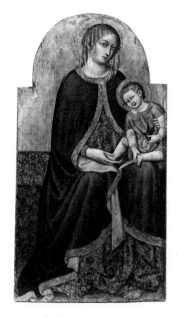

41.100.35 Priamo della Quercia

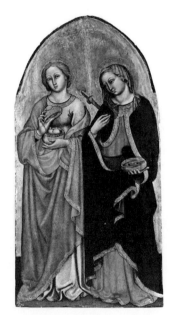

41.100.36 Priamo della Quercia

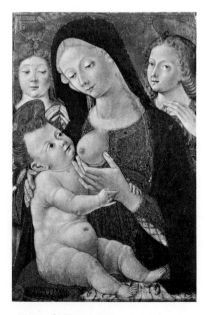

41.190.22 Pietro di Domenico

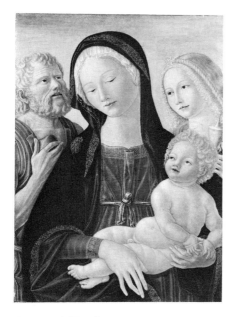

61.43 Neroccio de' Landi

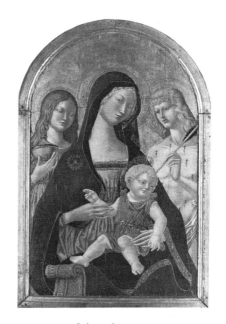

1975.1.57 Neroccio de' Landi

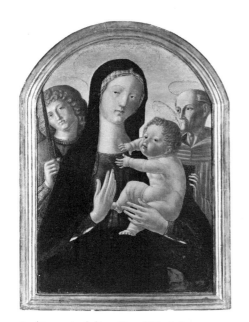

41.100.18 Neroccio de' Landi and Workshop

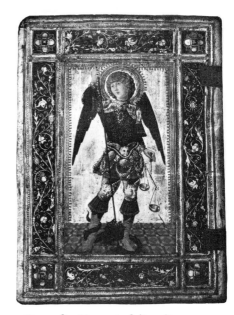

07.24.24 Copy after Neroccio de' Landi

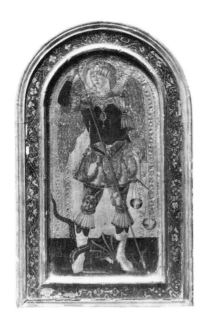

07.241 Corrado Scapecchi

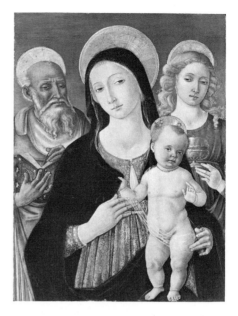

65.234 Matteo di Giovanni

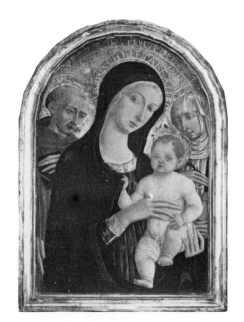

1975.1.52 Matteo di Giovanni

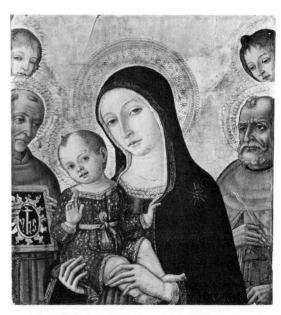

41.100.17 Workshop of Matteo di Giovanni

73

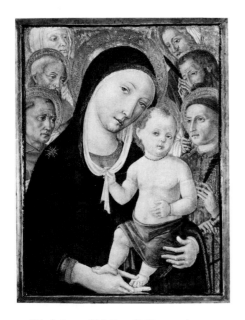

41.190.29 Workshop of Matteo di Giovanni

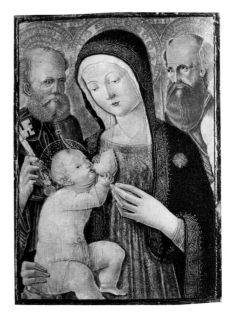

88.3.100 Sienese, late XV century

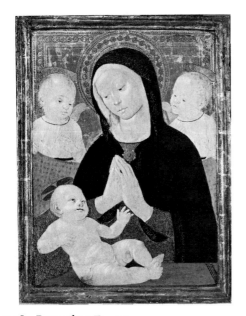

41.100.38 Bernardino Fungai

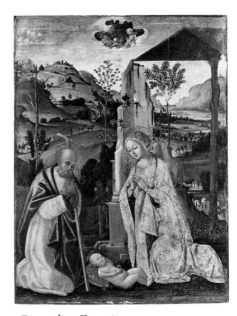

26.109 Bernardino Fungai

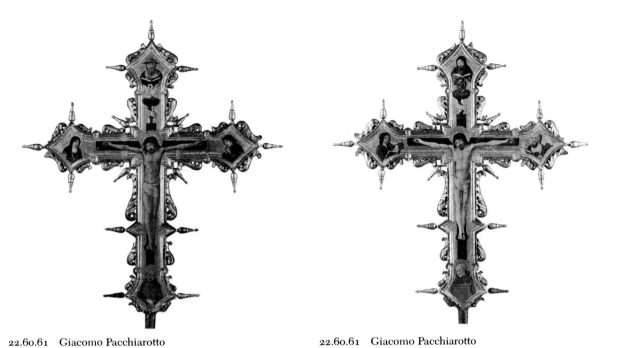

22.60.61 Giacomo Pacchiarotto

22.60.61 Giacomo Pacchiarotto

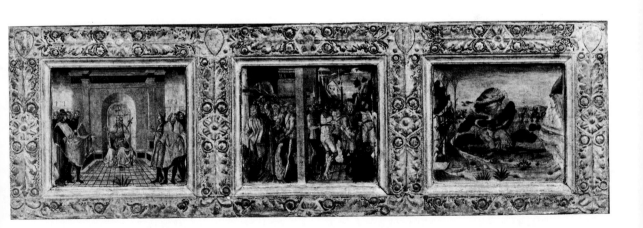

08.133 Sienese?, early XVI century

ITALIAN
PAINTINGS

CENTRAL AND SOUTH ITALIAN
LATE XIII–XVIII CENTURY

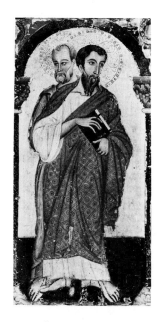

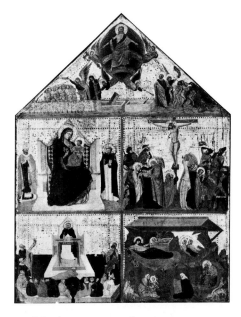

1975.1.104 Master of Saint Francis

1975.1.99 Marchigian, active about 1300

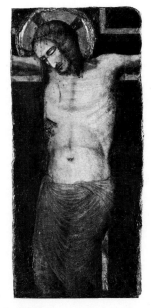

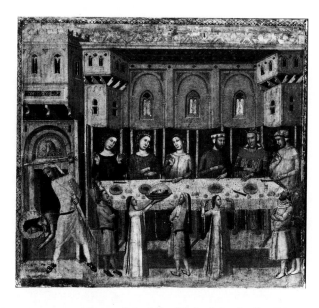

39.42 Pietro da Rimini

1975.1.103 Master of the Life of Saint John the Baptist

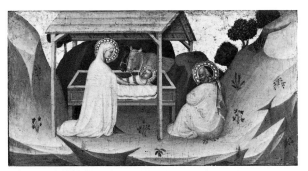

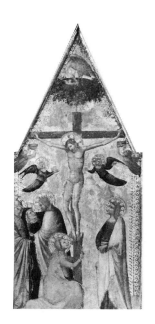

1975.1.105 Allegretto di Nuzio

1975.1.106 Allegretto di Nuzio

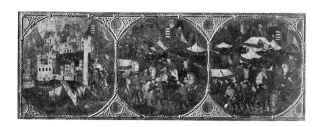

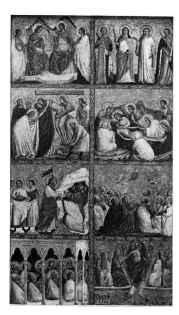

07.120.1 South Italian, early XV century

09.103 Riminese, middle XIV century

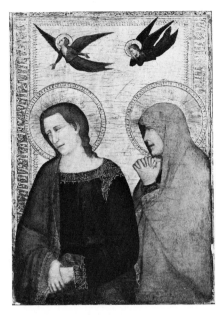

1975.1.102 Roberto d'Odorisio

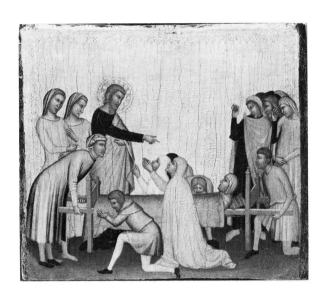

69.280.1 Francescuccio Ghissi

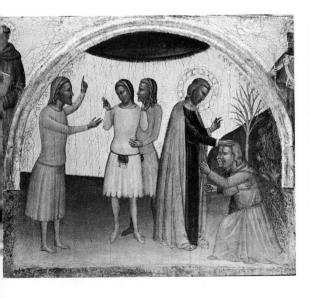

69.280.2 Francescuccio Ghissi

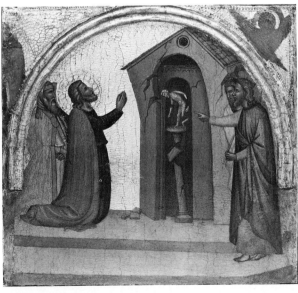

69.280.3 Francescuccio Ghissi

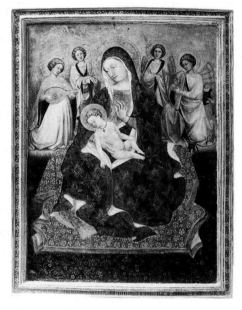

07.201 Pietro di Domenico da Montepulciano

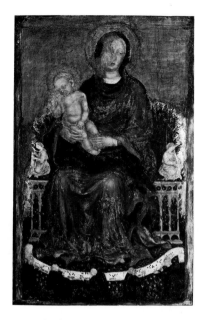

30.95.262 Gentile da Fabriano

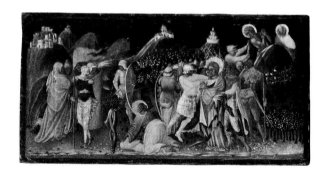

58.87.1 Bartolomeo di Tommaso

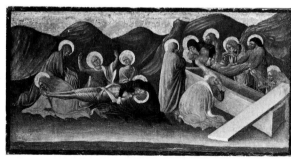

58.87.2 Bartolomeo di Tommaso

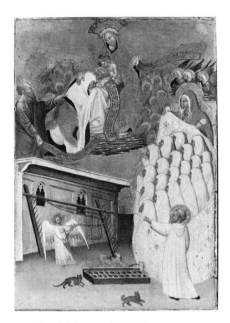

1975.1.100 Marchigian, middle XV century

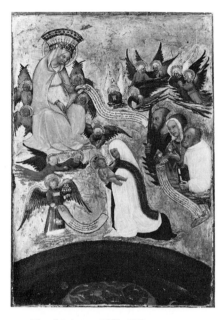

1975.1.101 Marchigian, middle XV century

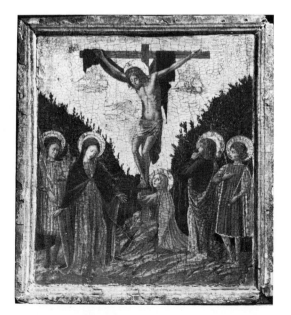

1975.1.108 Giovanni Boccati

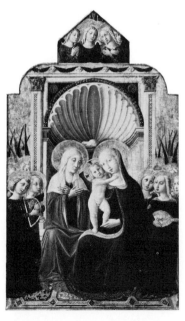

1975.1.107 Niccolò di Liberatore da Foligno

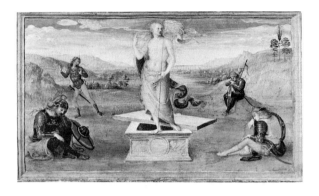

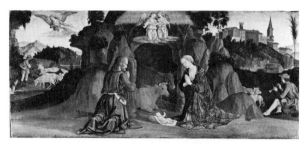

11.65 Perugino

06.1214 Antoniazzo Romano

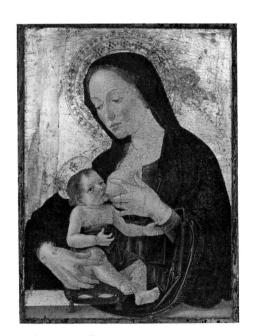

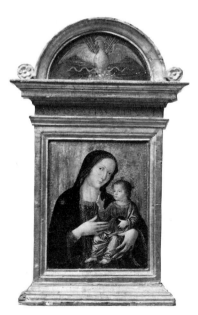

41.190.9 Antoniazzo Romano

30.95.290 Workshop of Antoniazzo Romano

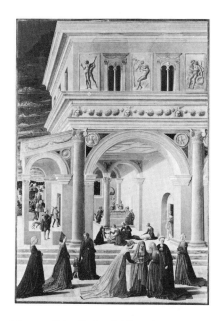

35.121 Master of the Barberini Panels

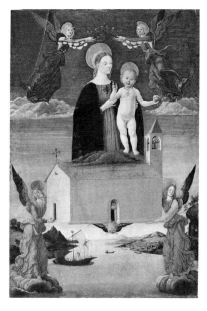

1973.319 Saturnino de'Gatti

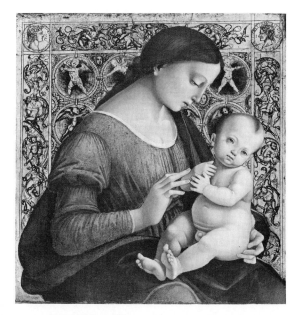

49.7.13 Luca Signorelli

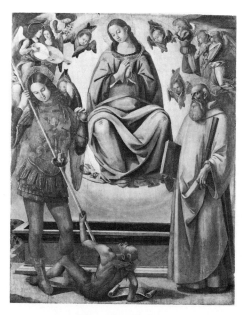

29.164 Luca Signorelli and Workshop

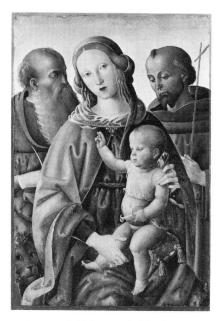

32.100.74 Antonio del Massaro da Viterbo

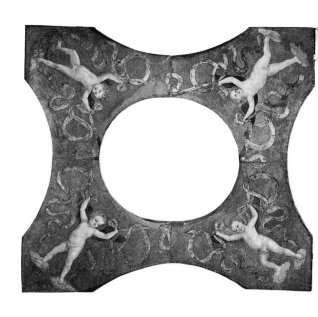

14.114.1–4 Pinturicchio and Workshop

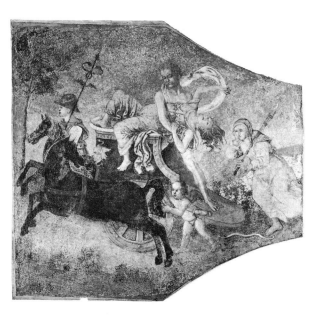

14.114.5 Pinturicchio and Workshop

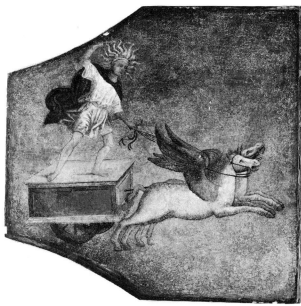

14.114.6 Pinturicchio and Workshop

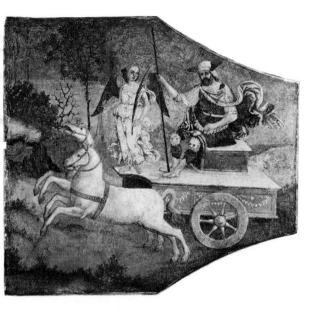

14.114.7 Pinturicchio and Workshop

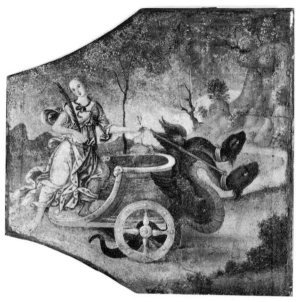

14.114.8 Pinturicchio and Workshop

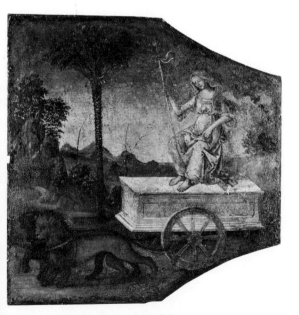

14.114.9 Pinturicchio and Workshop

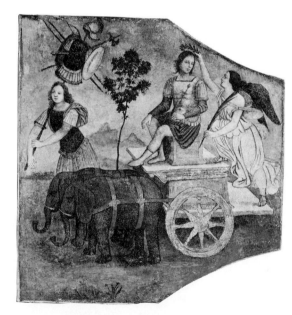

14.114.10 Pinturicchio and Workshop

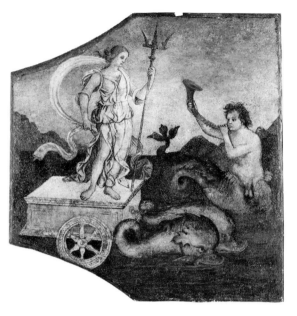

14.114.11 Pinturicchio and Workshop

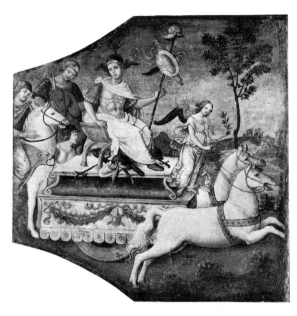

14.114.12 Pinturicchio and Workshop

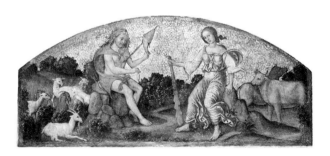

14.114.17 Pinturicchio and Workshop

14.114.18 Pinturicchio and Workshop

14.114.13 Pinturicchio and Workshop

14.114.14 Pinturicchio and Workshop

14.114.15 Pinturicchio and Workshop

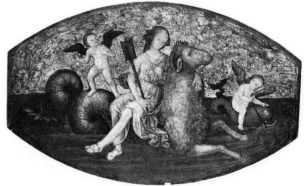

14.114.16 Pinturicchio and Workshop

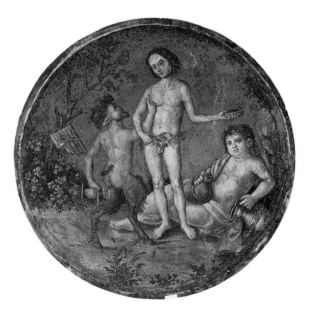

14.114.19 Pinturicchio and Workshop

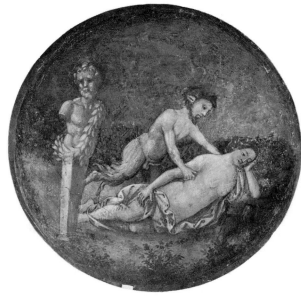

14.114.20 Pinturicchio and Workshop

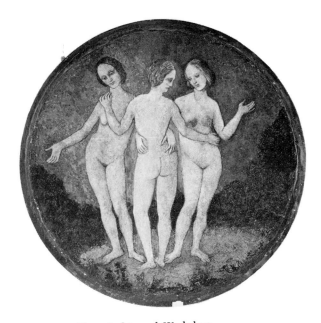

14.114.21 Pinturicchio and Workshop

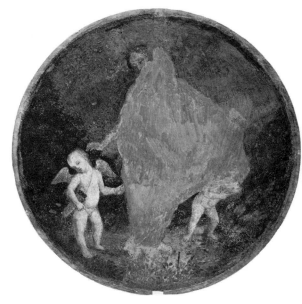

14.114.22 Pinturicchio and Workshop

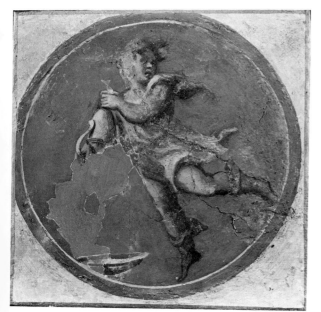

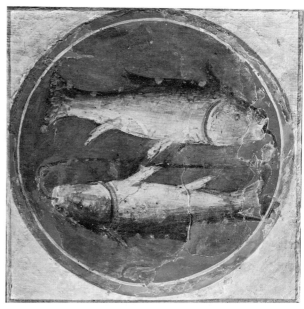

48.17.8 Baldassare Peruzzi

48.17.2 Baldassare Peruzzi

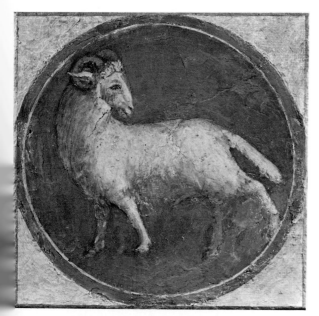

48.17.4 Baldassare Peruzzi

48.17.6 Baldassare Peruzzi

48.17.3 Baldassare Peruzzi

48.17.7 Baldassare Peruzzi

48.17.10 Baldassare Peruzzi

48.17.5 Baldassare Peruzzi

48.17.9 Baldassare Peruzzi

48.17.11 Baldassare Peruzzi

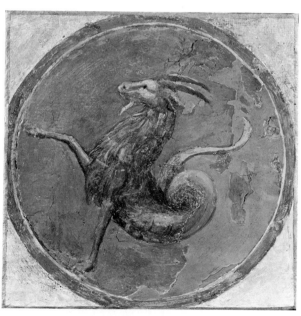

48.17.1 Baldassare Peruzzi

48.17.12 Baldassare Peruzzi

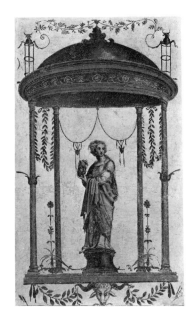

48.17.15 Baldassare Peruzzi

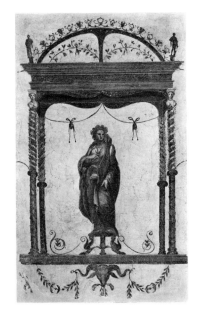

48.17.16 Baldassare Peruzzi

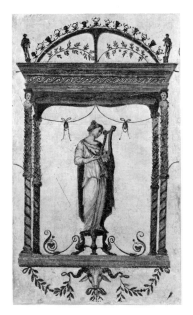

48.17.17 Baldassare Peruzzi

48.17.18 Baldassare Peruzzi

48.17.19 Baldassare Peruzzi

48.17.20 Baldassare Peruzzi

48.17.21 Baldassare Peruzzi

48.17.22 Baldassare Peruzzi

Central and South Italian

48.17.13 Baldassare Peruzzi

48.17.14 Baldassare Peruzzi

21.134.6 Andrea da Salerno

80.3.682–683 Attributed to Giovanni da Udine

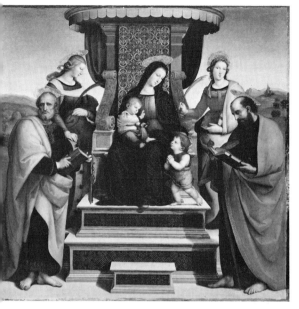

16.30a Raphael

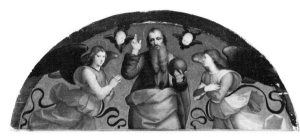

16.30b Raphael

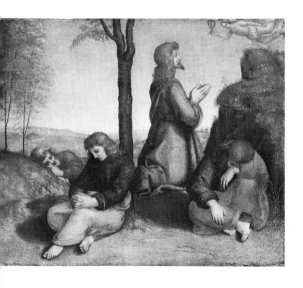

2.130.1 Raphael

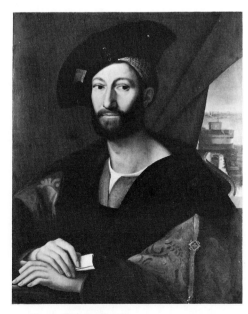

49.7.12 Copy after Raphael

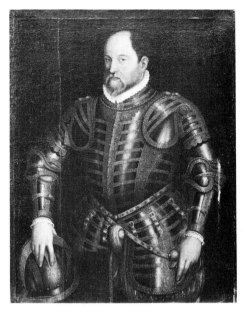

14.25.1885 Central Italian?, 2nd half XVI century

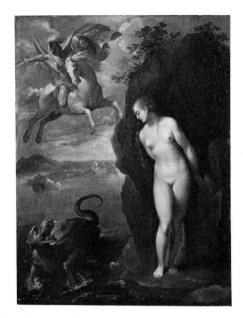

28.181 Giuseppe Cesari

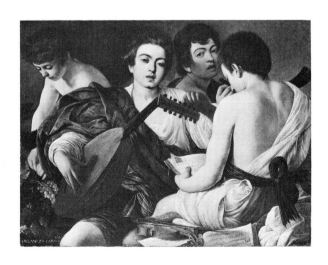

52.81 Caravaggio

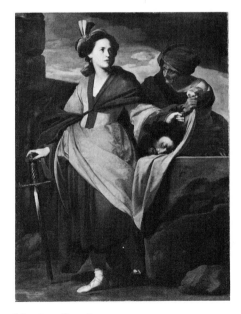

59.40 Massimo Stanzione

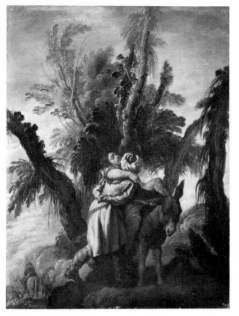

30.31 Domenico Fetti

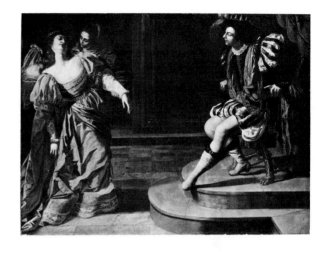

69.281 Artemisia Gentileschi

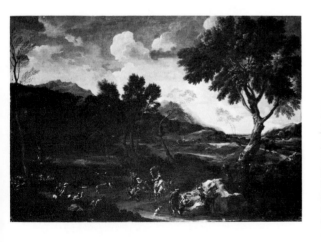

93.29 Michelangelo Cerquozzi

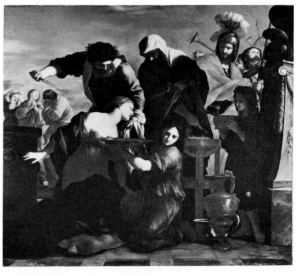

54.166 Giovanni Francesco Romanelli

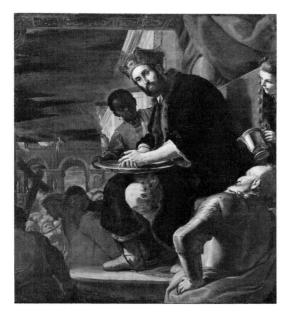

1978.402 Mattia Preti

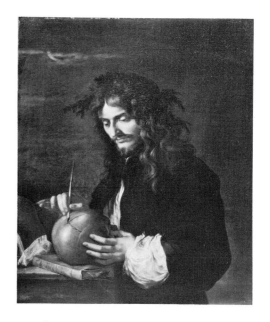

21.105 Salvator Rosa

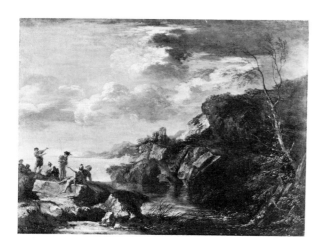

34.137 Salvator Rosa

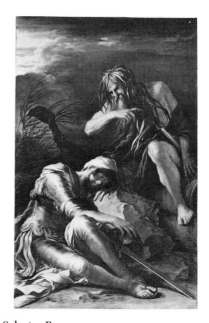

65.118 Salvator Rosa

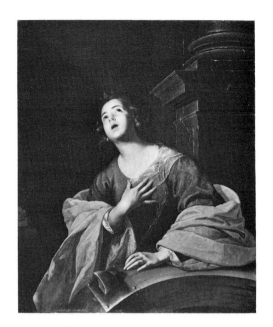

43.23 Bernardo Cavallino

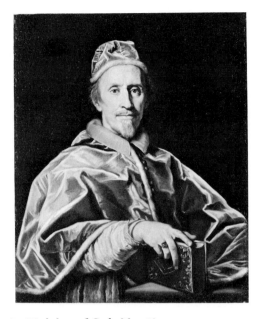

91.28 Workshop of Carlo Maratti

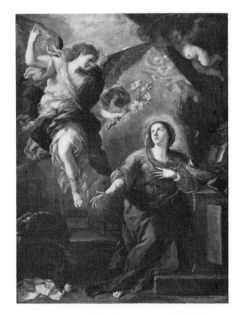

1973.311.2 Luca Giordano

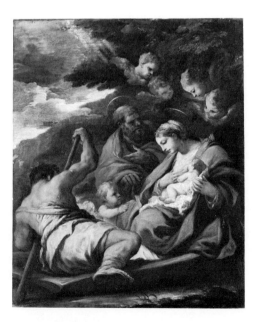

61.50 Luca Giordano

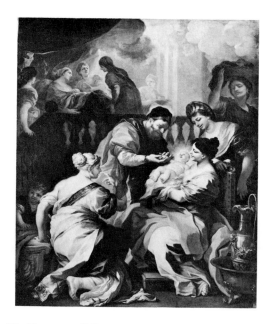

07.66 Francesco Solimena

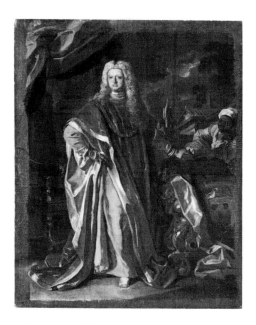

67.102 Francesco Solimena

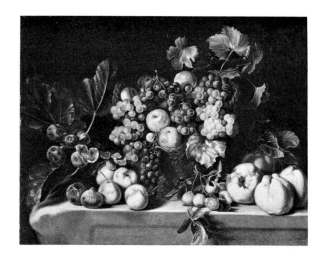

71.172 Luca Forte

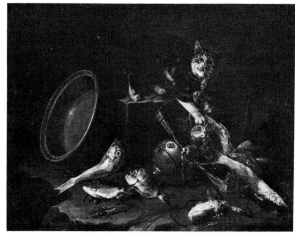

71.17 Giuseppe Recco

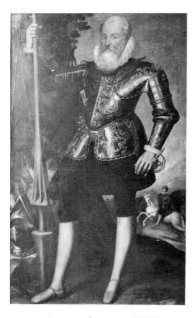

29.158.750 Neapolitan, 2nd quarter XVII century

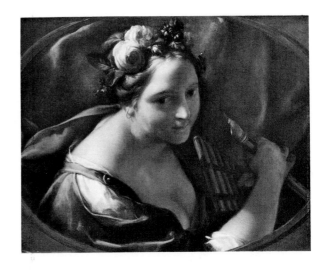

1974.108 Pietro Bianchi

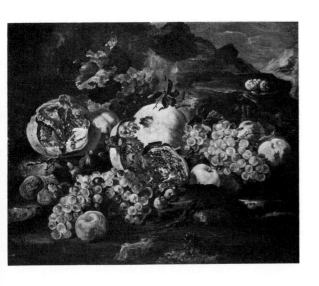

71.118 Giovanni Paolo Spadino

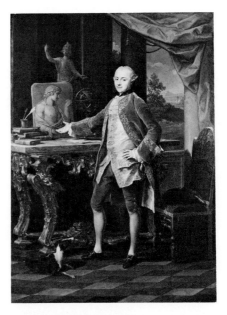

03.37.1 Pompeo Girolamo Batoni

Central and South Italian

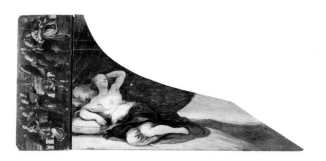

89.4.1231 Roman?, XVII century or later

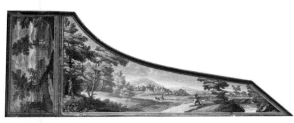

45.41 Roman?, late XVII/early XVIII century

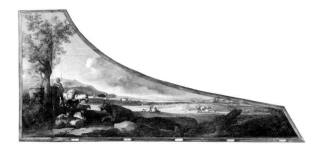

86.20 Roman?, 3rd quarter XVII century

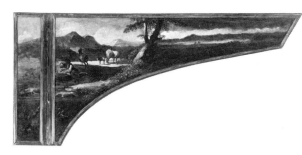

86.20 Roman?, 3rd quarter XVII century

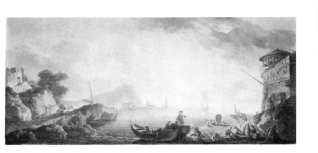

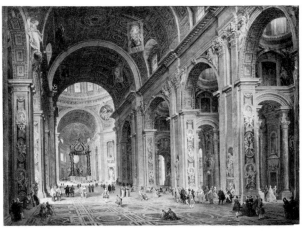

37.160.16 Carlo Bonaria

71.31 Giovanni Paolo Pannini

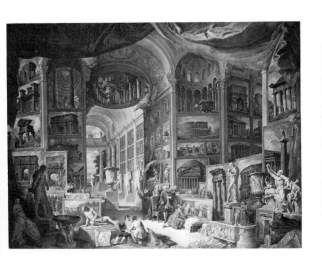

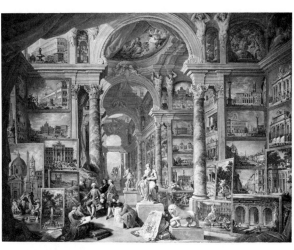

52.63.1 Giovanni Paolo Pannini

52.63.2 Giovanni Paolo Pannini

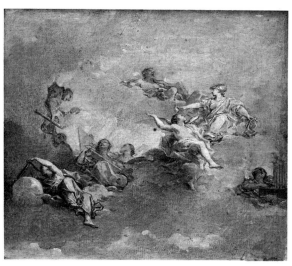

07.225.293 Corrado Giaquinto

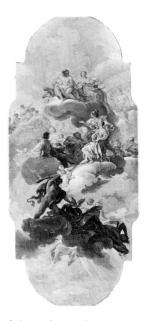

07.225.270 Workshop of Corrado Giaquinto

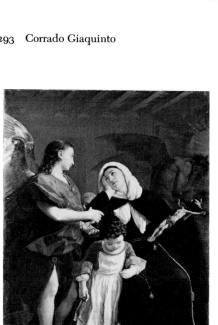

68.182 Gaspare Traversi

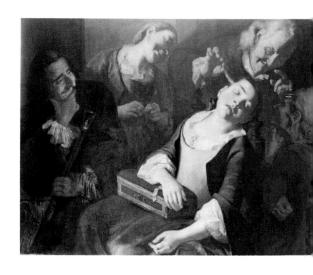

1976.100.19 Gaspare Traversi

ITALIAN PAINTINGS

VENETIAN, MIDDLE XIV–XVIII CENTURY

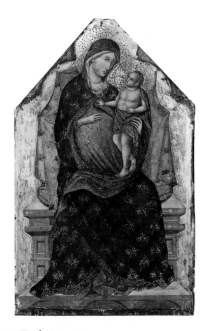

1971.115.5 Paolo Veneziano

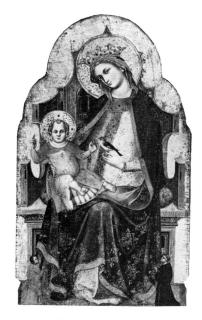

1975.1.78 Lorenzo Veneziano

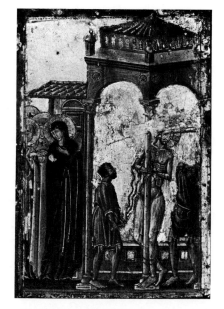

1975.1.79 Venetian, middle XIV century

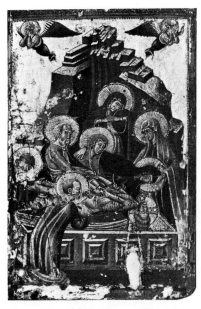

1975.1.80 Venetian, middle XIV century

109

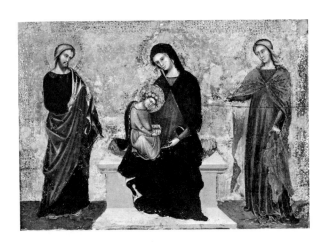

32.100.87 Master of Helsinus

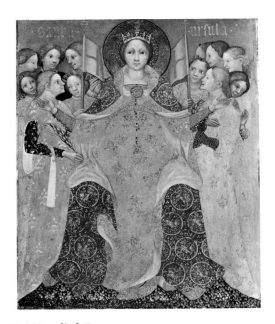

23.64 Niccolò di Pietro

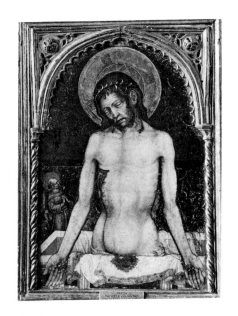

06.180 Michele Giambono

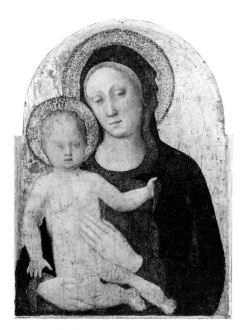

59.187 Jacopo Bellini

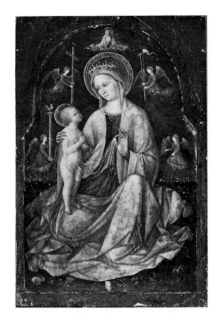

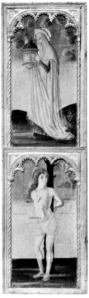

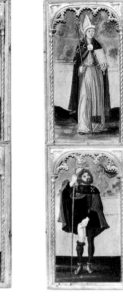

32.100.93 Venetian, 2nd quarter XV century

08.40 Venetian, 3rd quarter XV century

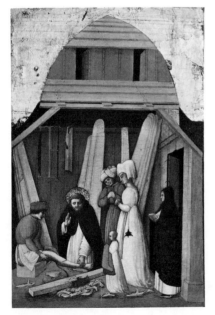

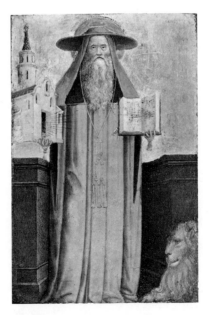

37.163.4 Antonio Vivarini

65.181.6 Workshop of Antonio Vivarini

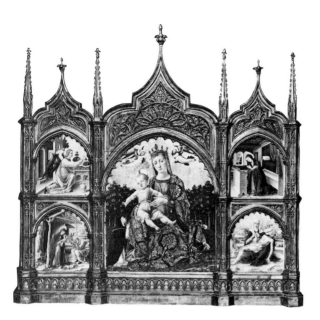

1975.1.82 Bartolomeo Vivarini

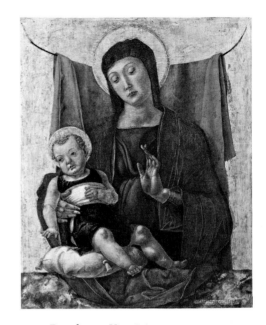

30.95.277 Bartolomeo Vivarini

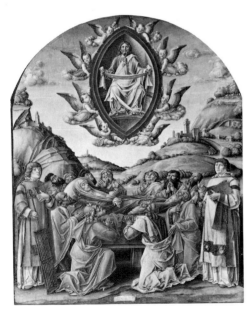

50.229.1 Bartolomeo Vivarini

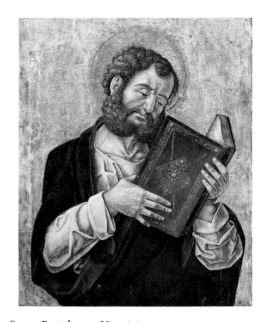

65.181.1 Bartolomeo Vivarini

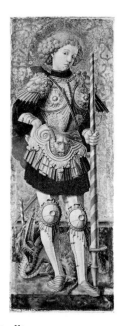

05.41.2 Carlo Crivelli

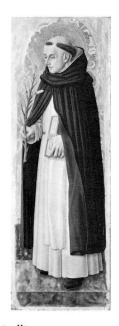

05.41.1 Carlo Crivelli

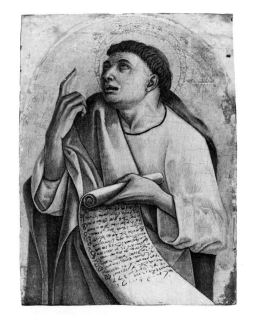

1975.1.84 Carlo Crivelli

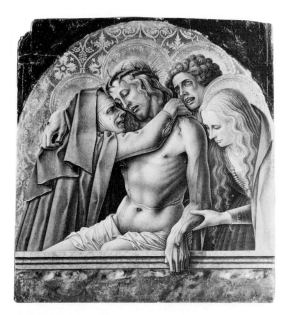

13.178 Carlo Crivelli

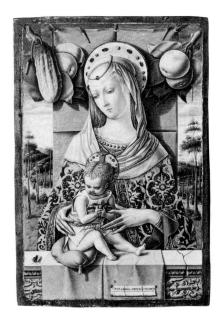

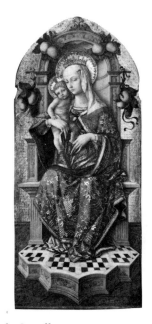

49.7.5 Carlo Crivelli

1975.1.83 Carlo Crivelli

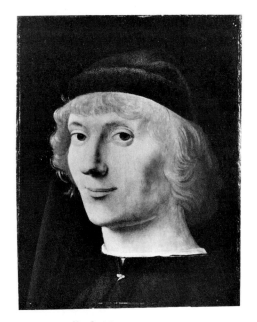

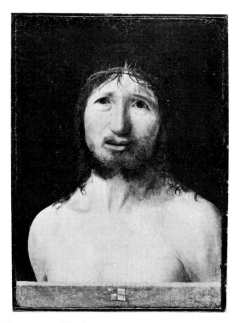

14.40.645 Antonello da Messina

32.100.82 Antonello da Messina

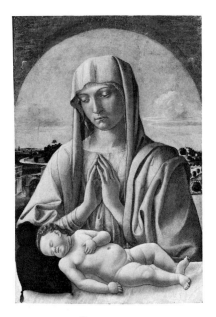

30.95.256 Giovanni Bellini

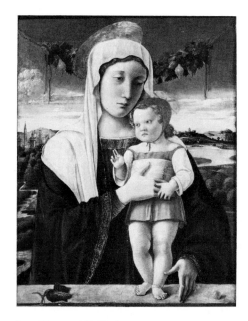

1975.1.81 Giovanni Bellini

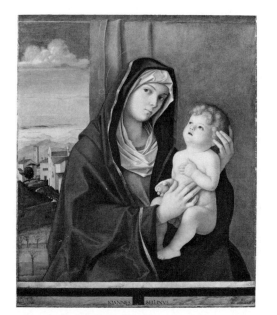

08.183.1 Giovanni Bellini

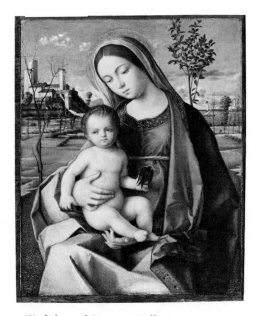

49.7.2 Workshop of Giovanni Bellini

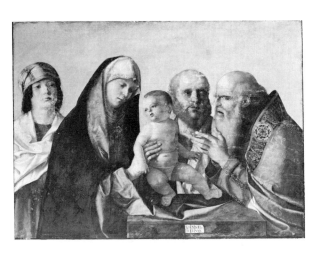

68.192 Workshop of Giovanni Bellini

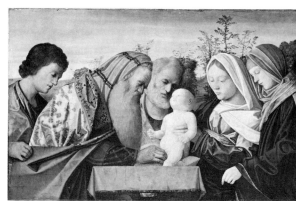

17.190.9 Workshop of Giovanni Bellini

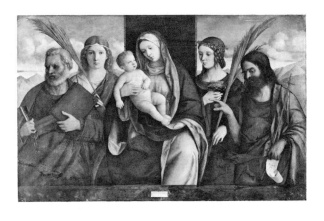

49.7.1 Giovanni Bellini and Workshop

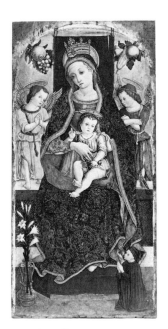

41.100.32 Vittore Crivelli

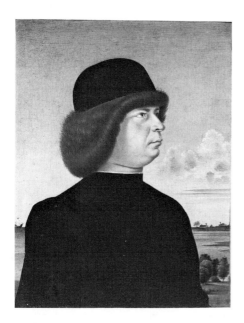

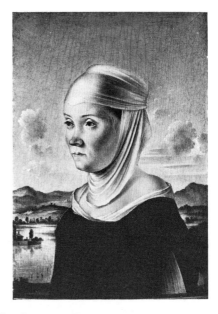

1975.1.86 Jacometto Veneziano

1975.1.85 Jacometto Veneziano

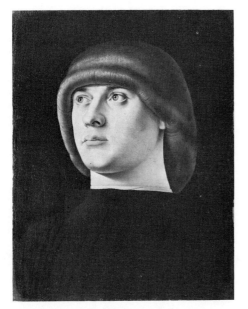

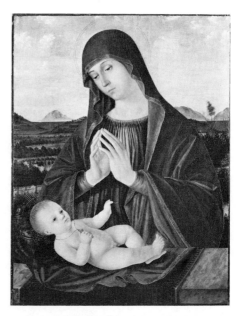

49.7.3 Jacometto Veneziano

30.95.249 Antonello de Saliba

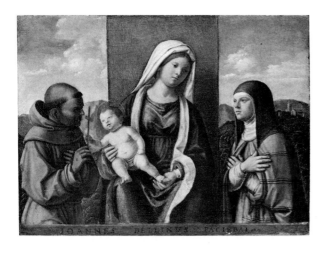

41.190.11 Giovanni Battista Cima

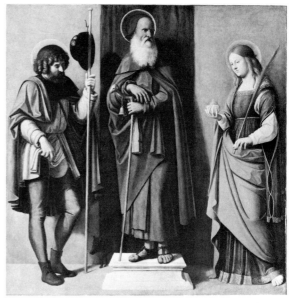

07.149 Giovanni Battista Cima

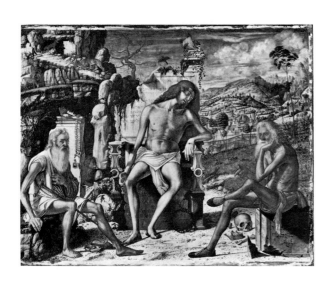

11.118 Vittore Carpaccio

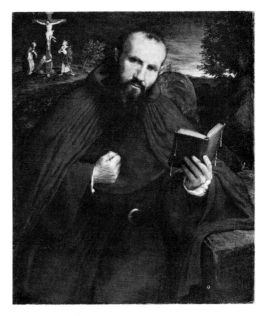

65.117 Lorenzo Lotto

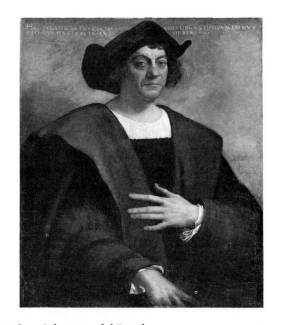

00.18.2 Sebastiano del Piombo

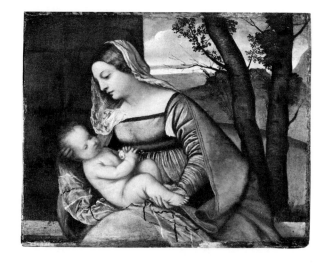

49.7.15 Titian

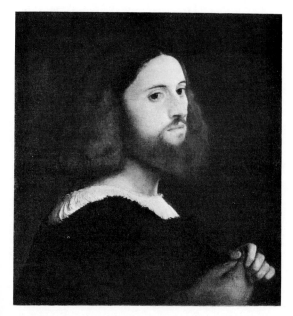

14.40.640 Titian

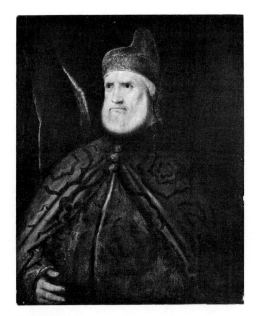

32.100.85 Titian

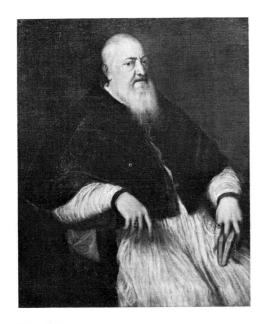

14.40.650 Titian

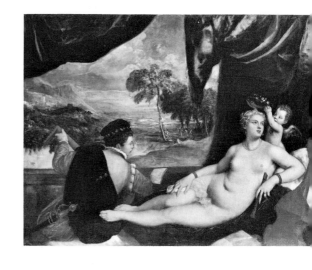

36.29 Titian

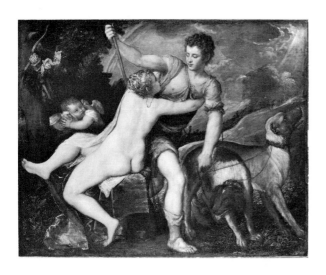

49.7.16 Titian

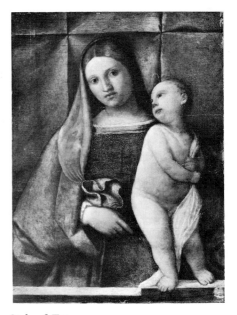

57.31 Style of Titian

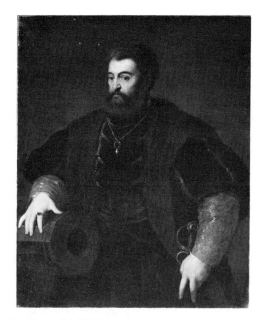

27.56 Copy after Titian

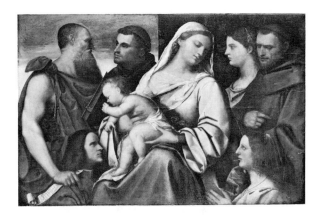

1973.155.5 Domenico Mancini

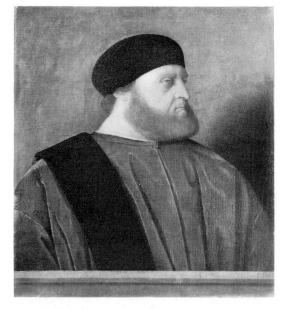

30.95.258 Catena

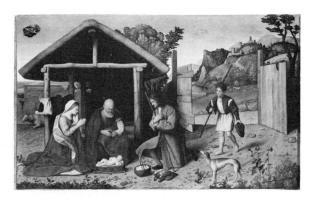

69.123 Catena

Italian / Venetian

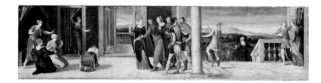

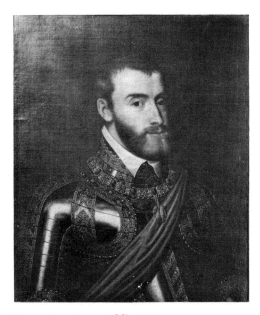

32.100.78 Bonifazio Veronese

1973.311.1 Paris Bordon

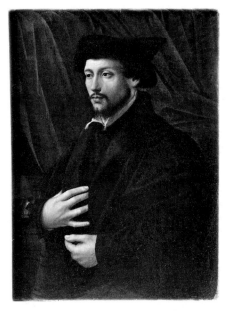

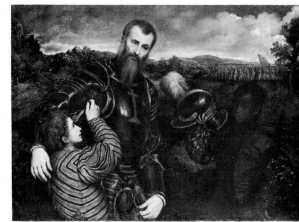

06.1324 Venetian, 2nd quarter XVI century

29.158.751 Venetian, middle XVI century

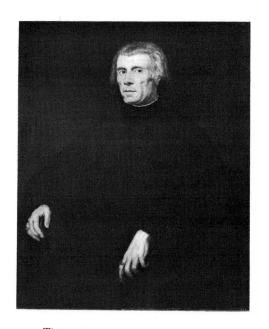

41.100.12 Tintoretto

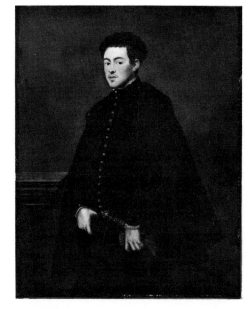

58.49 Tintoretto

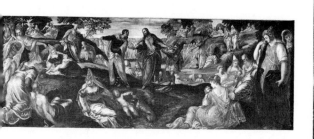

13.75 Tintoretto

39.55 Tintoretto

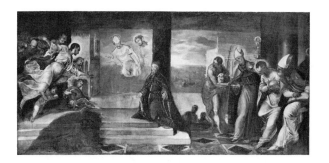

10.206 Tintoretto

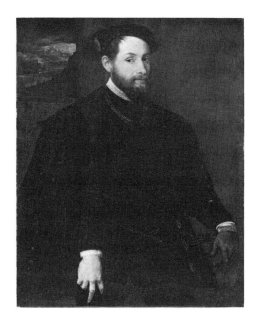

49.7.14 Lambert Sustris

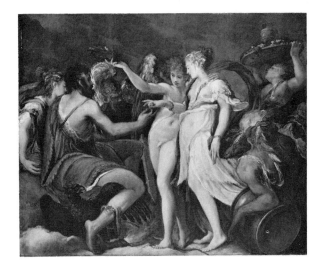

1973.116 Andrea Schiavone

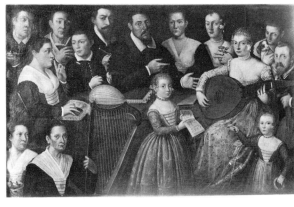

89.4.2742 Girolamo Forni

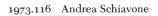

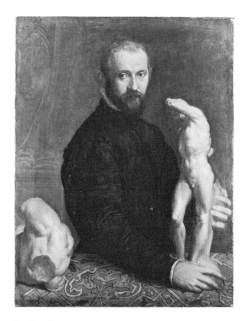

46.31 Paolo Veronese

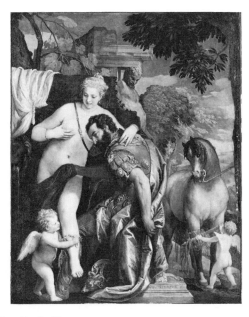

10.189 Paolo Veronese

29.100.105 Paolo Veronese

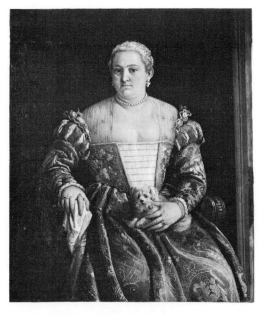

29.100.104 Francesco Montemezzano

125

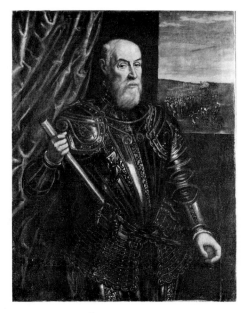

14.25.1871 Venetian, late XVI century

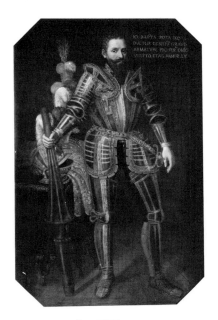

29.158.754 Venetian, late XVI century

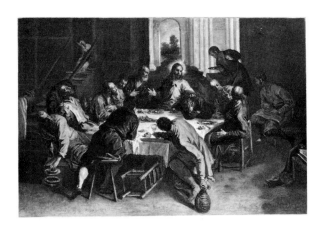

07.150 Venetian, late XVII century

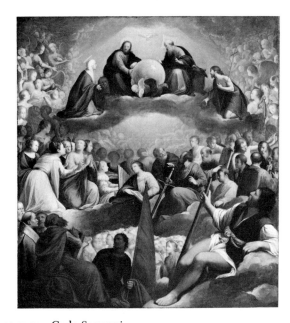

1971.93 Carlo Saraceni

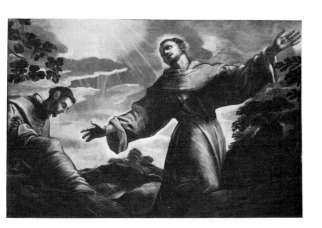

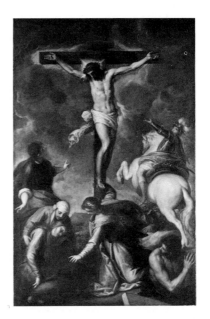

62.257 Jacopo Palma the Younger

57.170 Jacopo Palma the Younger

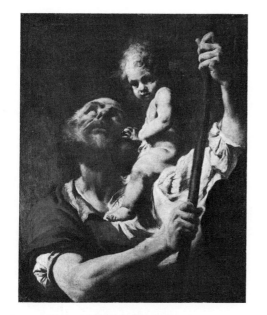

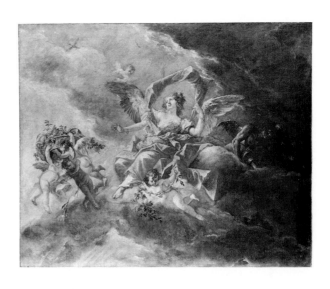

67.187.90 Giovanni Battista Piazzetta

06.1335.1b Gasparo Diziani

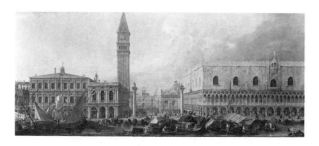

1975.1.87 Luca Carlevaris

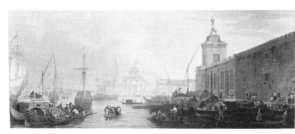

1975.1.88 Luca Carlevaris

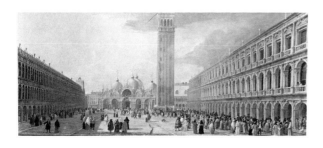

1975.1.89 Luca Carlevaris

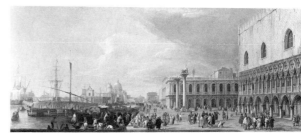

1975.1.90 Luca Carlevaris

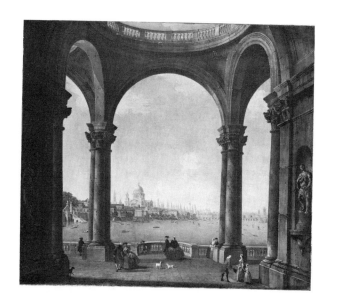

1970.212.2 Antonio Joli

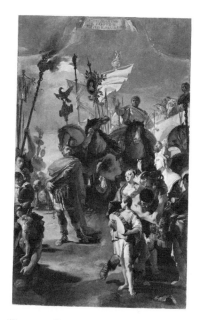

65.183.1 Giovanni Battista Tiepolo

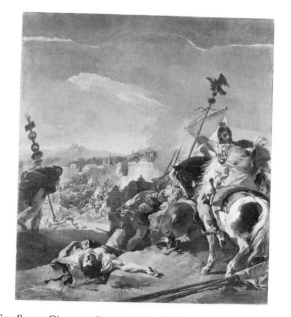

65.183.2 Giovanni Battista Tiepolo

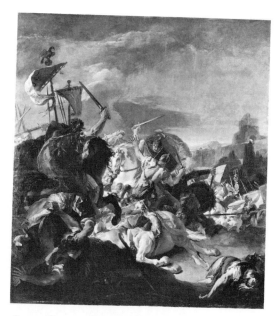

65.183.3 Giovanni Battista Tiepolo

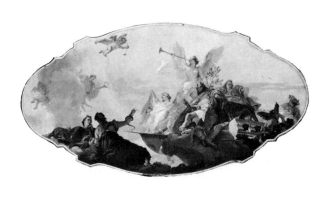

23.128 Giovanni Battista Tiepolo

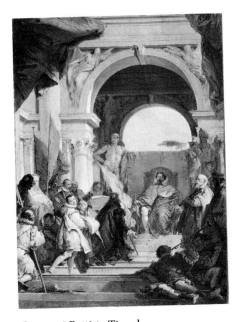

71.121 Giovanni Battista Tiepolo

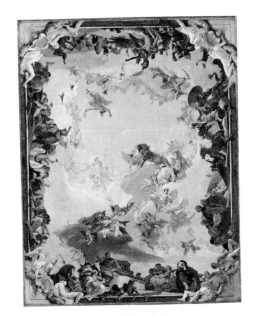

1977.1.3 Giovanni Battista Tiepolo

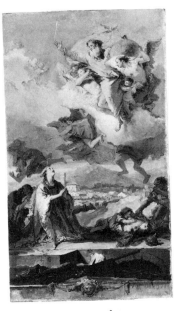

37.165.2 Giovanni Battista Tiepolo

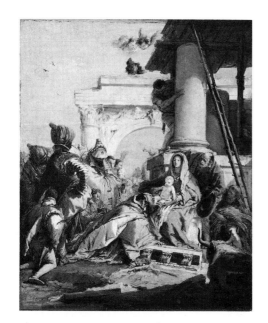

37.165.1 Giovanni Battista Tiepolo

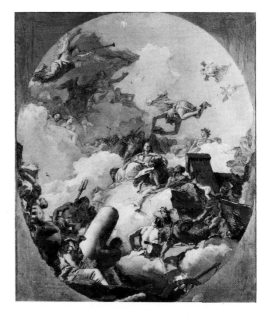

37.165.3 Giovanni Battista Tiepolo

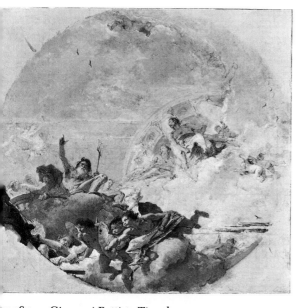

37.165.4 Giovanni Battista Tiepolo

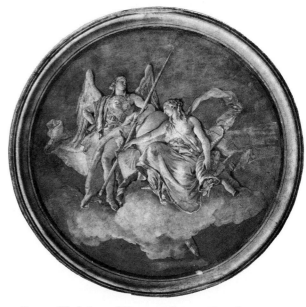

43.85.12 Workshop of Giovanni Battista Tiepolo

131

43.85.13 Workshop of Giovanni Battista Tiepolo

43.85.14 Workshop of Giovanni Battista Tiepolo

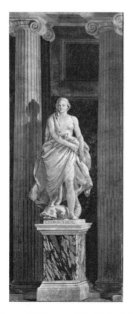

43.85.15 Workshop of Giovanni Battista Tiepolo

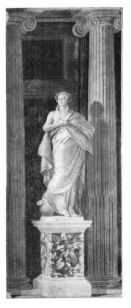

43.85.16 Workshop of Giovanni Battista Tiepolo

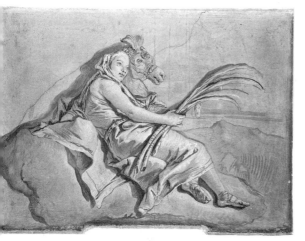

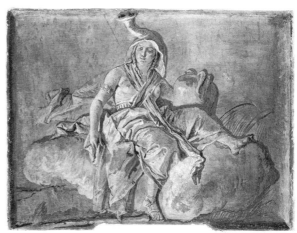

43.85.17 Workshop of Giovanni Battista Tiepolo

43.85.18 Workshop of Giovanni Battista Tiepolo

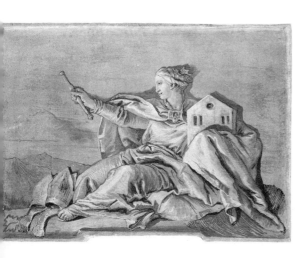

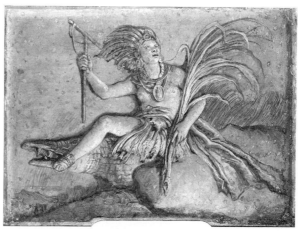

43.85.19 Workshop of Giovanni Battista Tiepolo

43.85.20 Workshop of Giovanni Battista Tiepolo

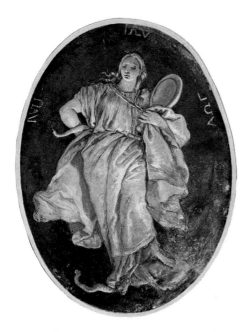

43.85.21 Workshop of Giovanni Battista Tiepolo

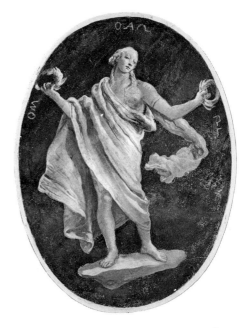

43.85.22 Workshop of Giovanni Battista Tiepolo

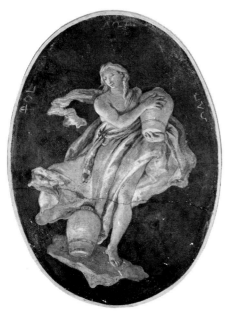

43.85.23 Workshop of Giovanni Battista Tiepolo

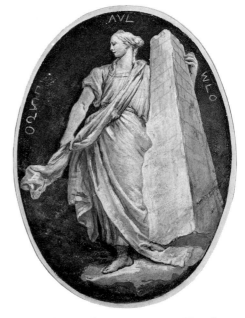

43.85.24 Workshop of Giovanni Battista Tiepolo

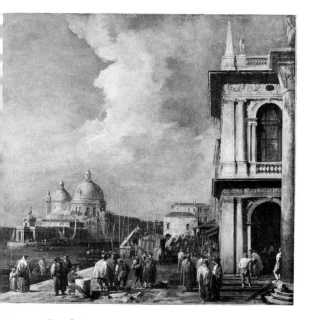

10.207 Canaletto

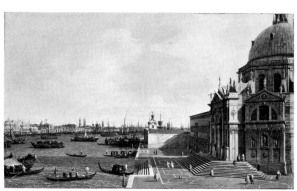

59.38 Canaletto

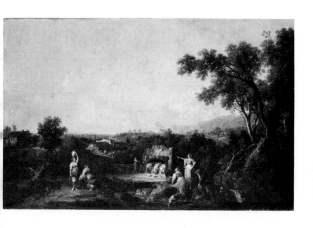

59.189.1 Francesco Zuccarelli

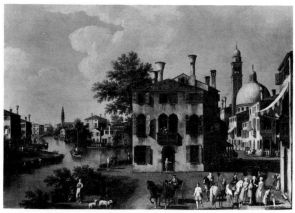

1975.1.91 Francesco Zuccarelli

135

Italian / Venetian

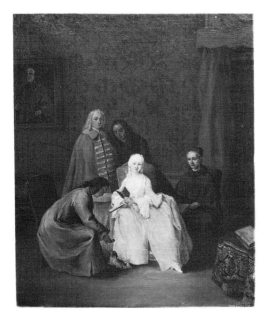

14.32.2 Pietro Longhi

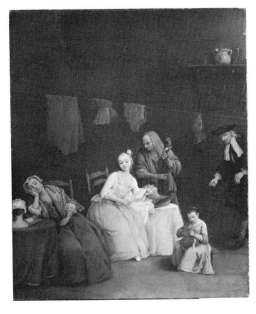

14.32.1 Pietro Longhi

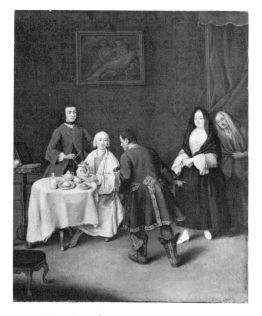

17.190.12 Pietro Longhi

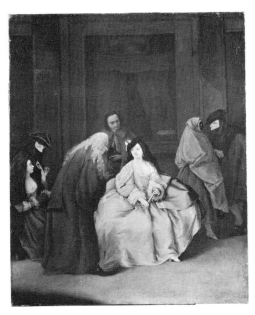

36.16 Pietro Longhi

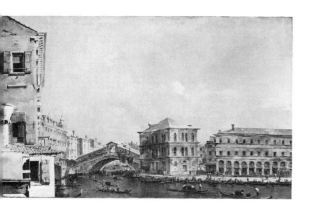

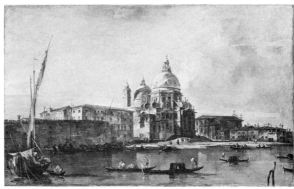

1.119 Francesco Guardi

71.120 Francesco Guardi

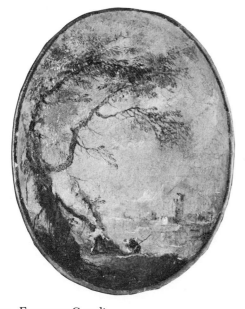

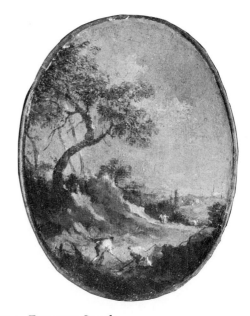

5.40.3 Francesco Guardi

35.40.4 Francesco Guardi

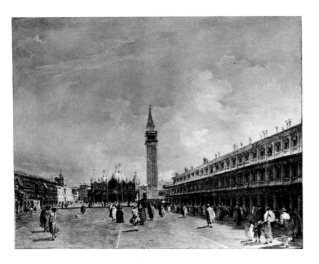

50.145.21 Francesco Guardi

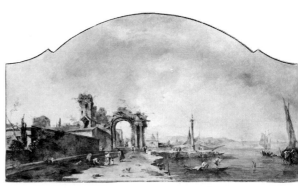

41.80 Francesco Guardi

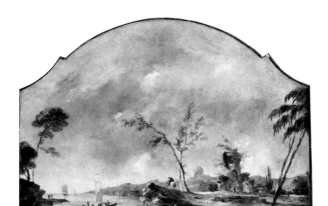

53.225.3 Francesco Guardi

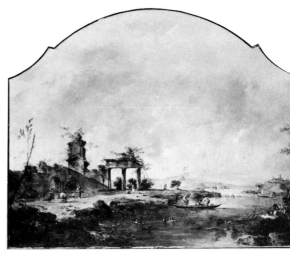

53.225.4 Francesco Guardi

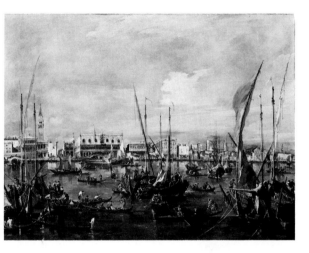

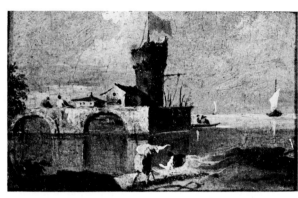

65.181.8 Francesco Guardi 1975.1.92 Francesco Guardi

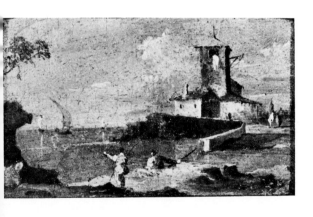

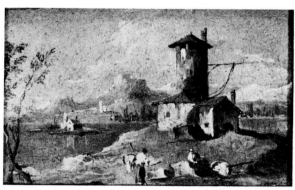

1975.1.93 Francesco Guardi 1975.1.94 Francesco Guardi

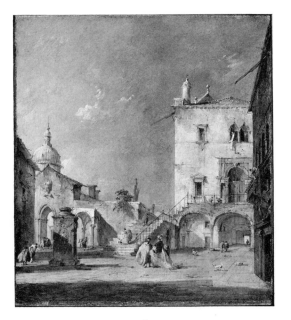

1974.356.28 Francesco Guardi

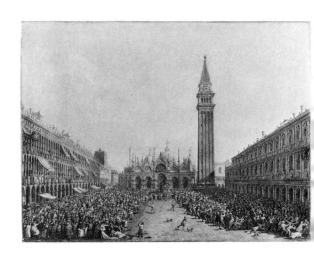

32.75.5 Copy after Francesco Guardi

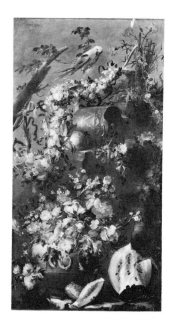

64.272.1 Attributed to Francesco Guardi

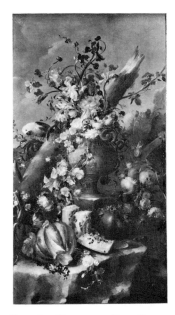

64.272.2 Attributed to Francesco Guardi

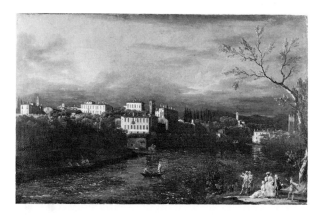

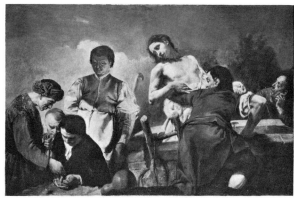

39.142 Bernardo Bellotto

29.70 Attributed to Maggiotto

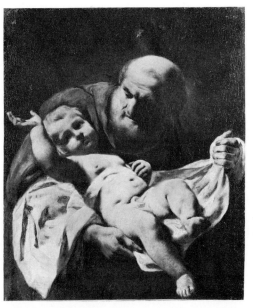

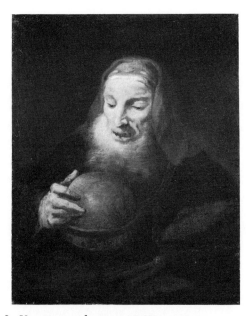

50.78 Antonio Marinetti

35.26 Venetian, 2nd quarter XVIII century

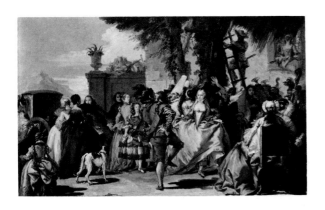

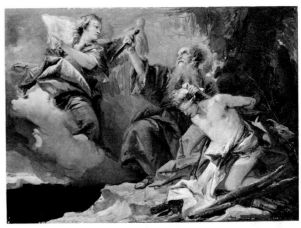

1980.67 Giovanni Domenico Tiepolo

71.28 Giovanni Domenico Tiepolo

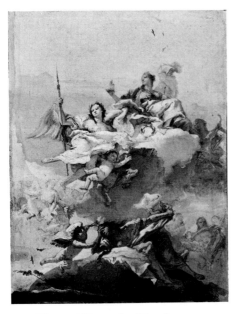

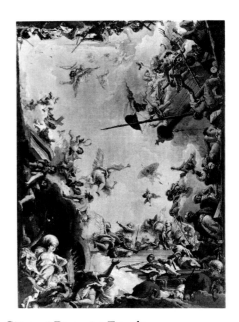

07.225.297 Giovanni Domenico Tiepolo

13.2 Giovanni Domenico Tiepolo

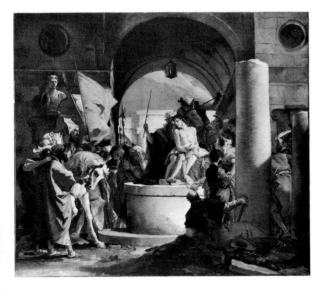

71.30 Jacopo Guarana

94.4.364 Giustino Menescardi

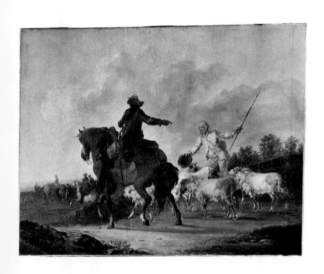

07.225.253 Francesco Casanova

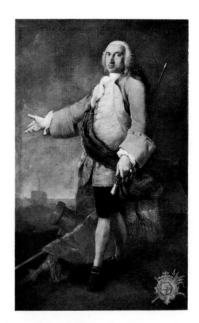

15.118 Alessandro Longhi

ITALIAN PAINTINGS

NORTH ITALIAN
MIDDLE XIV – XVIII CENTURY

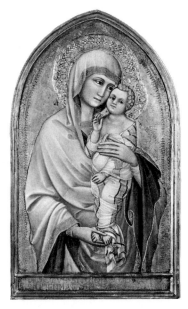

88.3.86 Guariento di Arpo

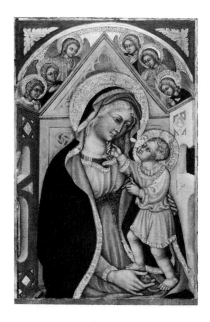

65.181.3 North Italian, 3rd quarter XIV century

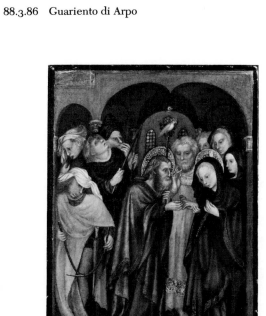

43.98.7 Michelino Molinari da Besozzo

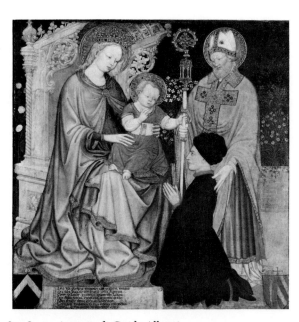

65.181.5 Antonio di Guido Alberti

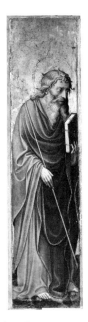

37.163.2 Donato de'Bardi

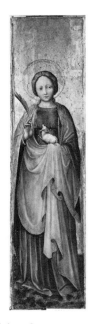

37.163.3 Donato de'Bardi

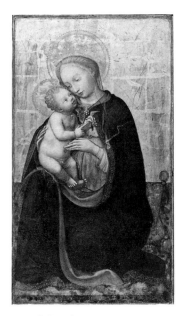

37.163.1 Donato de'Bardi

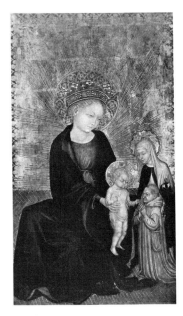

1975.1.98 Cristoforo Morettis

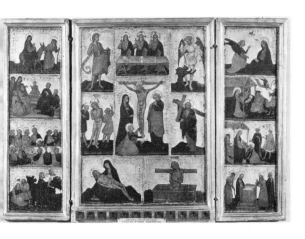

9.104 Veronese, 1st half XV century

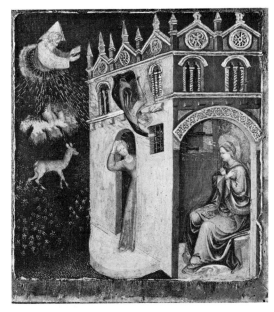

32.100.96 Veronese, 1st half XV century

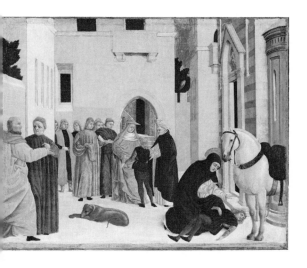

2.60.59 Bartolomeo degli Erri

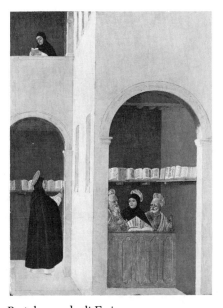

23.140 Bartolomeo degli Erri

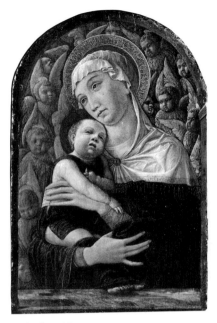

32.100.97 Andrea Mantegna

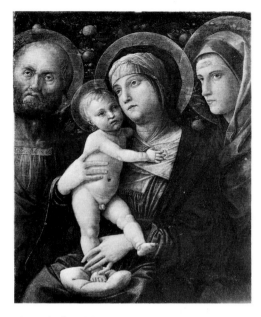

14.40.643 Andrea Mantegna

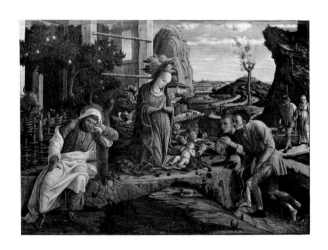

32.130.2 Andrea Mantegna

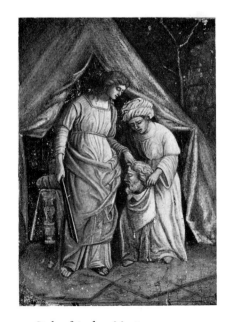

1975.1.109 Style of Andrea Mantegna

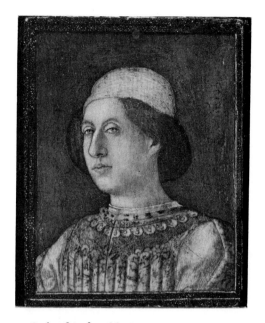

49.7.11 Style of Andrea Mantegna

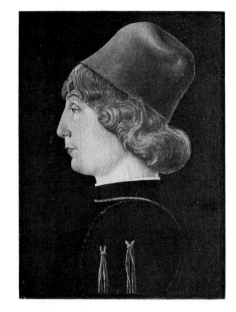

14.40.649 Cosimo Tura

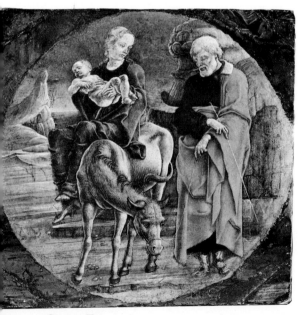

49.7.17 Cosimo Tura

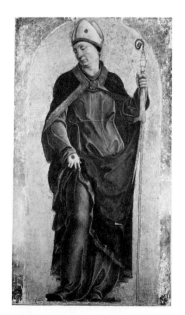

30.95.259 Cosimo Tura

North Italian

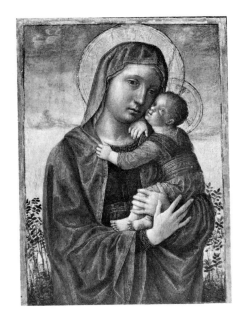

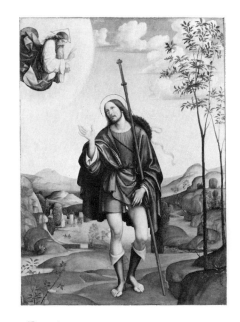

30.95.293 Vincenzo Foppa

65.220.1 Francia

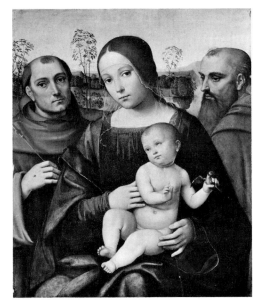

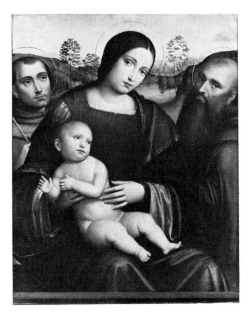

41.100.3 Francia

1975.1.97 Francia

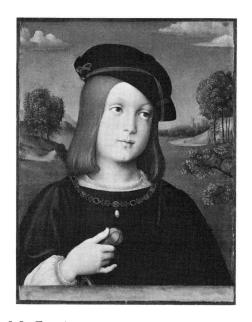

4.40.638 Francia

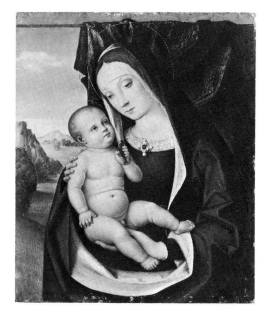

32.100.94 Follower of Francia

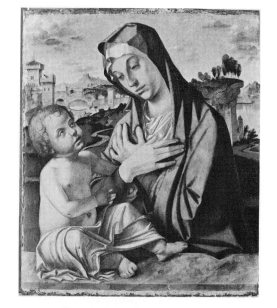

9.102 Bartolomeo Montagna

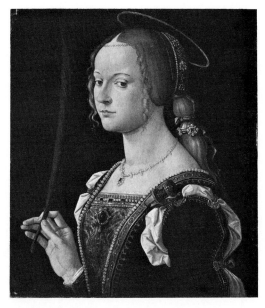

14.40.606 Bartolomeo Montagna

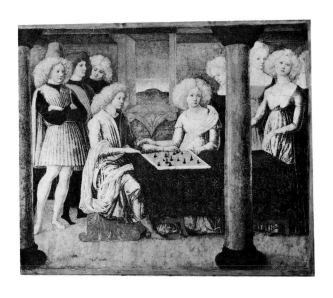

43.98.8 Girolamo da Cremona

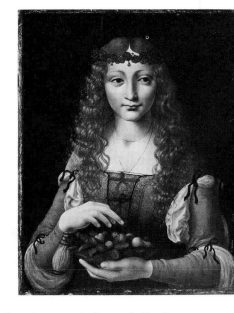

91.26.5 Giovanni Ambrogio de Predis

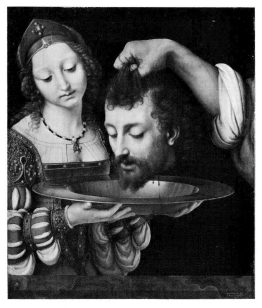

32.100.81 Andrea Solario

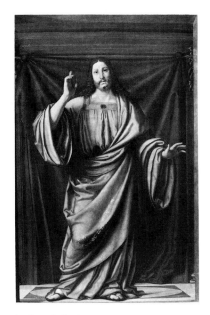

22.16.12 Andrea Solario

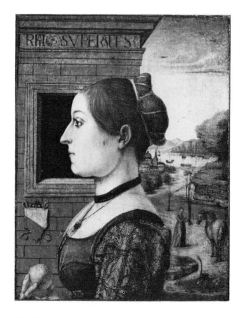

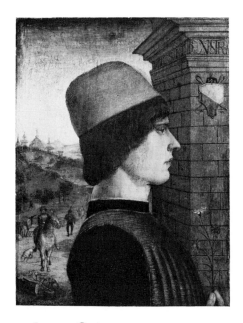

1975.1.95 Lorenzo Costa

1975.1.96 Lorenzo Costa

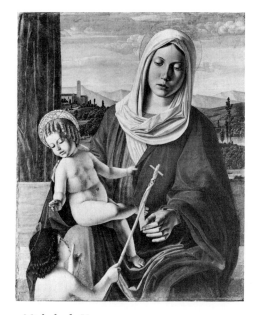

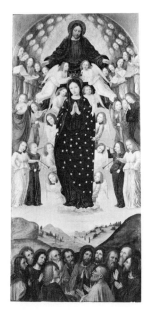

27.41 Michele da Verona

27.39.1 Bergognone

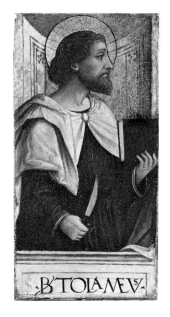

27.39.2 Bergognone

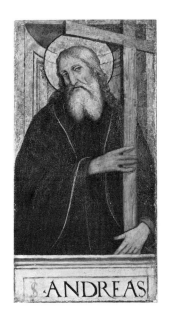

27.39.3 Bergognone

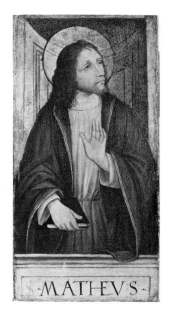

27.39.4 Bergognone

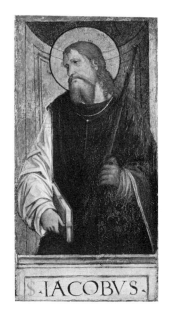

27.39.5 Bergognone

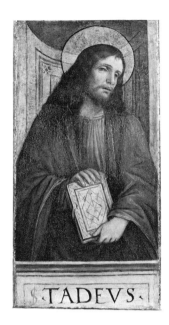

27.39.6 Bergognone

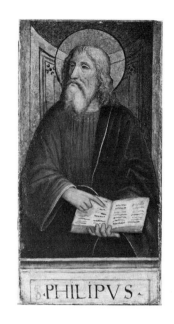

27.39.7 Bergognone

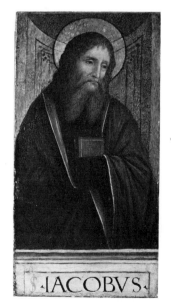

27.39.8 Bergognone

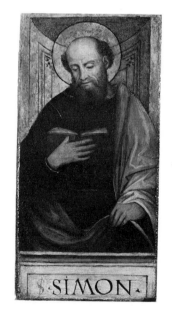

27.39.9 Bergognone

157

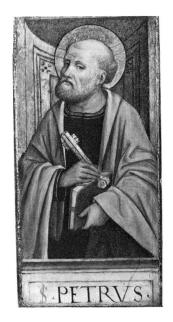

27.39.10 Bergognone

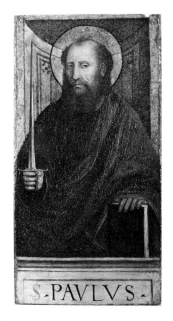

27.39.11 Bergognone

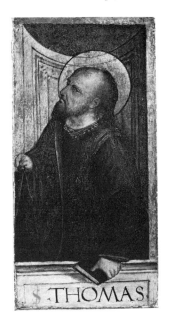

27.39.12 Bergognone

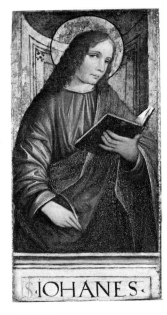

27.39.13 Bergognone

30.95.289 Boccaccio Boccaccino

30.95.292 Francesco Zaganelli

12.178.2 Bramantino

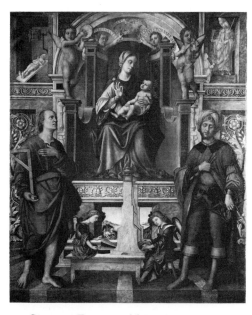

42.57.5 Giovanni Francesco Maineri

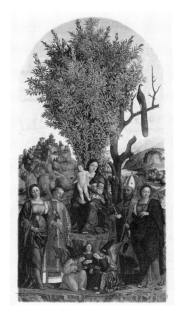

20.92 Girolamo dai Libri

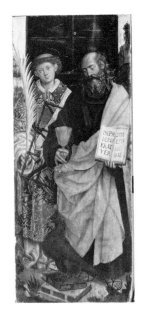

15.56 Defendente Ferrari

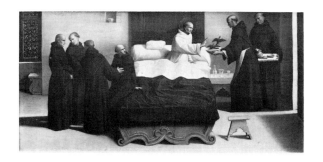

17.190.23 Garofalo

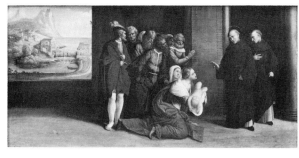

17.190.24 Garofalo

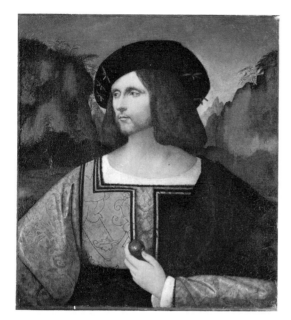

58.182 Pseudo-Boccaccino

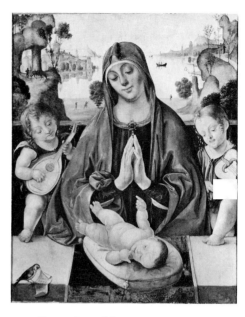

41.100.13 Bernardino of Genoa

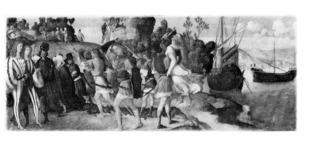

12.57 Zenone Veronese

30.95.296 L'Ortolano

161

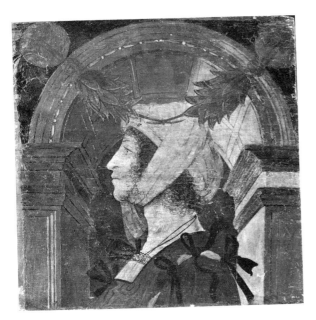

05.2.1 Lombard, 1st quarter XVI century

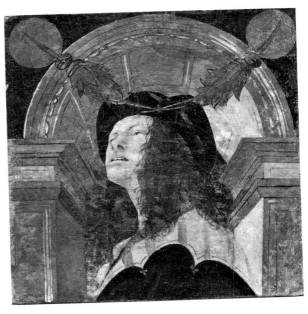

05.2.2 Lombard, 1st quarter XVI century

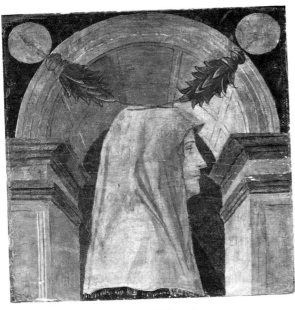

05.2.3 Lombard, 1st quarter XVI century

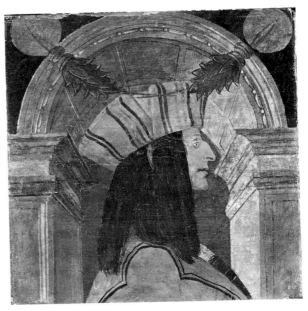

05.2.4 Lombard, 1st quarter XVI century

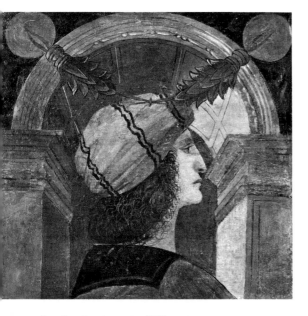

05.2.5 Lombard, 1st quarter XVI century

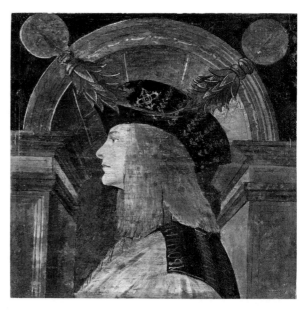

05.2.6 Lombard, 1st quarter XVI century

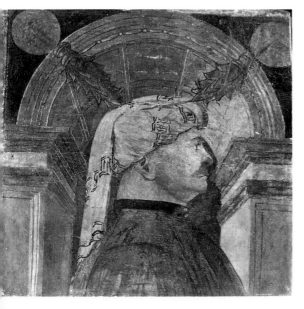

05.2.7 Lombard, 1st quarter XVI century

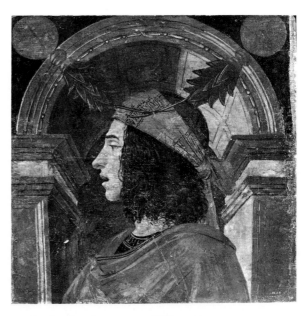

05.2.8 Lombard, 1st quarter XVI century

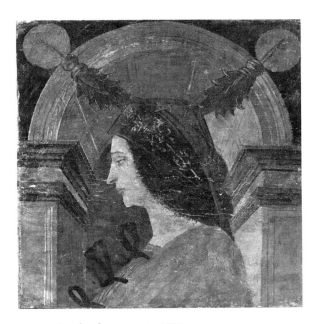

05.2.9 Lombard, 1st quarter XVI century

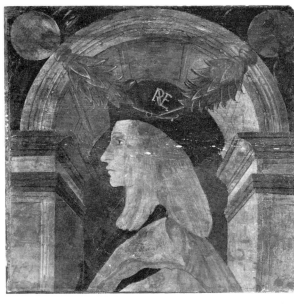

05.2.10 Lombard, 1st quarter XVI century

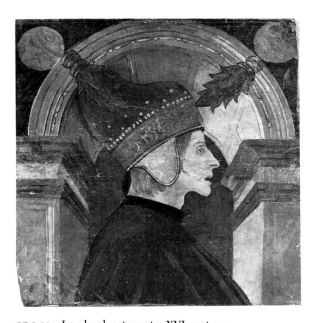

05.2.11 Lombard, 1st quarter XVI century

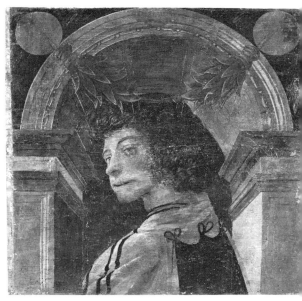

05.2.12 Lombard, 1st quarter XVI century

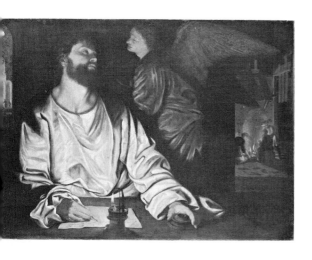

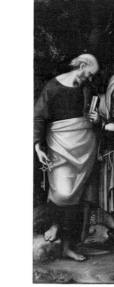

2.14 Giovanni Girolamo Savoldo

12.211 Correggio

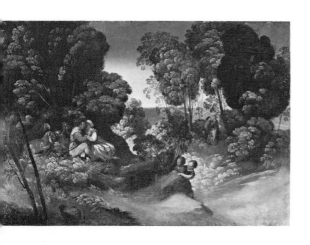

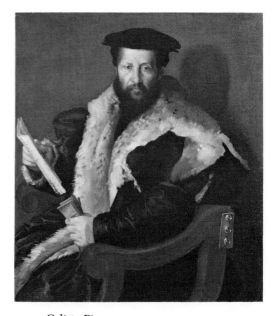

6.83 Dosso Dossi

41.100.7 Calisto Piazza

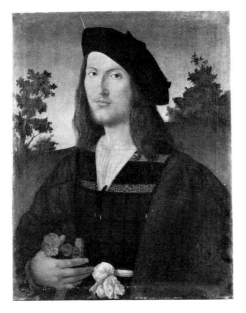

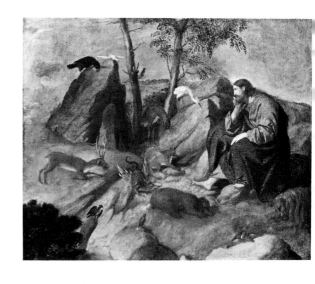

30.95.246 Lombard, 1st quarter XVI century

11.53 Moretto da Brescia

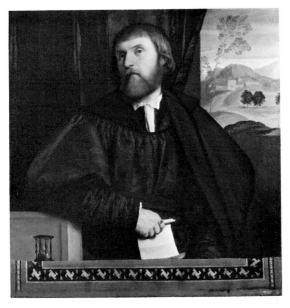

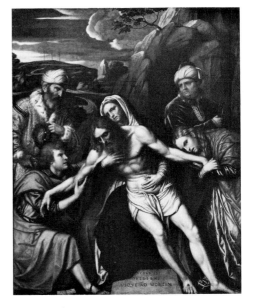

28.79 Moretto da Brescia

12.61 Moretto da Brescia

23.188.1 North Italian, early XVI century

23.188.2 North Italian, early XVI century

23.188.3 North Italian, early XVI century

23.188.4 North Italian, early XVI century

North Italian

23.188.5 North Italian, early XVI century

23.188.6 North Italian, early XVI century

23.188.7 North Italian, early XVI century

23.188.8 North Italian, early XVI century

3.188.9 North Italian, early XVI century

23.188.10 North Italian, early XVI century

3.188.11 North Italian, early XVI century

23.188.12 North Italian, early XVI century

169

23.188.13 North Italian, early XVI century

23.188.14 North Italian, early XVI century

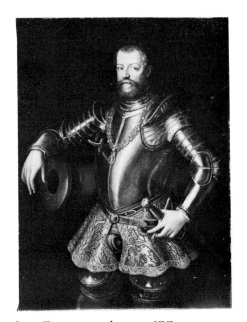

14.25.1874 Ferrarese, 2nd quarter XVI century

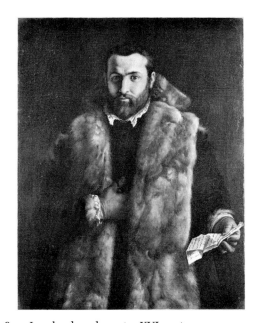

91.26.2 Lombard, 2nd quarter XVI century

170

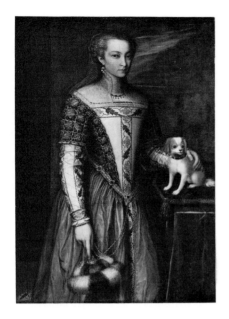

63.43.1 Bernardino Campi

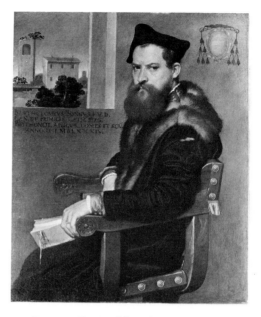

13.177 Giovanni Battista Moroni

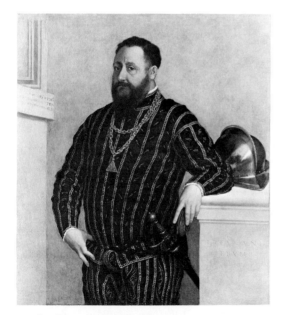

30.95.238 Giovanni Battista Moroni

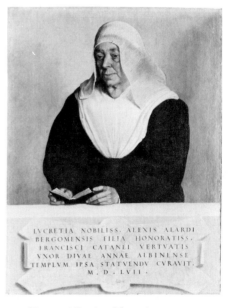

30.95.255 Giovanni Battista Moroni

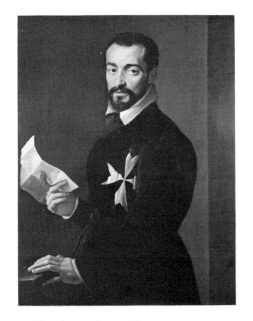

41.100.5 Bartolomeo Passerotti

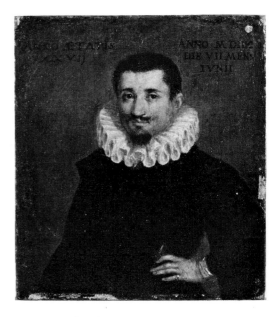

32.100.88 North Italian, late XVI century

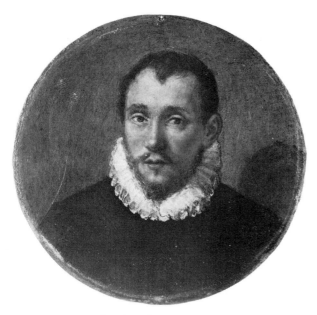

32.100.101 North Italian, late XVI century

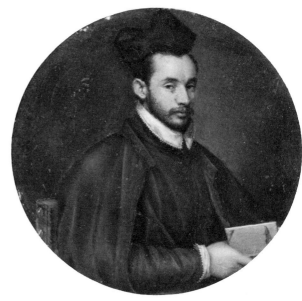

62.122.141 Bolognese, late XVI century

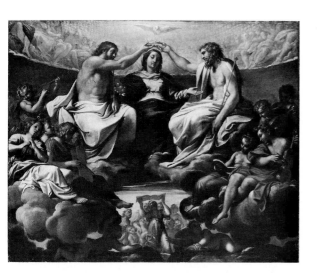

1971.155 Annibale Carracci

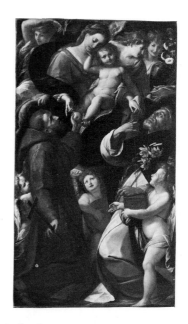

1979.209 Giulio Cesare Procaccini

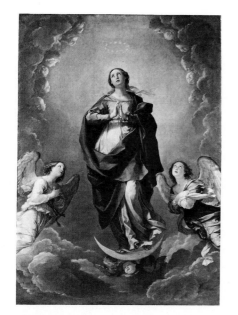

59.32 Guido Reni

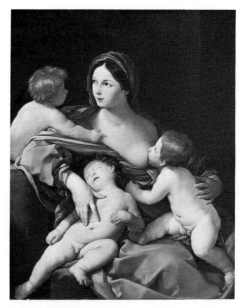

1974.348 Guido Reni

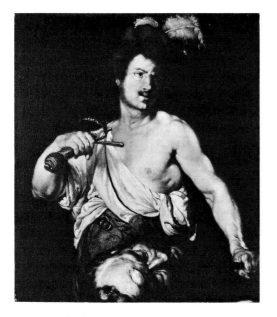

27.93 Bernardo Strozzi

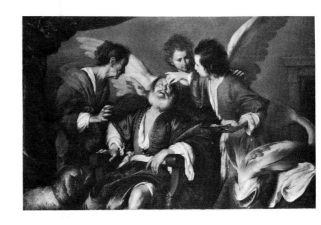

57.23 Bernardo Strozzi

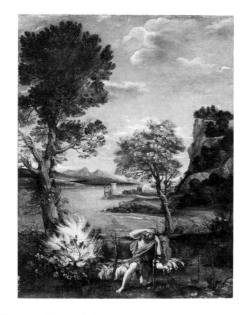

1976.155.2 Domenichino

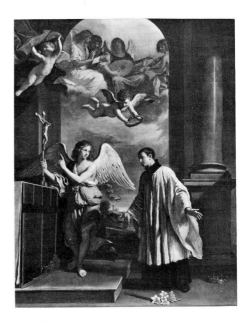

1973.311.3 Guercino

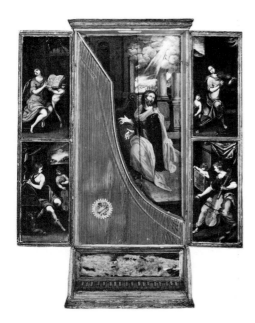

89.4.1224 North Italian?, XVII century or later

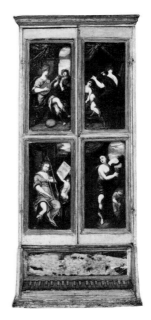

89.4.1224 North Italian?, XVII century or later

89.4.1222 Italian, XVII century or later

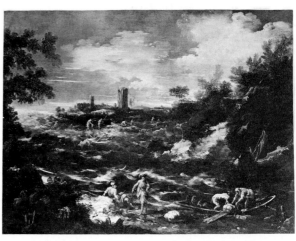

27.163 Alessandro Magnasco

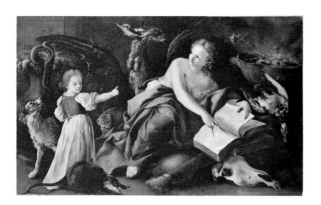

1970.261 Bartolommeo Guidobono

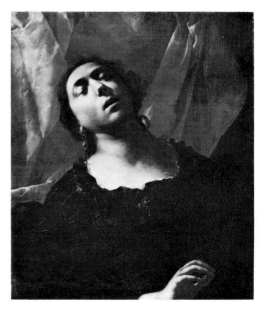

1973.165 Francesco del Cairo

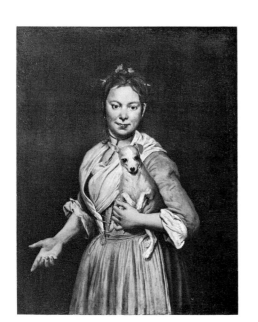

30.15 Giacomo Ceruti

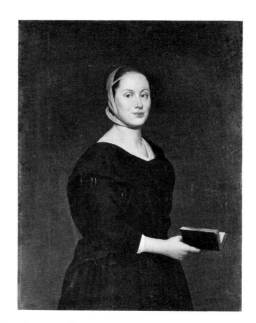

54.61 Giacomo Ceruti

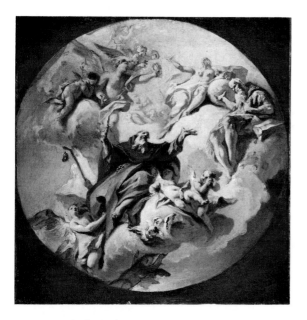

07.225.295 Carlo Carloni

08.237.2 Giovanni Raggi

ITALIAN
PAINTINGS

XIX CENTURY

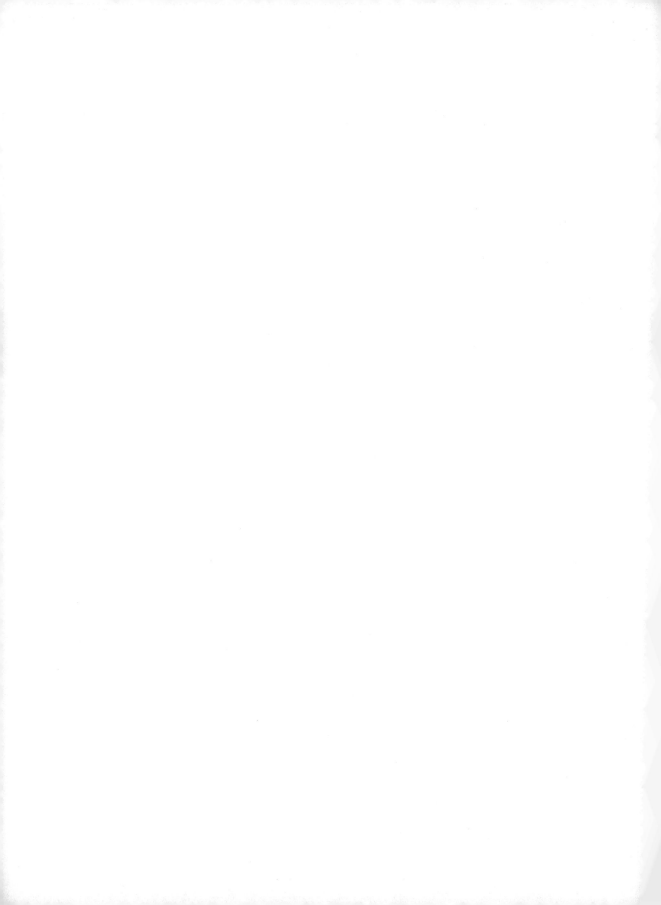

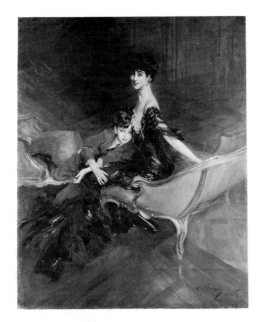

47.71 Giovanni Boldini

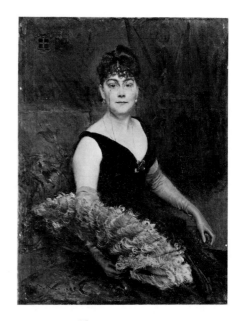

59.78 Giovanni Boldini

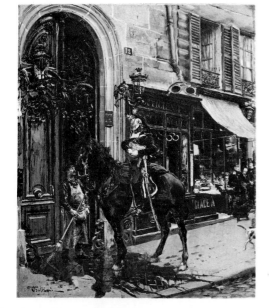

08.136.12 Giovanni Boldini

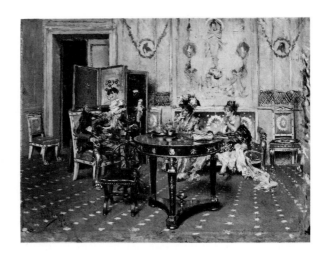

87.15.81 Giovanni Boldini

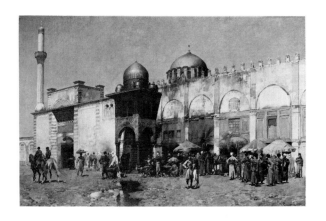

08.136.13 Alberto Pasini

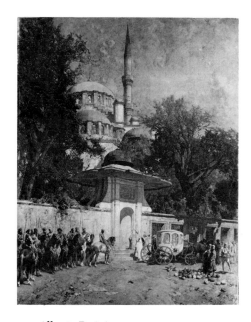

25.110.94 Alberto Pasini

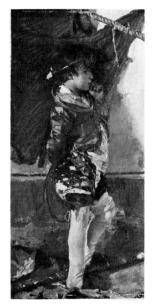

92.1.62 Antonio Mancini

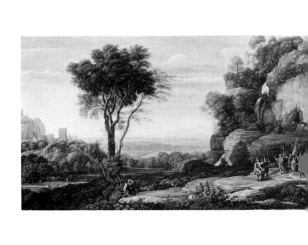

21.184 Giovanni Maldura

SPANISH PAINTINGS

including Portuguese and Peruvian

XII–XIX CENTURY

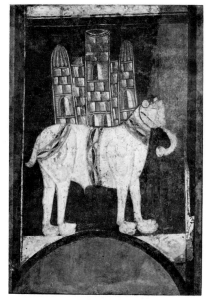

7.97.5 Spanish, XII century

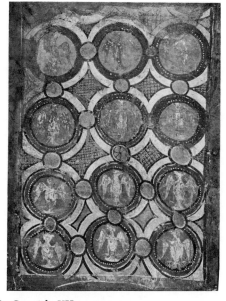

61.219 Spanish, XII century

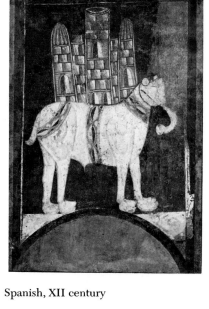

7.97.6 Spanish, XII century

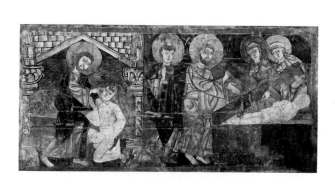

59.196 Spanish, XII century

185

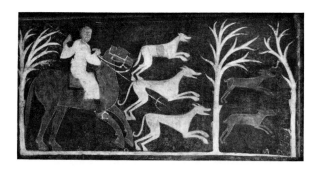

57.97.1 Spanish, XII century

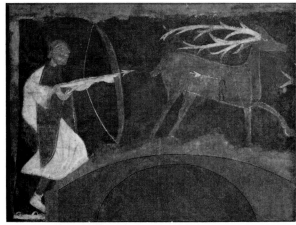

57.97.2 Spanish, XII century

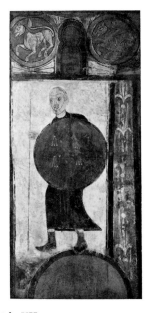

57.97.3 Spanish, XII century

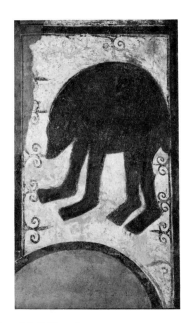

57.97.4 Spanish, XII century

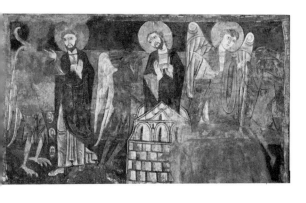

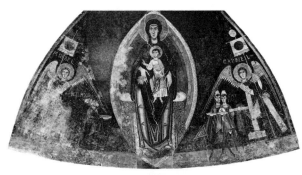

51.248 Spanish, XII century

50.180a–c Master of Pedret

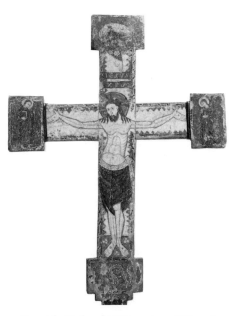

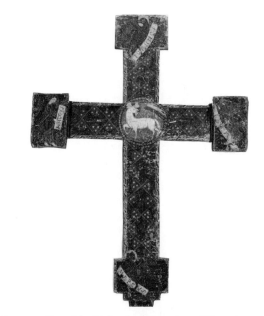

55.120.3 Spanish, Style of XIII century, XX century

55.120.3 Spanish, Style of XIII century, XX century

187

Spanish

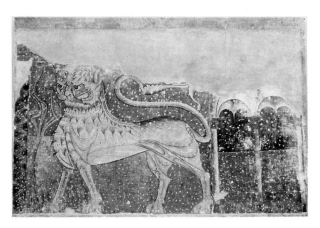

31.38.1a Castilian, early XIII century

31.38.1b Castilian, early XIII century

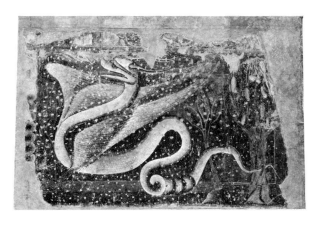

31.38.2a Castilian, early XIII century

31.38.2b Castilian, early XIII century

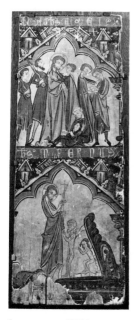

55.62a Spanish, last quarter XIII century

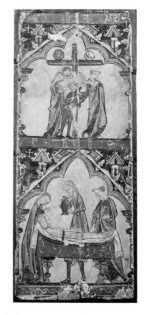

55.62b Spanish, last quarter XIII century

1977.94 Spanish, last quarter XIII century

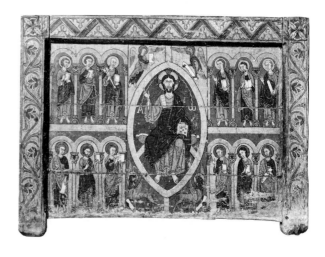

57.49 Spanish, Style of XIII century, XX century

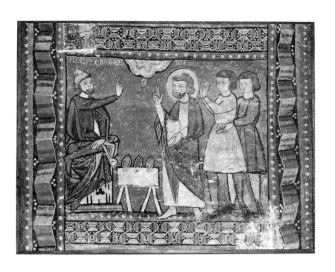

50.162 Catalan, late XIII/early XIV century

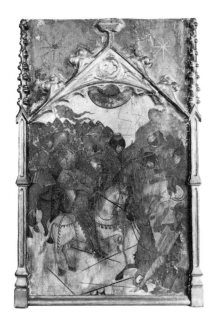

29.158.742 Catalan, late XIV century

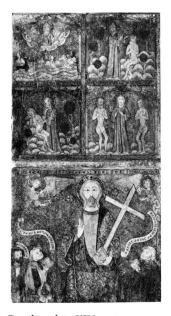

25.120.257 Castilian, late XIV century

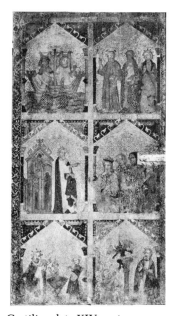

25.120.257 Castilian, late XIV century

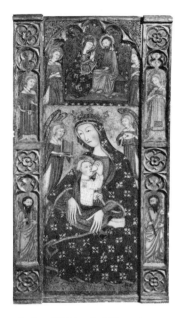

57.50a Spanish, late XIV/early XV century

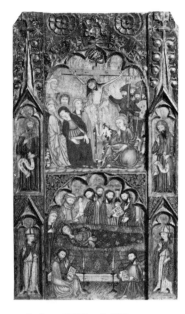

57.50b Spanish, late XIV/early XV century

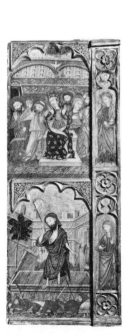

57.50c Spanish, late XIV/early XV century

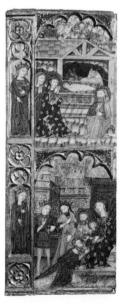

57.50d Spanish, late XIV/early XV century

Spanish

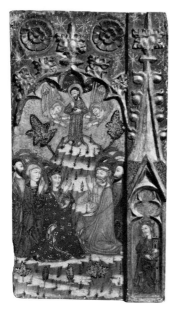

57.50e Spanish, late XIV/early XV century

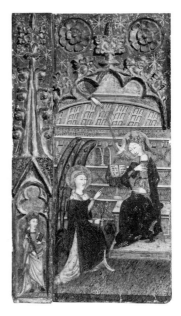

57.50f Spanish, late XIV/early XV century

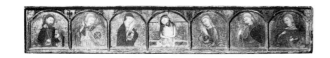

57.50g Spanish, late XIV/early XV century

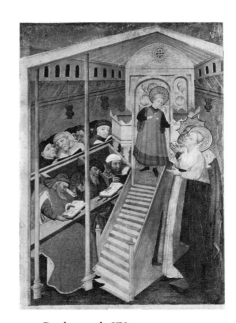

32.100.123 Catalan, early XV century

192

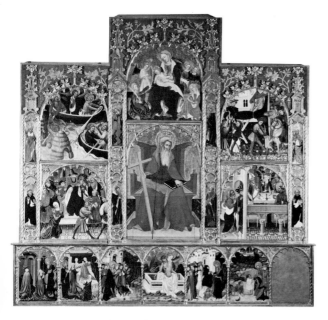

06.1211.1–9 Catalan, early XV century

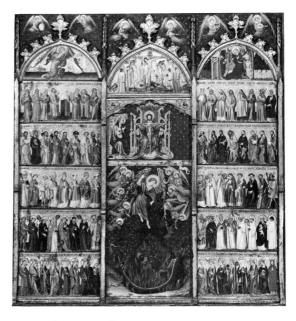

39.54 Valencian, early XV century

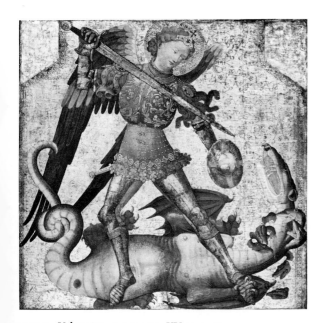

12.192 Valencian, 1st quarter XV century

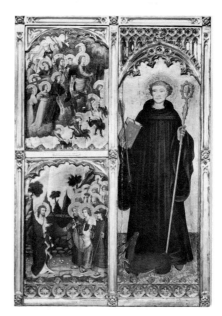

76.10 Miguel Alcañiz

Spanish

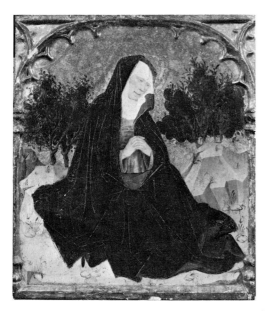

52.35 Master of Riglos

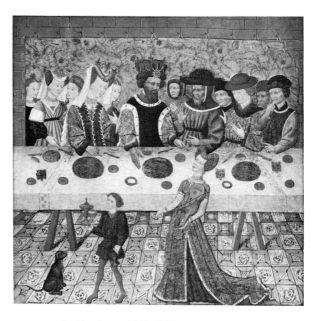

32.100.126 Catalan, middle XV century

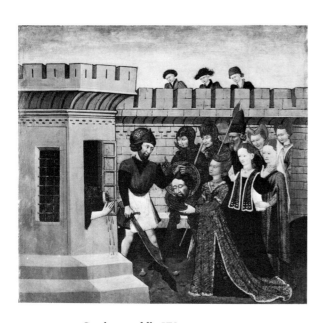

32.100.127 Catalan, middle XV century

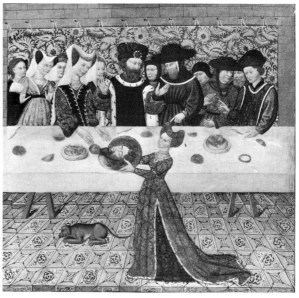

32.100.128 Catalan, middle XV century

194

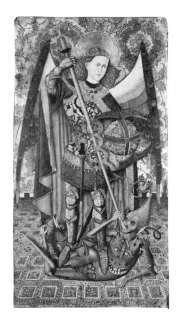

55.120.2 Master of Belmonte

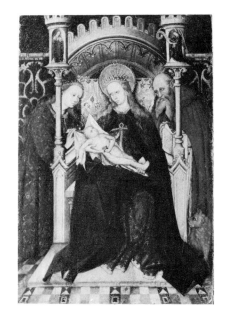

32.100.105 Spanish, middle XV century

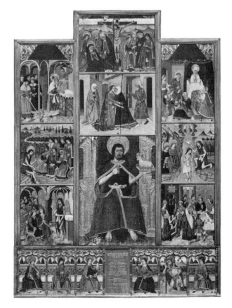

25.120.668–671, 673, 674, 927–929 Domingo Ram

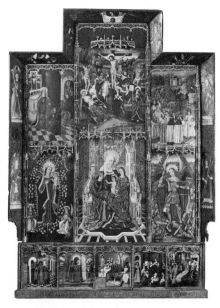

38.141a–o Aragonese, late XV century

Spanish

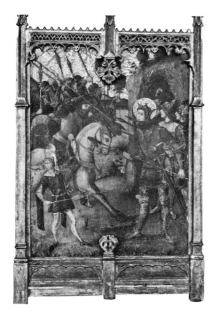

29.158.744 Castilian, late XV century

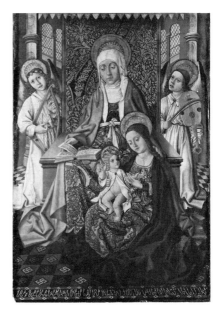

88.3.82 Castilian, late XV century

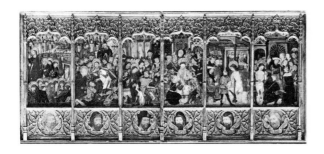

10.12 Master of Bonnat

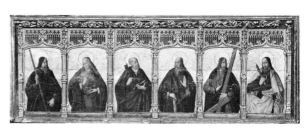

61.249 Spanish, XV century

196

44.63.1ab Spanish, XV century

44.63.1ab Spanish, XV century

44.63.1ab Spanish, XV century

44.63.1ab Spanish, XV century

Spanish

41.190.28a–d Aragonese, XV century

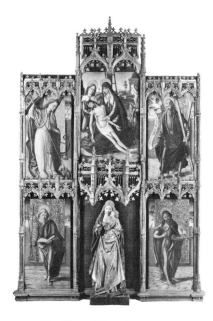

41.190.27a–e Castilian, XV century

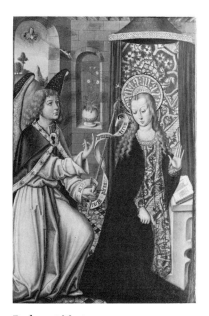

58.145.1 Budapest Master

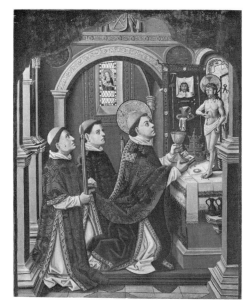

1976.100.24 Spanish, about 1500

198

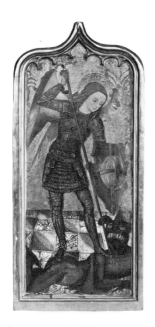

29.158.745　Valencian, early XVI century

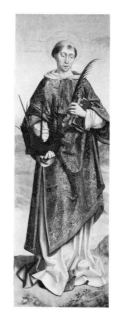

58.145.2　Frei Carlos

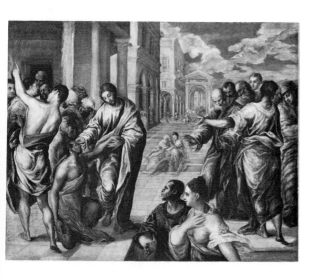

1978.416　El Greco

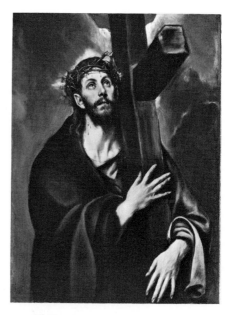

1975.1.145　El Greco

Spanish

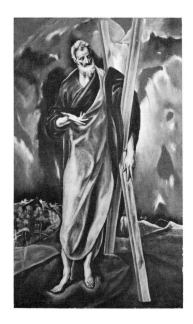

61.101.8　El Greco

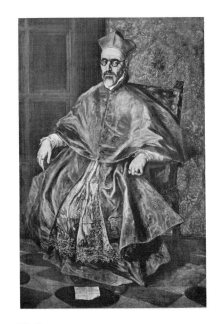

29.100.5　El Greco

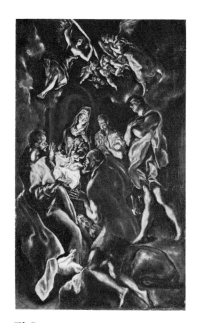

41.190.17　El Greco

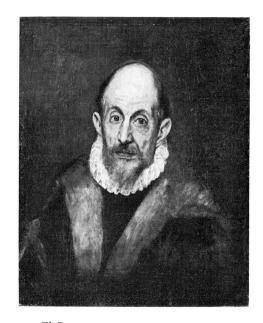

24.197.1　El Greco

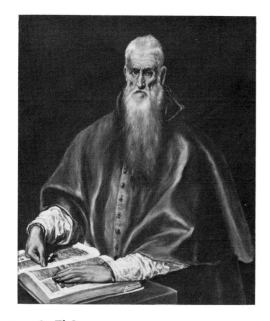

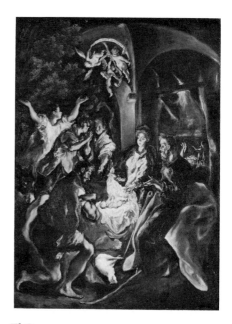

1975.1.146 El Greco

05.42 El Greco

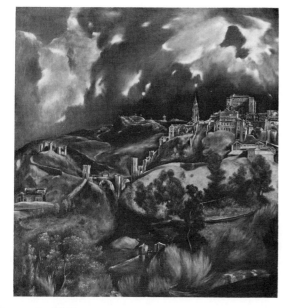

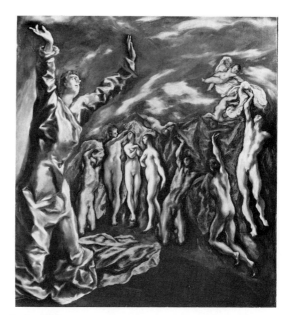

29.100.6 El Greco

56.48 El Greco

Spanish

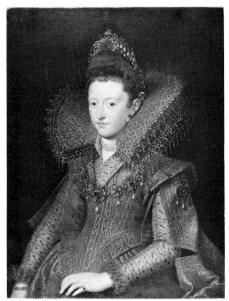

25.110.21 Alonzo Sánchez Coello

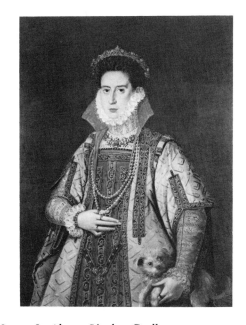

1976.100.18 Alonzo Sánchez Coello

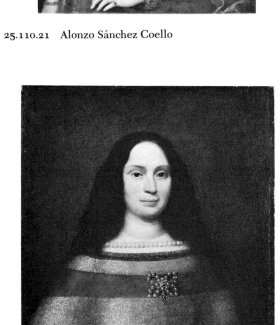

55.174 Attributed to Juan Pantoja de la Cruz

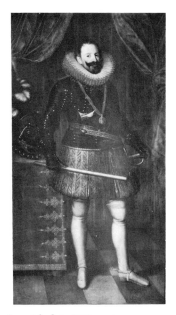

29.158.755 Spanish, late XVI century

202

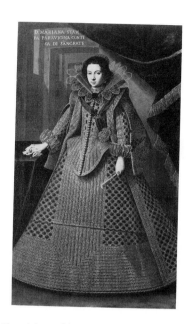

45.128.15 Spanish, early XVII century

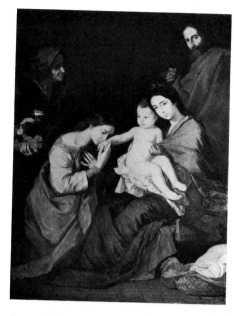

34.73 Jusepe Ribera

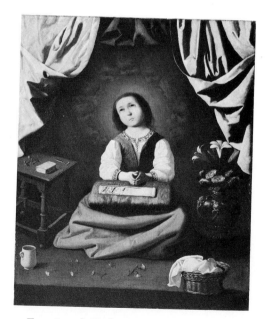

27.137 Francisco de Zurbarán

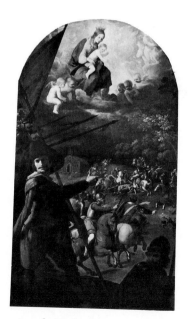

20.104 Francisco de Zurbarán

Spanish

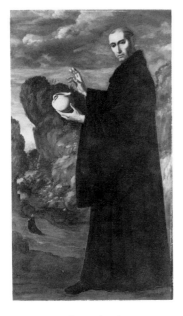

1976.100.21 Francisco de Zurbarán

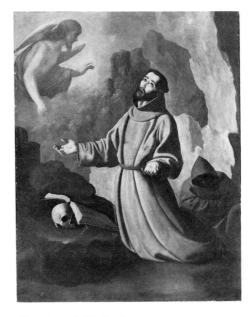

69.54 Francisco de Zurbarán

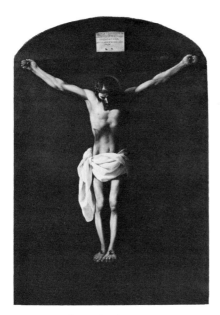

65.220.2 Francisco de Zurbarán

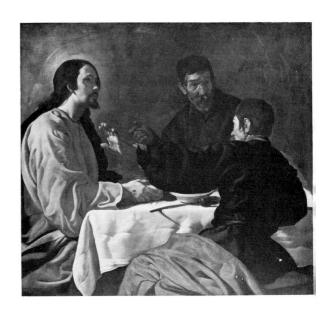

14.40.631 Velázquez

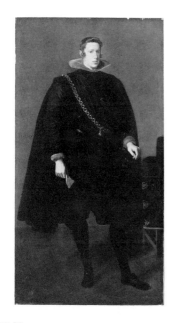

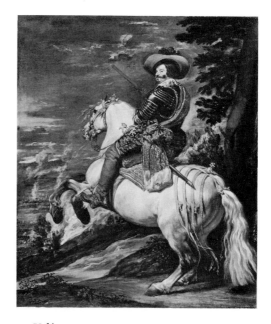

14.40.639 Velázquez

52.125 Velázquez

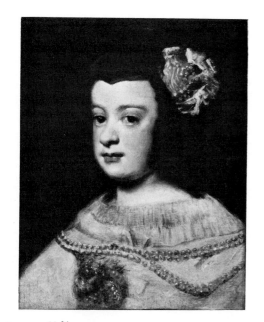

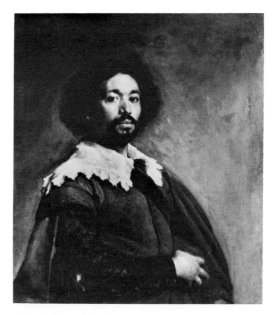

1975.1.147 Velázquez

1971.86 Velázquez

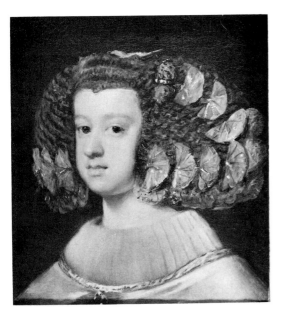

Spanish

49.7.43 Velázquez

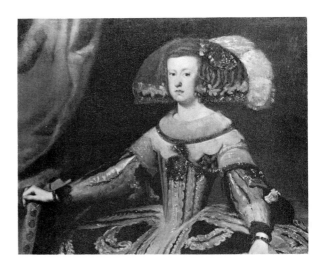

89.15.18 Workshop of Velázquez

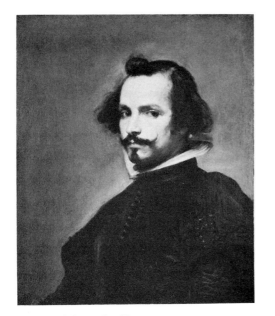

89.15.29 Workshop of Velázquez

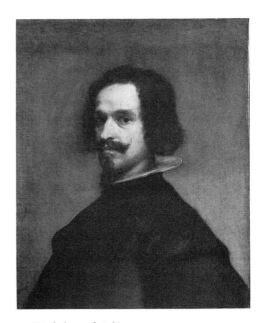

49.7.42 Workshop of Velázquez

206

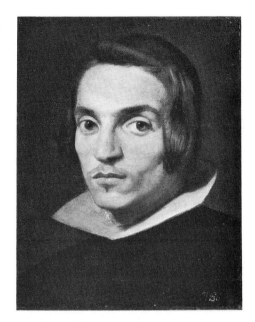

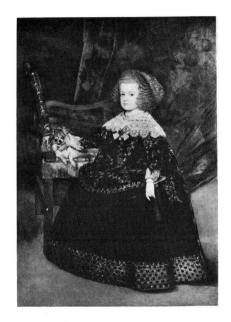

29.100.607 Castilian, XVII century

43.101 Juan Bautista Martínez del Mazo

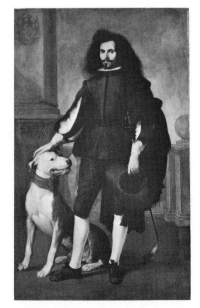

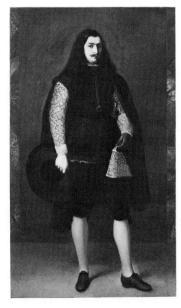

27.219 Bartolomé Esteban Murillo

54.190 Bartolomé Esteban Murillo

Spanish

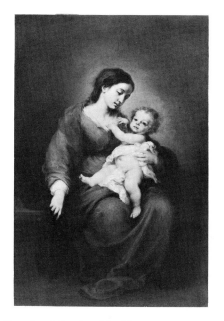

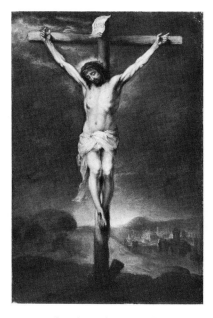

43.13 Bartolomé Esteban Murillo

1976.100.17 Bartolomé Esteban Murillo

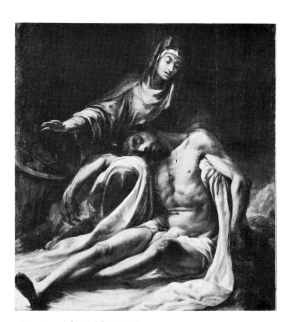

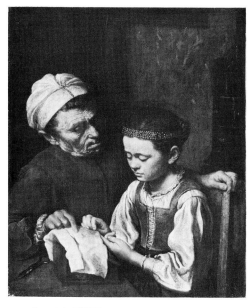

54.168 Juan de Valdés Leal

63.194.2 Spanish, XVII century

208

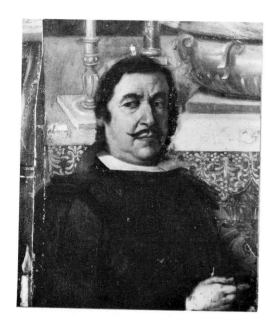

32.100.7 Andalusian, late XVII century

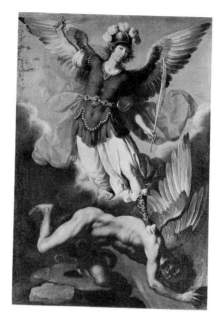

89.15.17 Andalusian, late XVII century

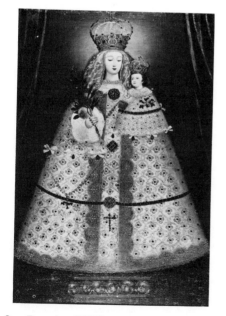

64.164.385 Peruvian, XVIII century

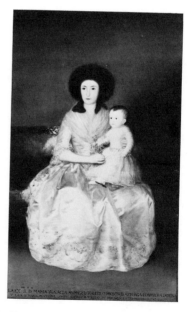

1975.1.148 Goya

Spanish

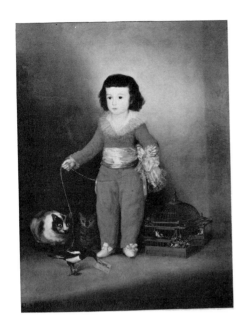

49.7.41 Goya

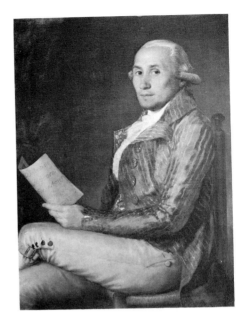

06.289 Goya

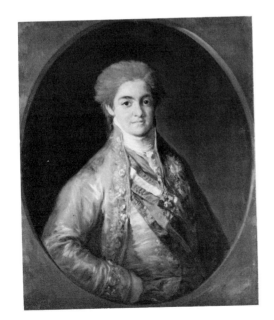

51.70 Goya

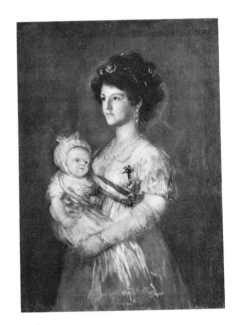

30.95.243 Goya

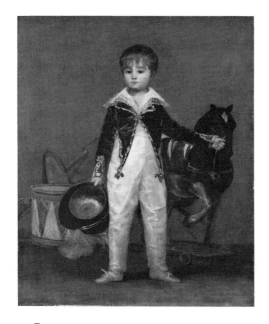

61.259 Goya

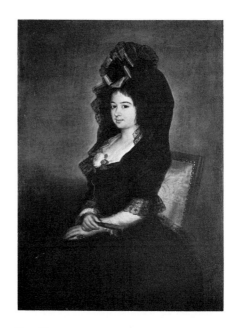

29.100.180 Goya

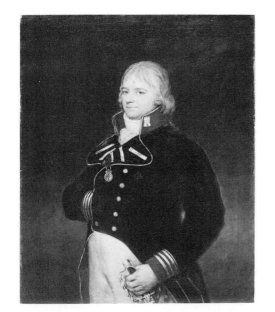

55.145.1 Goya

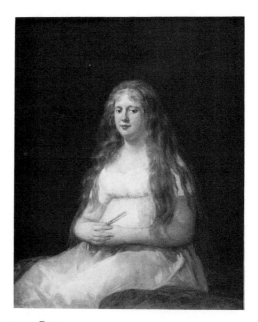

55.145.2 Goya

Spanish

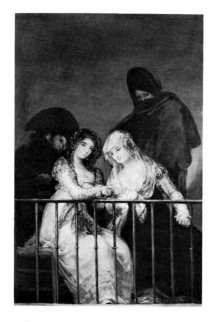

29.100.10 Goya

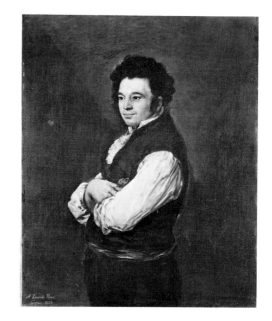

30.95.242 Goya

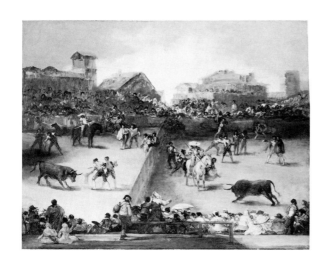

22.181 Goya

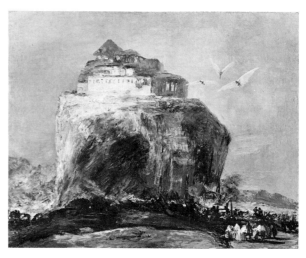

29.100.12 Style of Goya

212

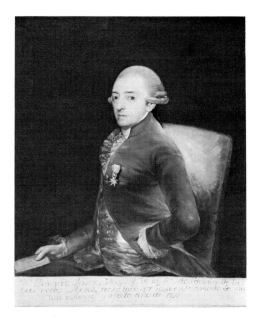

50.145.19 Copy after Goya

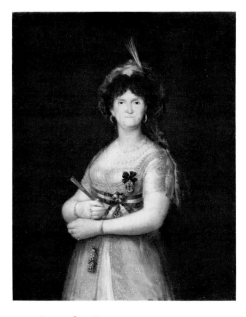

29.100.11 Copy after Goya

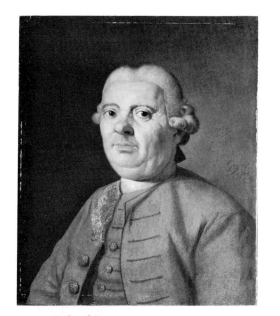

29.100.179 Style of Goya

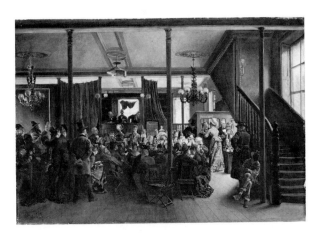

83.11 Ignacio de Leon y Escosura

Spanish

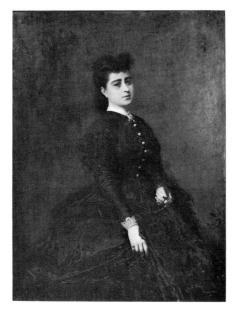

89.22 Mariano Fortuny

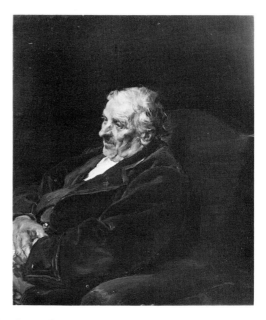

08.136.14 Francisco Domingo y Marqués

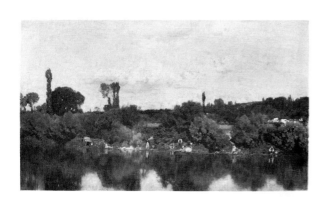

15.30.71 Rico

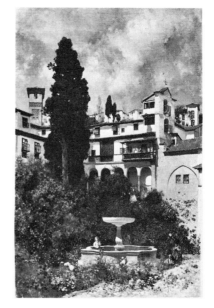

81.1.666 Rico

214

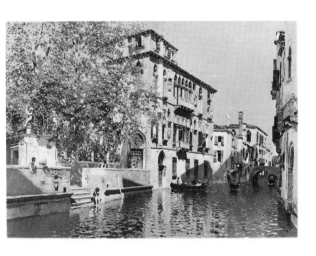

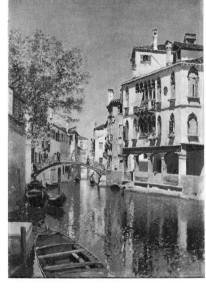

87.15.57 Rico

25.110.81 Rico

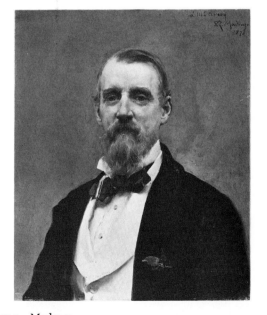

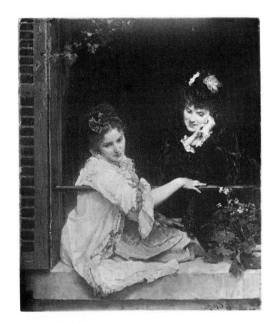

04.29.1 Madrazo

87.15.131 Madrazo

Spanish

37.20.3 Madrazo

1975.1.233 Madrazo

87.15.39 José Villegas

87.4.7 Dionisio Baixeras y Verdaguer

216

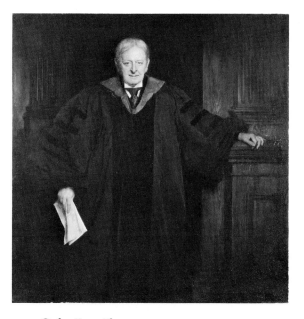

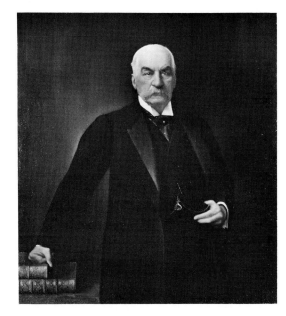

30.22 Carlos Baca-Flor

39.119 Carlos Baca-Flor

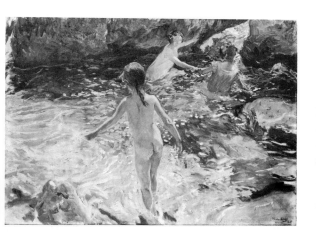

09.71.2 Sorolla

22.119.1 Sorolla

Spanish

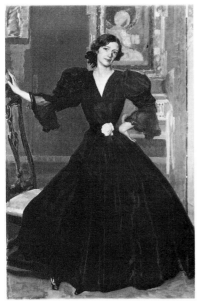

09.71.3 Sorolla

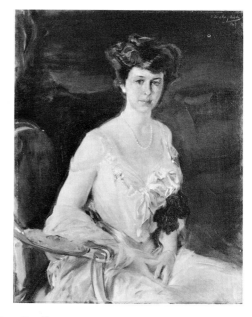

58.81 Sorolla

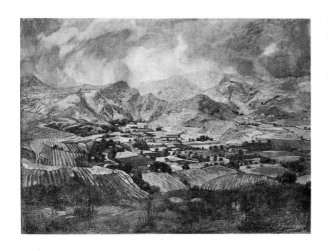

59.16.4 Ignacio Zuloaga

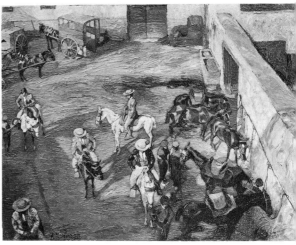

28.199 Ignacio Zuloaga

218

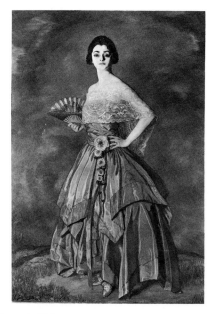

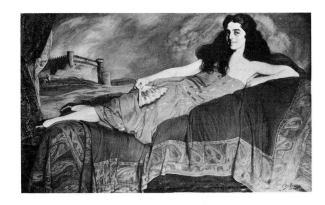

49.64 Ignacio Zuloaga

64.171 Ignacio Zuloaga

ICONS

Byzantine, Post-Byzantine, and Russian

XV–XIX CENTURY

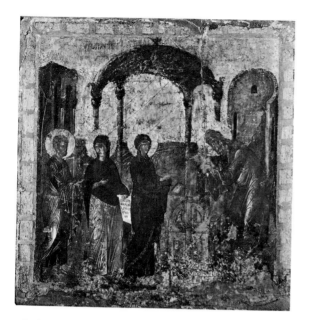

31.67.8 Byzantine, XV century

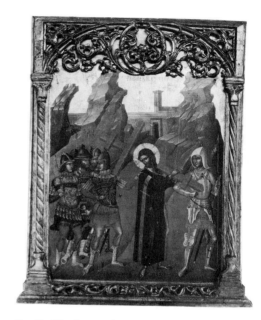

29.158.746 Nicolaus Zafuri

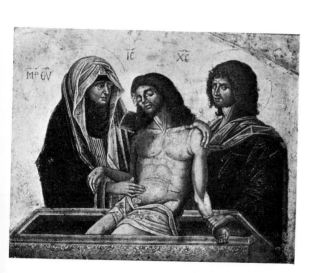

88.3.81 Post-Byzantine, Cretan, XVI century

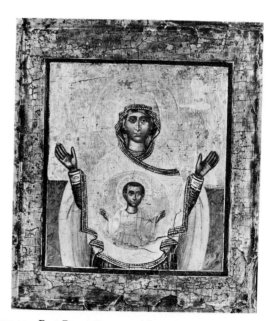

33.79.19 Post-Byzantine, possibly Russian, XVII century

223

Icons

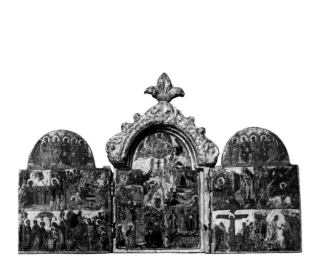

33.79.16 Post-Byzantine, Greek, XVII century

33.79.16 Post-Byzantine, Greek, XVII century

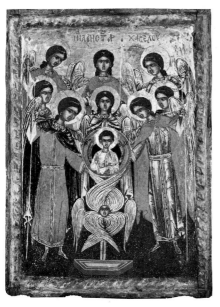

1972.145.30 Post-Byzantine, Greek, probably XVII century

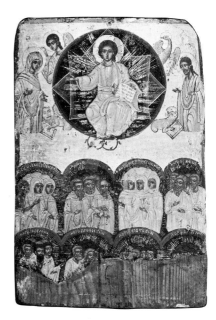

31.67.9 Post-Byzantine, possibly XVII century

224

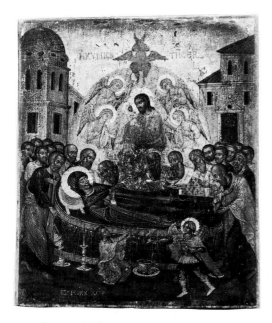

33.79.17 Ioannes Mokos

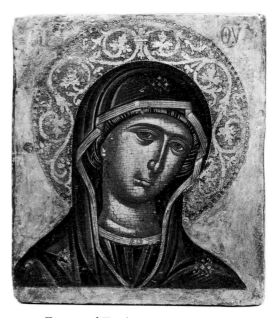

33.79.15 Emmanuel Tzanès

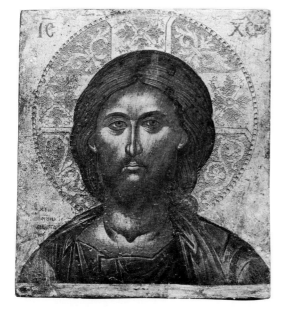

33.79.14 Emmanuel Tzanès

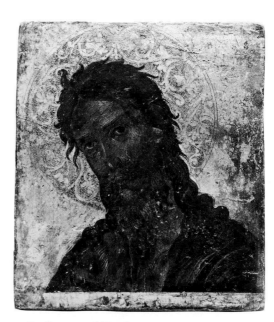

33.79.18 Emmanuel Tzanès

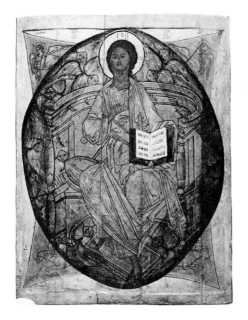

44.101 Russian, Novgorod, XV century

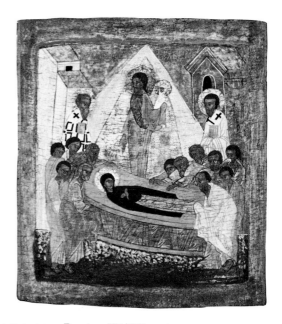

1972.145.27 Russian, XV/XVI century

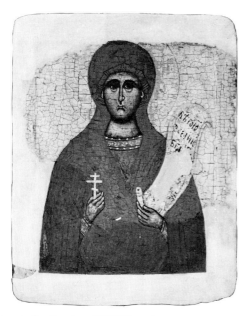

1972.145.28 Russian, XV/XVI century

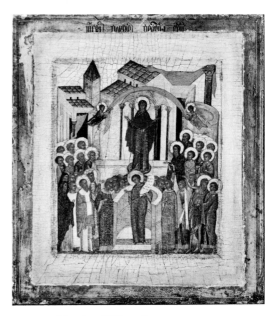

1972.145.24 Russian, XVI century

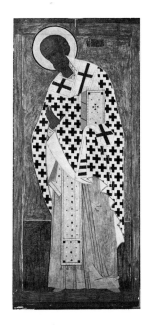

1972.145.33 Russian, XVI century

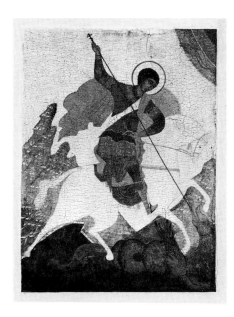

1972.145.13 Russian, possibly XVI century

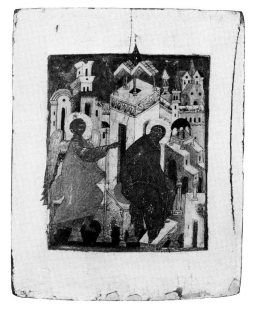

1972.145.14 Russian, 2nd half XVI century

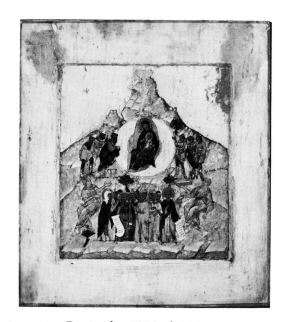

1972.145.19 Russian, late XVI/early XVII century

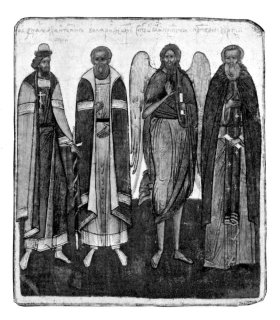

1972.145.23 Russian, possibly XVI century

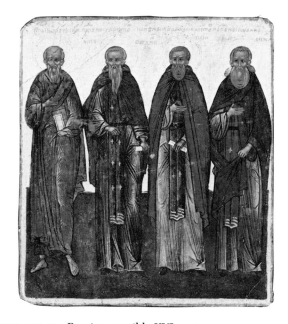

1972.145.23 Russian, possibly XVI century

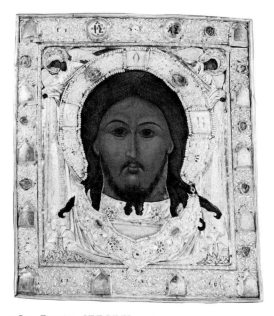

1975.87 Russian, XVI/XVII century

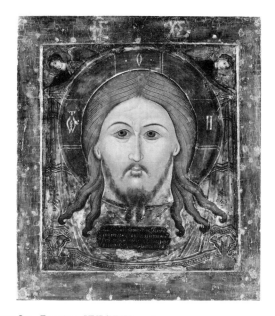

1975.87 Russian, XVI/XVII century

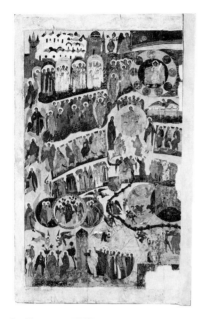

1972.145.26 Russian, XVII century

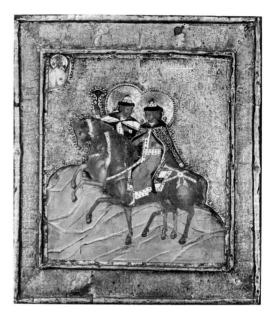

1972.145.29 Russian, XVII century

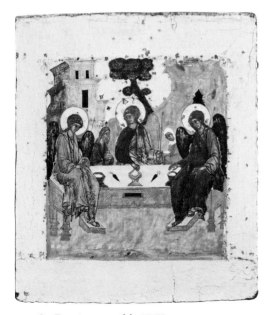

1972.145.16 Russian, possibly XVII century

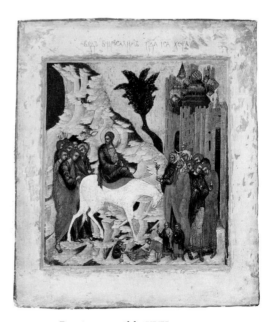

1972.145.21 Russian, possibly XVII century

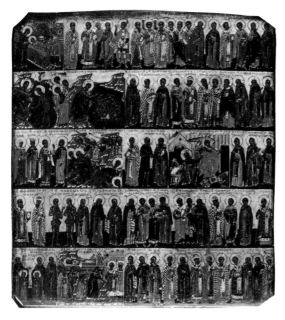

33.79.12 Russian, XVII/XVIII century

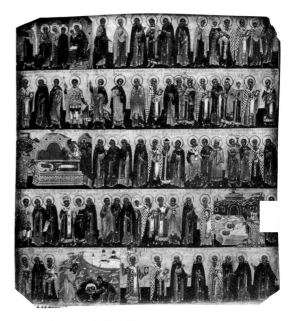

33.79.6 Russian, XVII/XVIII century

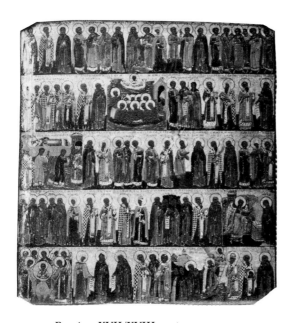

33.79.10 Russian, XVII/XVIII century

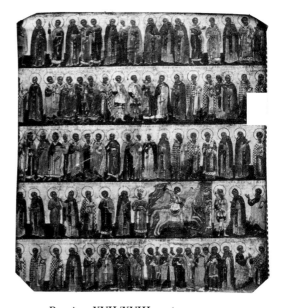

33.79.11 Russian, XVII/XVIII century

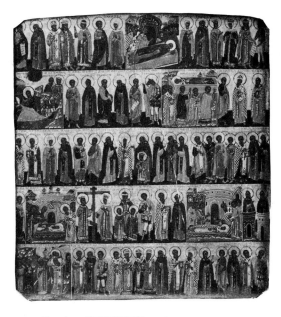

33.79.7 Russian, XVII/XVIII century

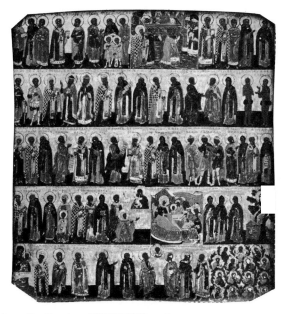

33.79.8 Russian, XVII/XVIII century

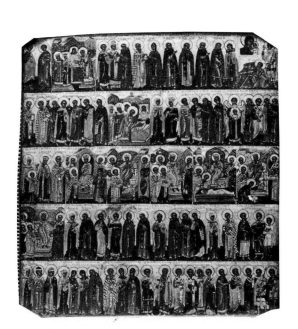

33.79.3 Russian, XVII/XVIII century

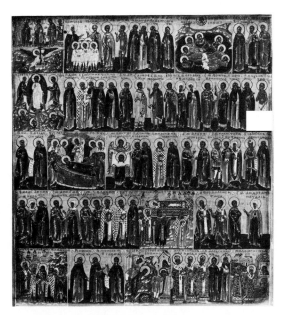

33.79.1 Russian, XVII/XVIII century

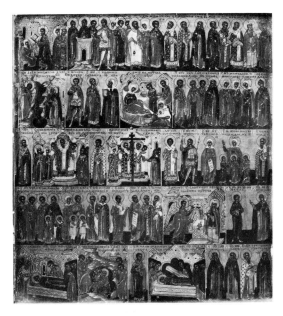

33.79.5 Russian, XVII/XVIII century

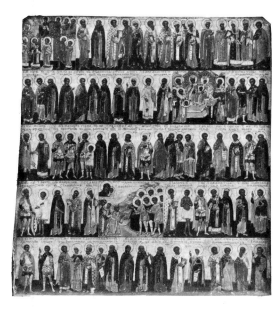

33.79.9 Russian, XVII/XVIII century

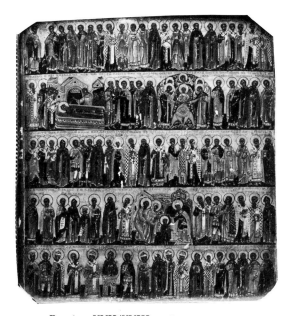

33.79.4 Russian, XVII/XVIII century

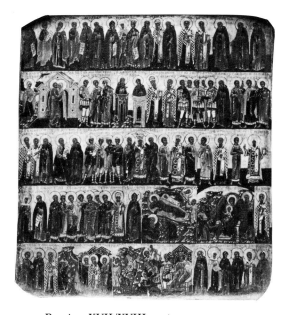

33.79.2 Russian, XVII/XVIII century

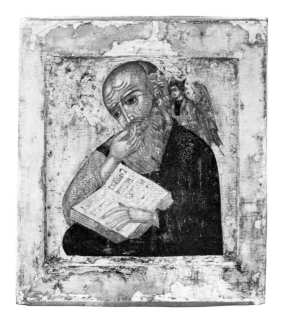

1972.145.17 Russian, late XVII/XVIII century

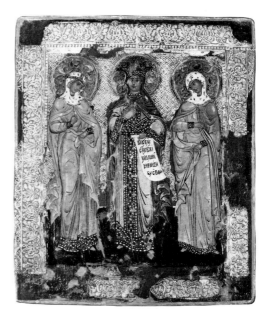

1972.145.31 Russian, XVIII century

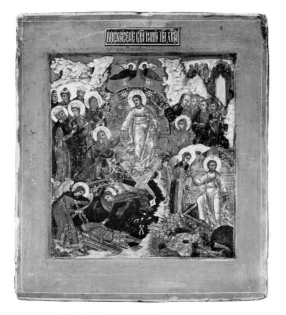

1972.145.32 Russian, XVIII/XIX century

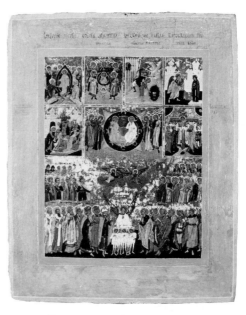

1972.145.35 Russian, XVIII/XIX century

Icons

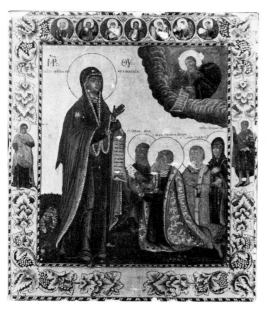

68.160a Russian, about 1815

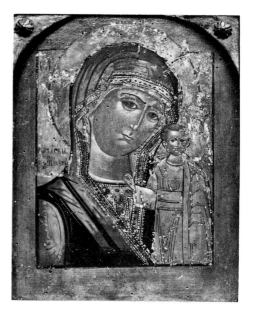

33.79.13 Russian, XIX century

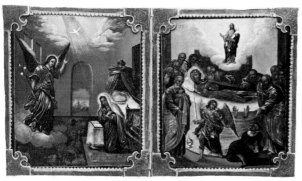

89.2.108 Russian, XIX century

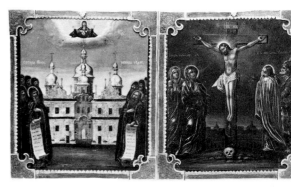

89.2.108 Russian, XIX century

234

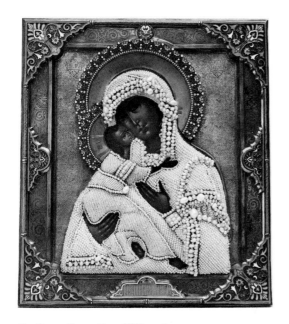

54.58 Russo-Byzantine, XIX century

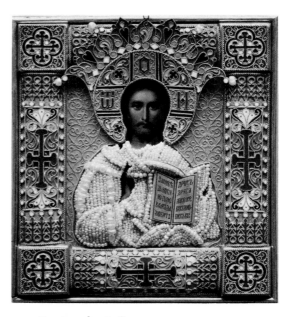

32.72 Russian, about 1890

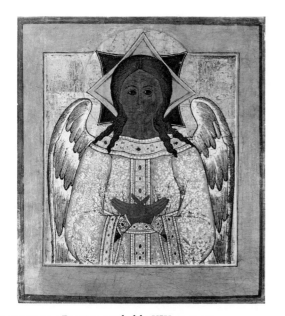

1972.145.34 Russian, probably XIX century

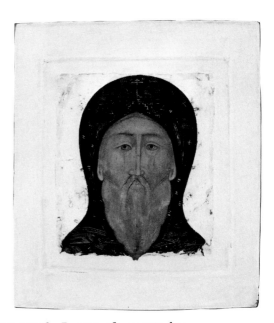

1972.145.18 Russian, of uncertain date

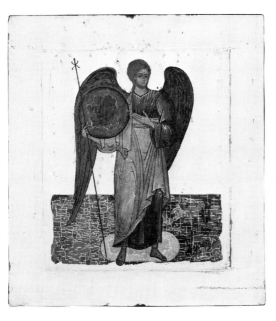

1972.145.15 Russian, of uncertain date

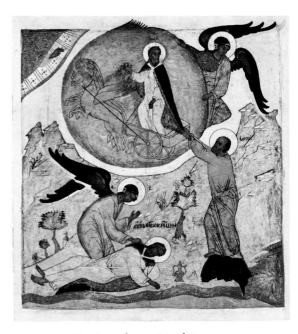

1972.145.20 Russian, of uncertain date

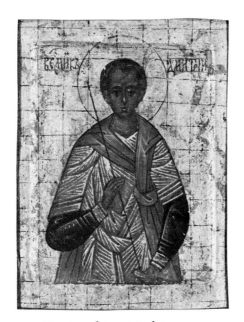

1972.145.22 Russian, of uncertain date

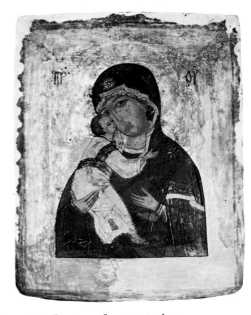

1972.145.25 Russian, of uncertain date

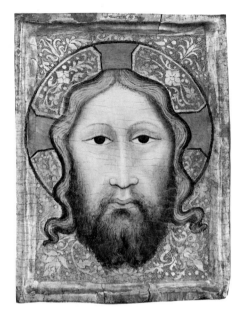

1976.100.4 European, of uncertain date

RUSSIAN PAINTINGS

XIX CENTURY

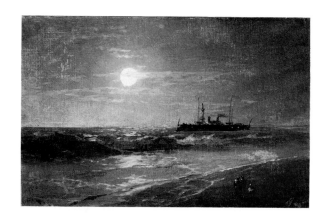

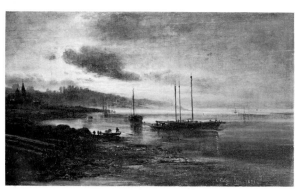

1975.280.2 Ivan Constantinovich Aivazovski

1972.145.4 Alexei Kondratievich Savrasov

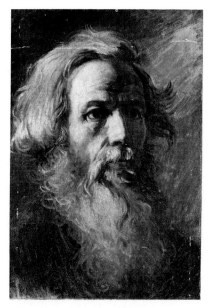

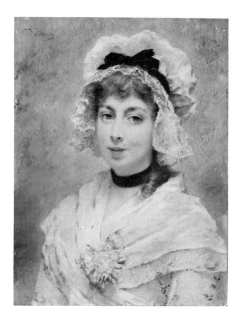

1975.280.6 Vassili Grigorievich Perov

1975.280.5 Constantin Igorovich Makowsky

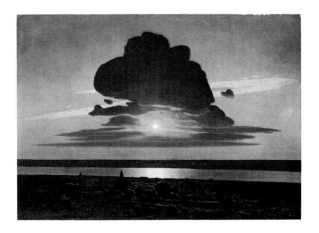

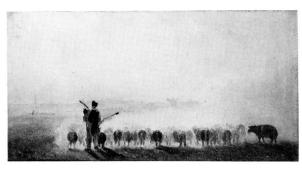

1974.100 Arkhip Ivanovich Kuindji

1975.280.4 Ilya Efimovich Repin

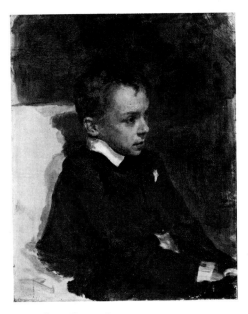

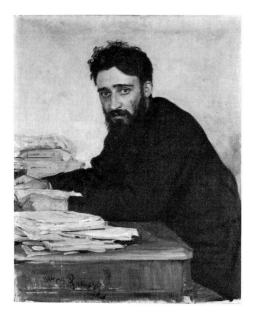

1972.145.1 Ilya Efimovich Repin

1972.145.2 Ilya Efimovich Repin

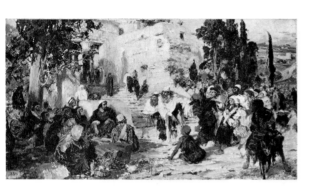

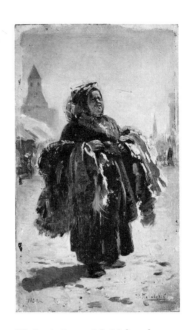

1972.145.5 Vassili Dmitrivich Polenov

1972.145.3 Vladimir Igorovich Makovsky

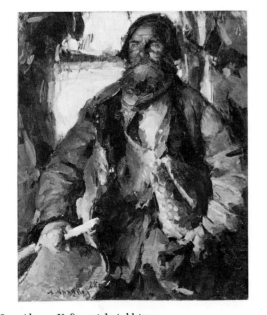

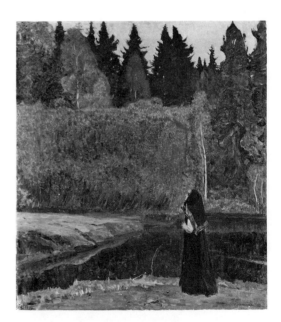

29.63 Abram Yefimovich Arkhipov

1972.145.6 Mikhail Vasilievich Nesterov

BRITISH PAINTINGS

XVI-XIX CENTURY

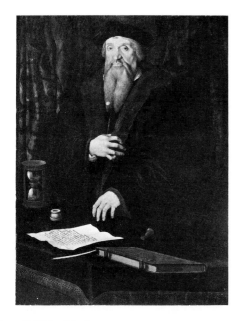

91.26.3 British, dated 1539

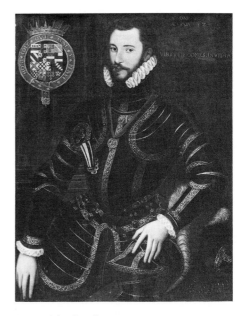

20.151.6 British, dated 1572

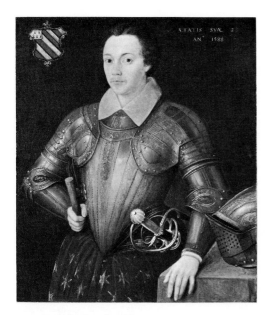

51.194.2 British, dated 1588

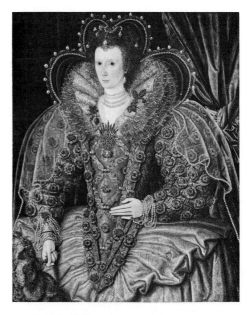

11.149.1 British, XVI century

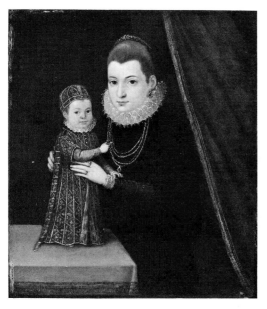

17.190.2 British, Style of XVI century, probably XX
 century

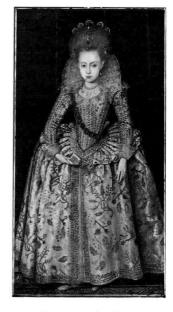

51.194.1 Marcus Gheeraerts the Younger

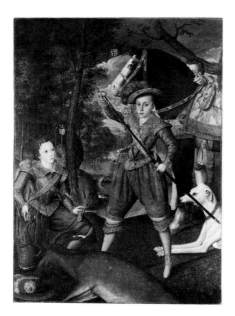

44.27 Robert Peake the Elder

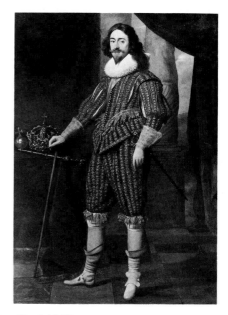

06.1289 Daniel Mijtens

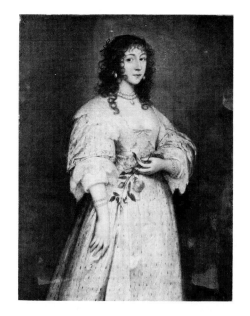

25.110.57 William Dobson

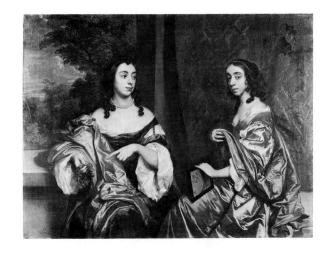

39.65.3 Sir Peter Lely

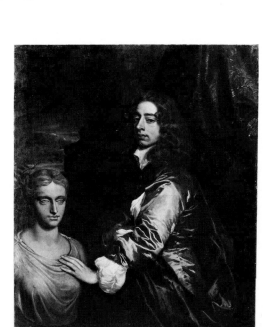

39.65.6 Sir Peter Lely

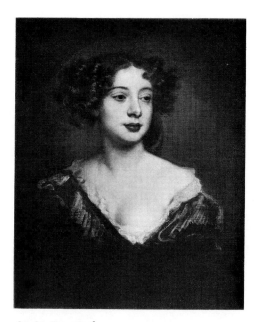

06.1198 Sir Peter Lely

British

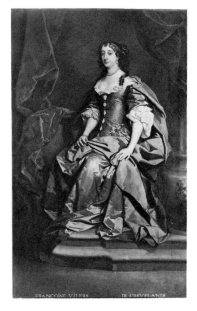

39.65.9 Workshop of Sir Peter Lely

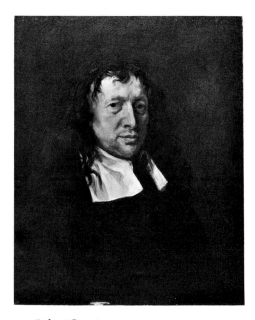

08.237.1 Robert Streater

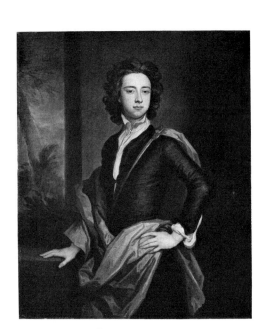

39.65.8 Godfrey Kneller

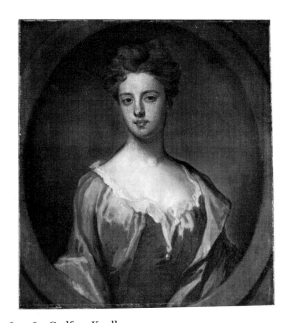

96.30.6 Godfrey Kneller

250

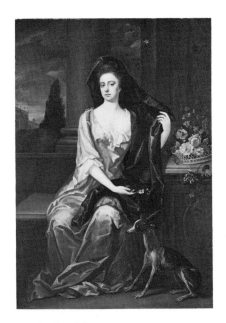

56.224.1 Michael Dahl

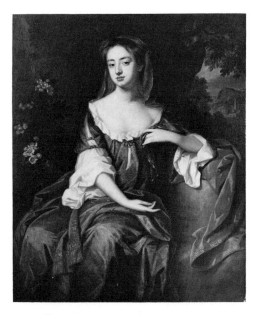

39.65.7 Willem Wissing

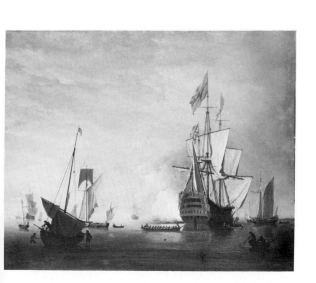

60.94.2 Peter Monamy

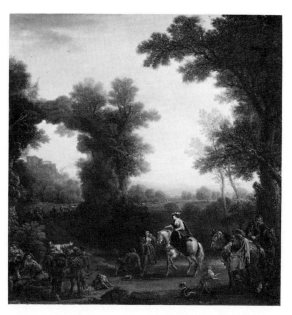

32.53.2 John Wootton

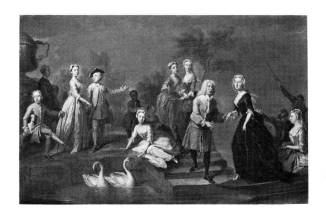

20.40　Bartholomew Dandridge

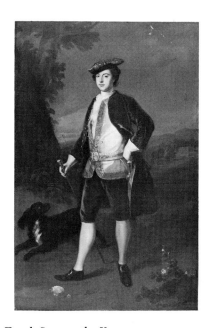

56.190　Enoch Seeman the Younger

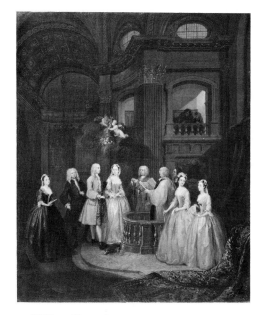

36.111　William Hogarth

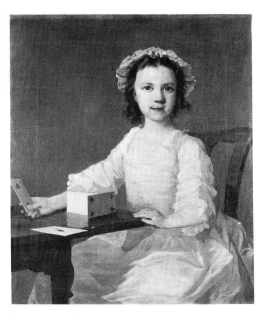

91.26.1　George Knapton

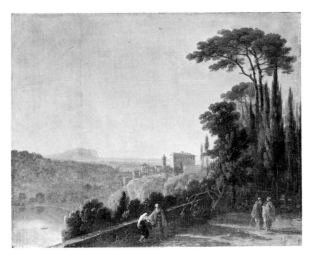

05.32.3 Richard Wilson

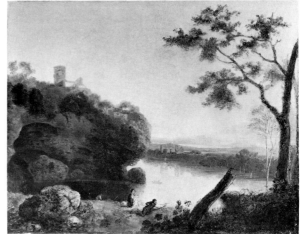

15.30.42 Workshop of Richard Wilson

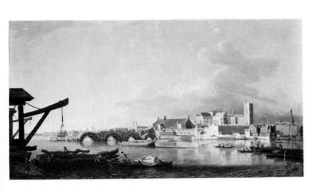

44.56 Samuel Scott

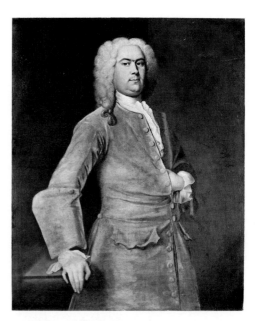

46.60 British, middle XVIII century

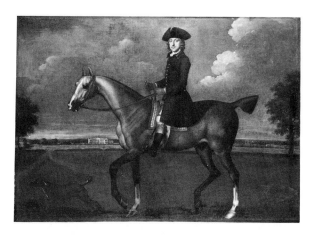

56.54.1 James Seymour

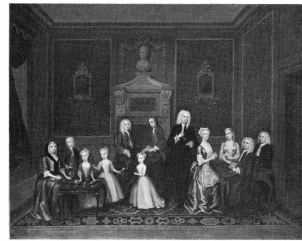

44.159 Charles Philips

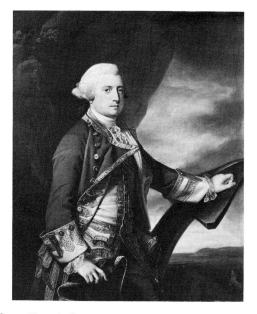

39.65.5 Francis Cotes

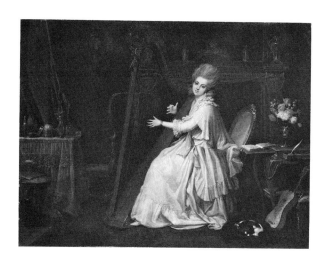

69.104 Richard Cosway

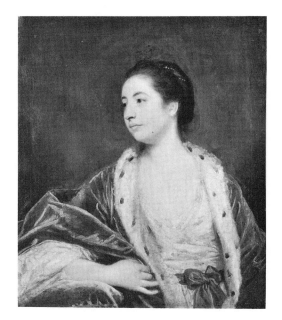

42.152.1 Sir Joshua Reynolds

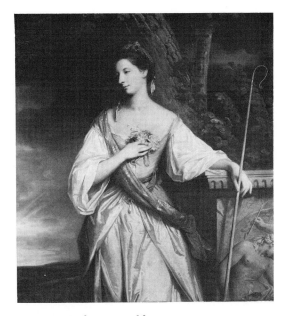

50.238.2 Sir Joshua Reynolds

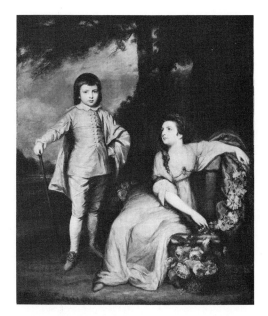

48.181 Sir Joshua Reynolds

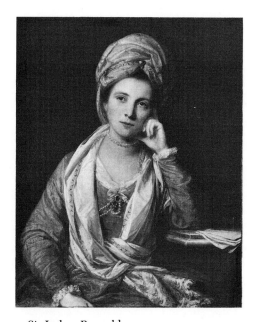

45.59.3 Sir Joshua Reynolds

British

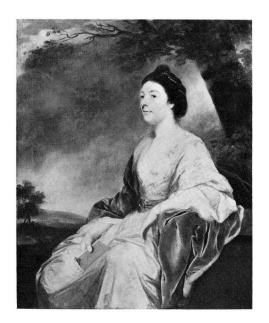

10.58.3 Sir Joshua Reynolds

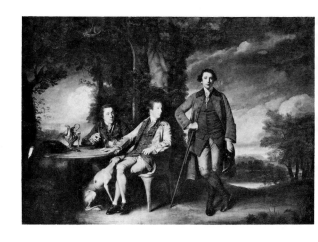

87.16 Sir Joshua Reynolds

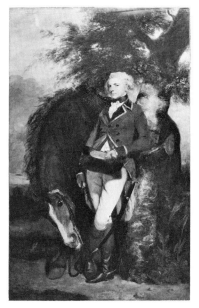

20.155.3 Sir Joshua Reynolds

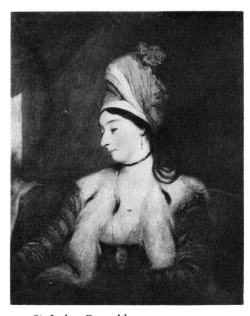

06.1241 Sir Joshua Reynolds

256

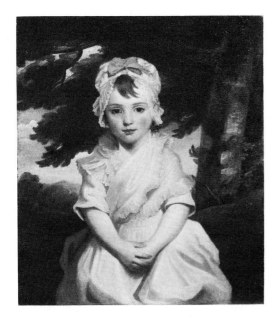

15.30.38 Sir Joshua Reynolds

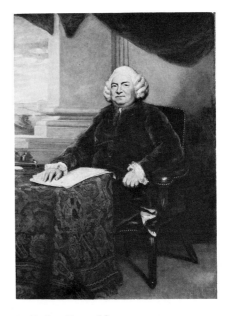

54.192 Sir Joshua Reynolds

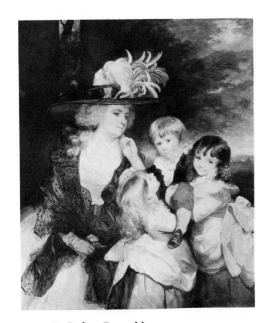

25.110.10 Sir Joshua Reynolds

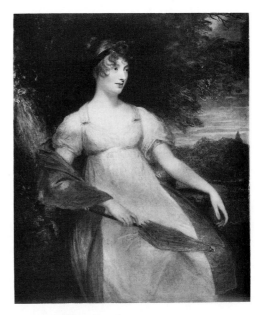

05.32.1 Sir William Beechey

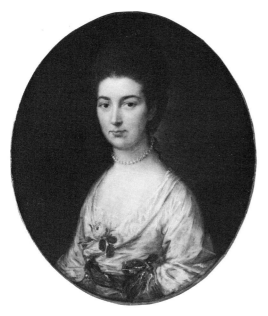

66.88.1 Thomas Gainsborough

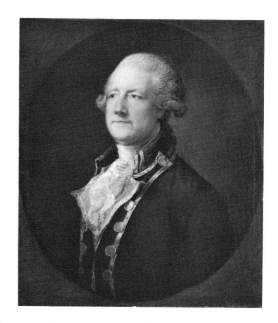

60.71.7 Thomas Gainsborough

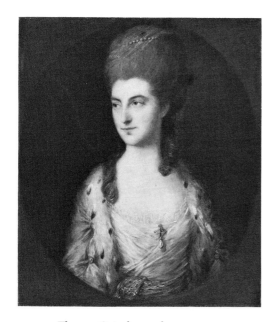

17.120.224 Thomas Gainsborough

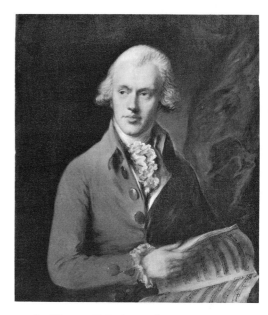

50.145.16 Thomas Gainsborough

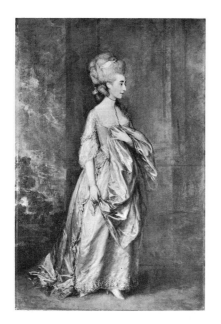

20.155.1 Thomas Gainsborough

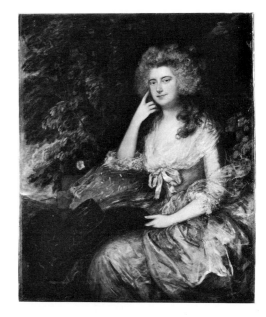

45.59.1 Thomas Gainsborough

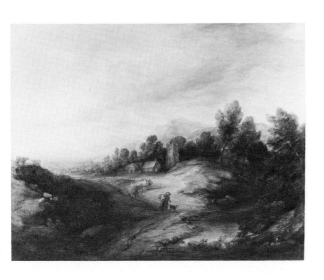

06.1279 Thomas Gainsborough

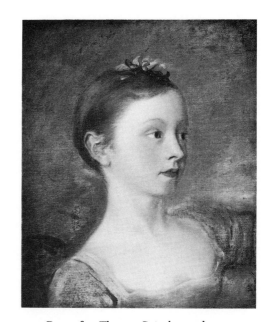

15.30.34 Copy after Thomas Gainsborough

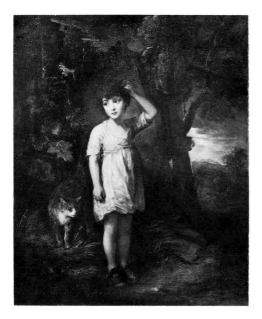

89.15.8 Thomas Gainsborough

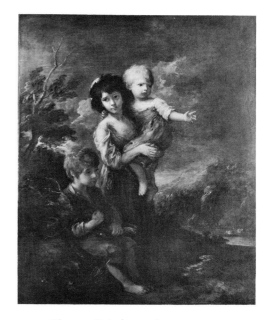

50.145.17 Thomas Gainsborough

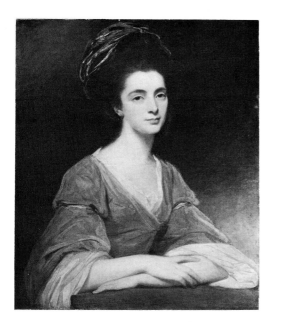

45.59.5 George Romney

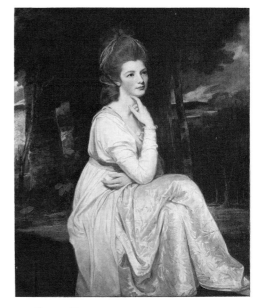

49.7.57 George Romney

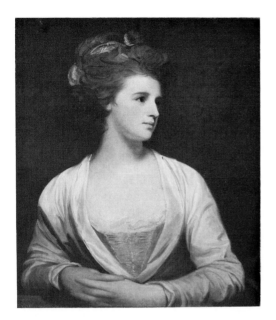

58.102.2 George Romney

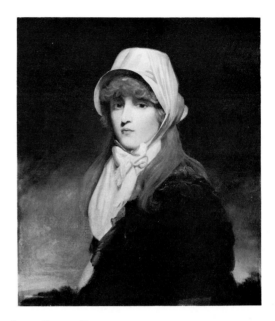

39.65.1 George Romney

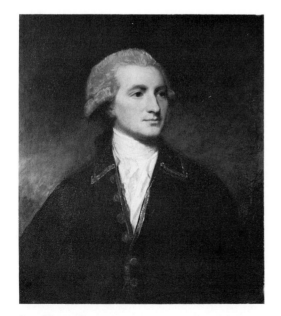

50.169 George Romney

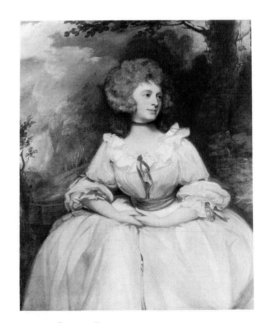

1975.1.235 George Romney

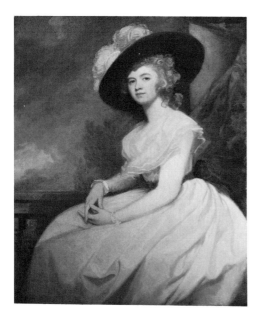

45.59.4 George Romney

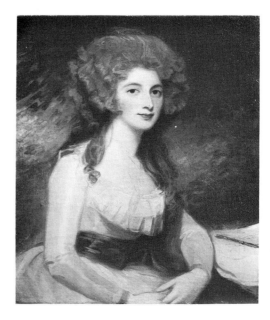

15.30.36 George Romney

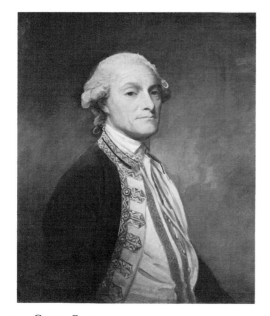

53.220 George Romney

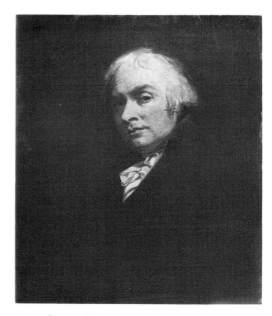

15.30.37 George Romney

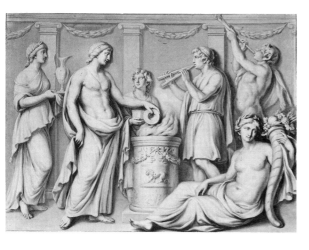

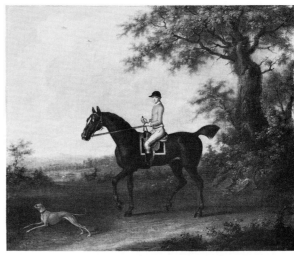

60.50a British, 3rd quarter XVIII century

1976.201.20 British, 2nd half XVIII century

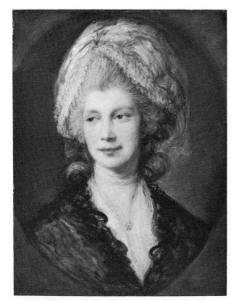

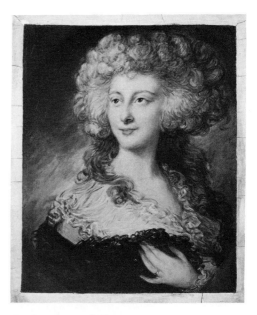

49.7.55 Gainsborough Dupont

49.7.56 Gainsborough Dupont

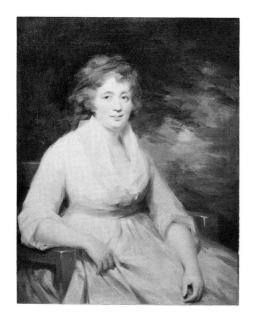

46.13.5 Sir Henry Raeburn

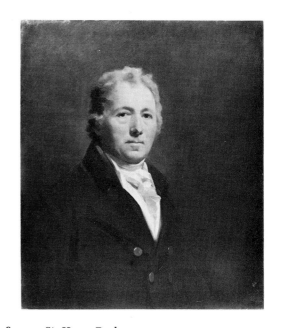

96.30.5 Sir Henry Raeburn

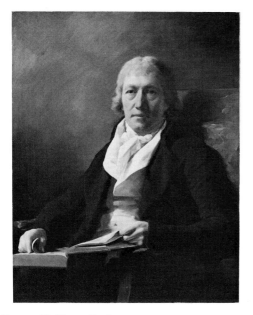

65.181.13 Sir Henry Raeburn

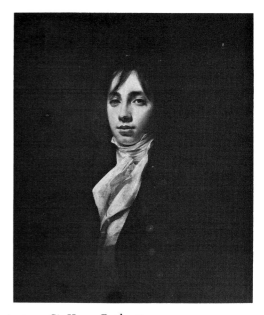

1975.1.234 Sir Henry Raeburn

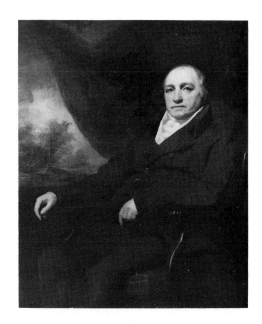

12.43.1 Sir Henry Raeburn

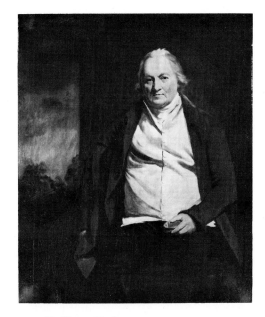

60.71.13 Sir Henry Raeburn

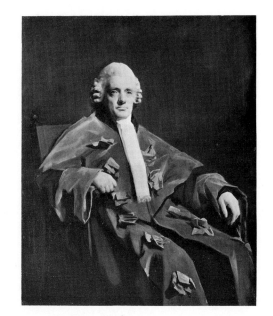

50.145.32 Sir Henry Raeburn

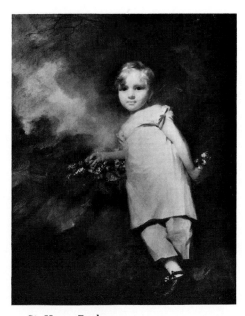

45.59.2 Sir Henry Raeburn

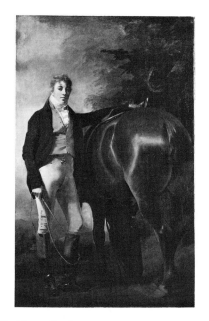

49.142 Sir Henry Raeburn

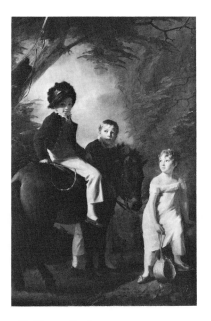

50.145.31 Sir Henry Raeburn

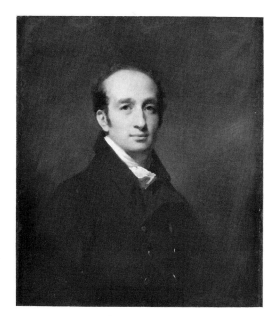

60.94.1 Sir Henry Raeburn

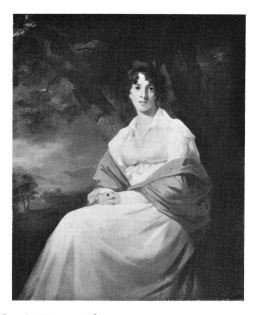

53.180 Sir Henry Raeburn

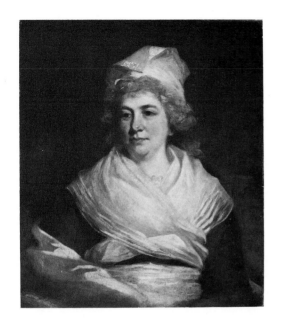

01.20 John Hoppner

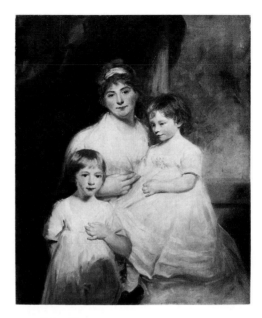

15.30.41 John Hoppner

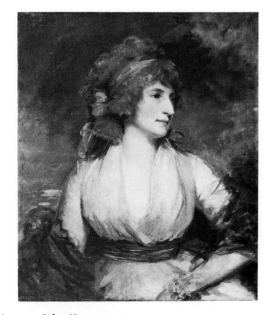

06.1242 John Hoppner

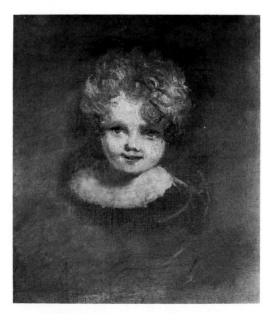

06.1242 John Hoppner

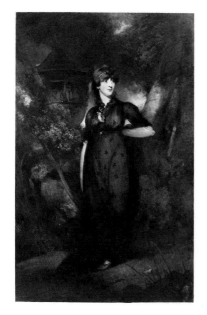

47.138　John Hoppner

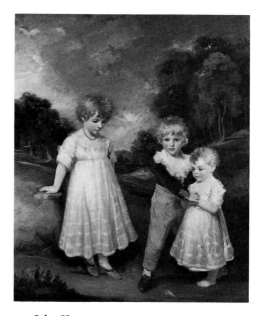

53.59.3　John Hoppner

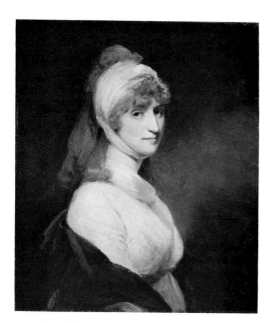

46.13.4　John Hoppner

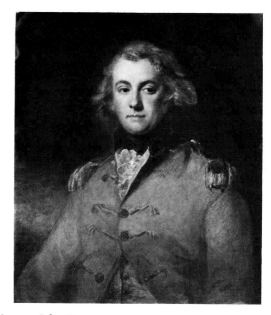

46.13.3　John Hoppner

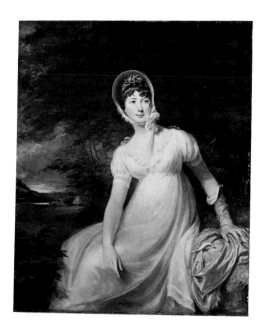

53.61.3 John Hoppner

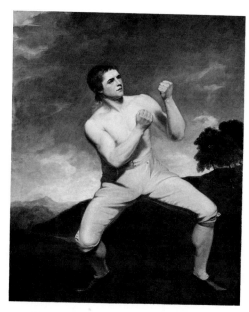

53.113 John Hoppner

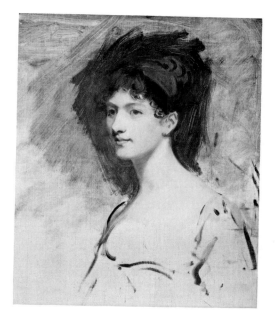

59.189.3 John Hoppner

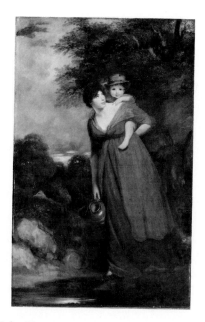

65.203 John Hoppner

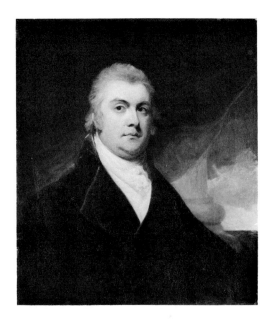

60.71.8 John Hoppner

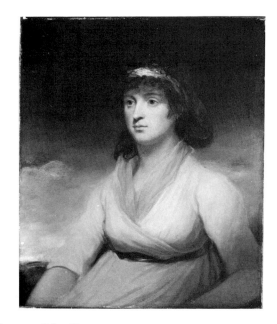

60.71.9 John Hoppner

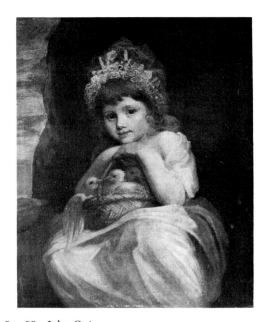

24.80.488 John Opie

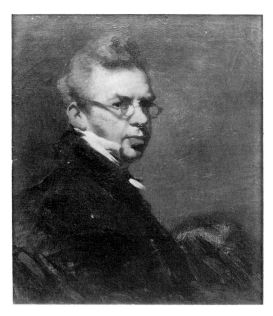

43.132.4 George Chinnery

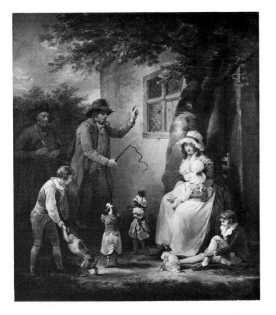

52.116 George Morland

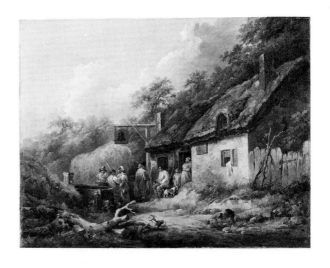

25.110.20 George Morland

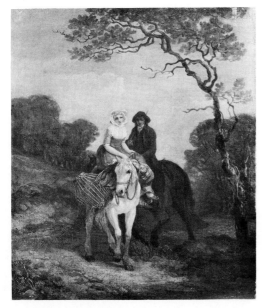

15.30.49 Francis Wheatley

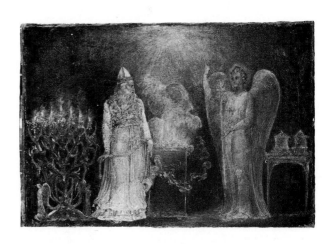

51.30.1 William Blake

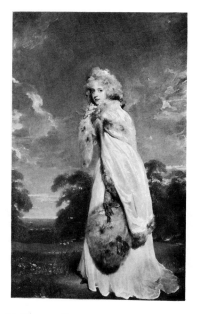

50.135.5 Sir Thomas Lawrence

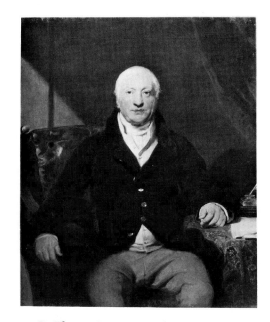

12.43.2 Sir Thomas Lawrence

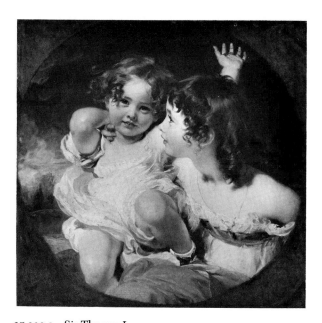

25.110.1 Sir Thomas Lawrence

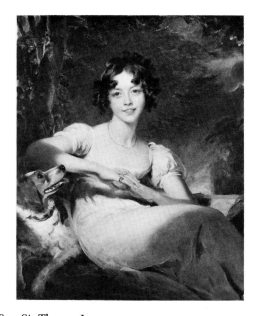

55.89 Sir Thomas Lawrence

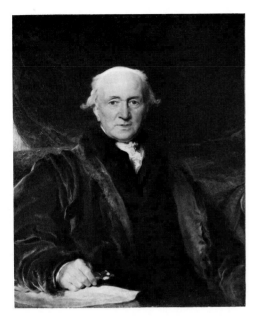

65.181.9 Sir Thomas Lawrence

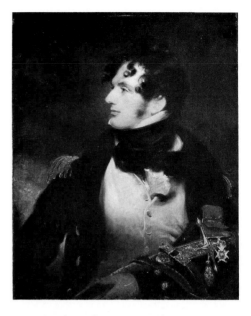

59.91.2 Style of Sir Thomas Lawrence

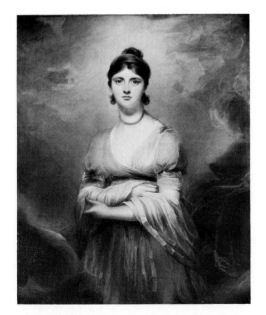

59.91.1 Workshop of Sir Thomas Lawrence

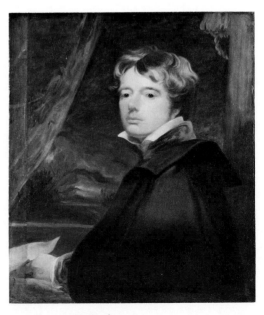

95.27.2 George H. Harlow

273

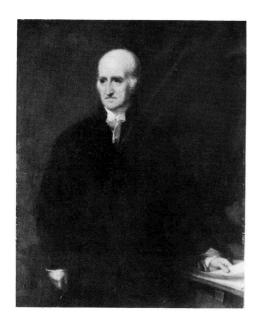

95.22.6a James Green

95.22.6b James Green

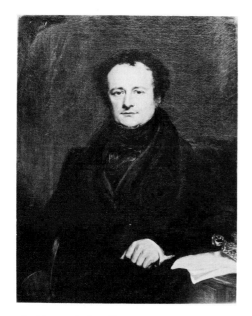

99.30 Sir Martin Archer Shee

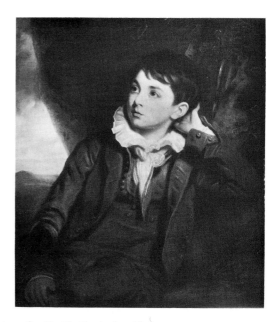

15.30.48 Sir Martin Archer Shee

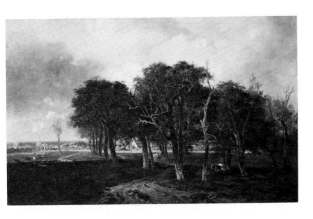

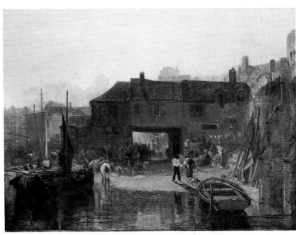

89.15.14 John Crome

89.15.9 Joseph Mallord William Turner

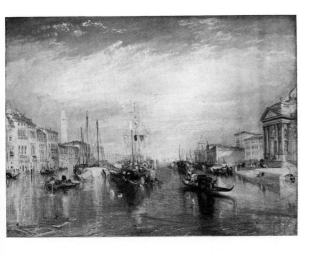

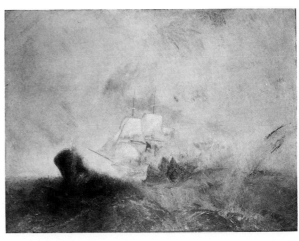

99.31 Joseph Mallord William Turner

96.29 Joseph Mallord William Turner

British

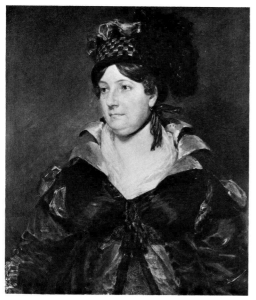

06.1272 John Constable

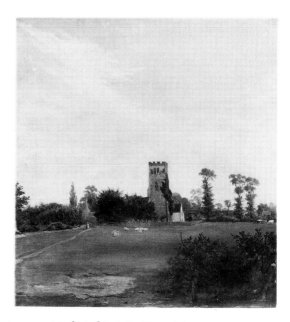

50.145.8 John Constable

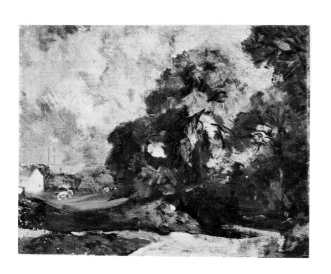

26.128 John Constable

15.30.50 Attributed to John Constable

276

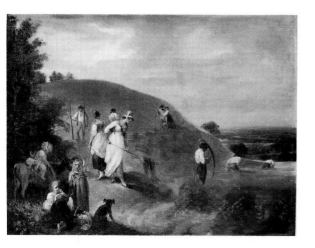

1973.331.1 British, 1st quarter XIX century

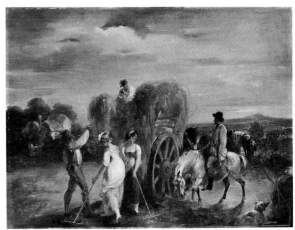

1973.331.2 British, 1st quarter XIX century

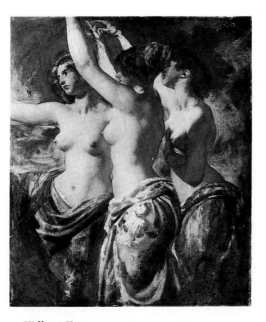

05.31 William Etty

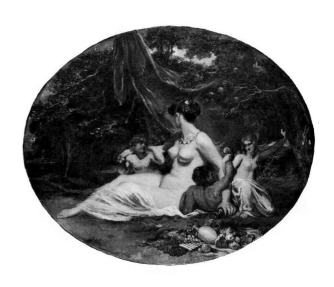

59.131 William Etty

British

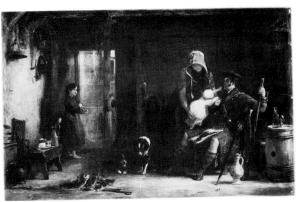

15.30.52 Sir David Wilkie

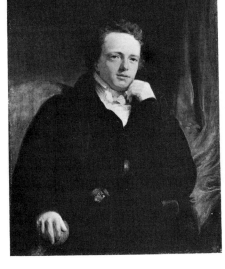

96.25 Charles Robert Leslie

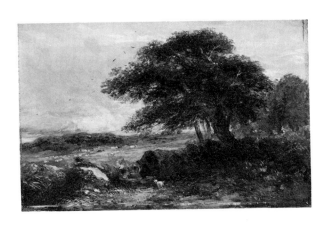

65.258.2 David Cox

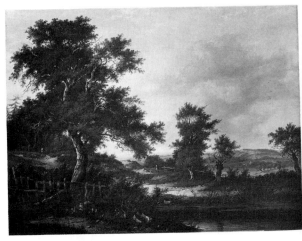

15.30.56 Patrick Nasmyth

278

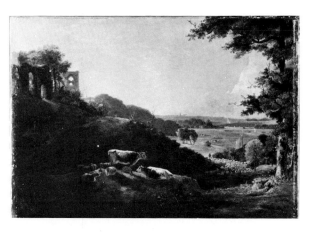

06.1300 George Vincent

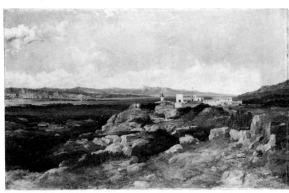

1974.159 Frederick Richard Lee

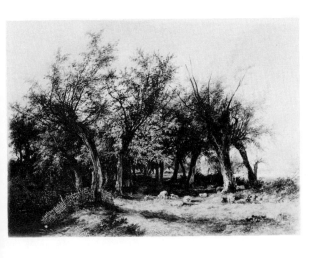

97.41.1 James Stark

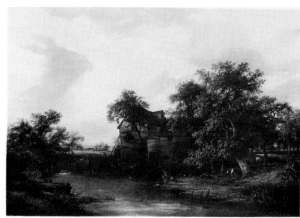

15.30.53 James Stark

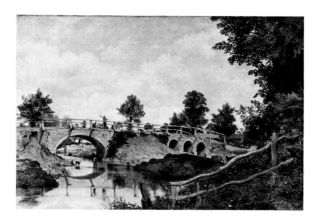

97.41.3 Frederick Waters Watts

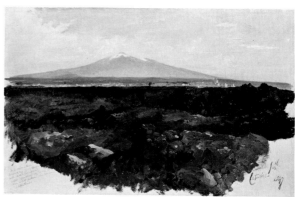

61.233 Edward Lear

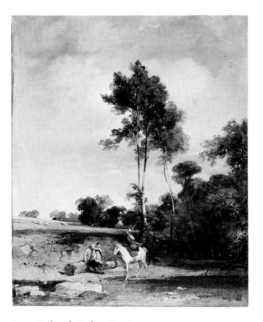

45.146.1 Richard Parkes Bonington

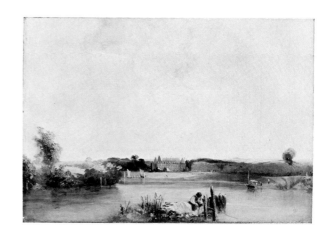

45.146.2 Richard Parkes Bonington

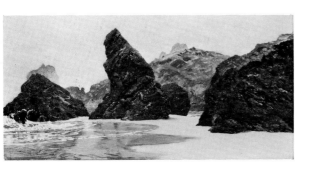

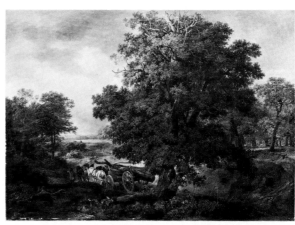

1974.289.2 John Brett

10.58.2 British, XIX century

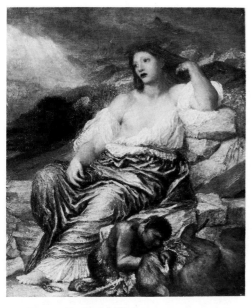

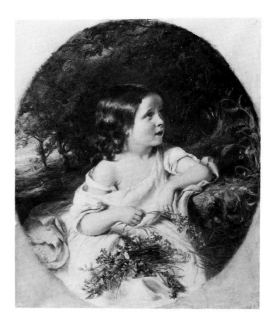

05.39.1 George Frederick Watts

04.29.4 John Thomas Peele

British

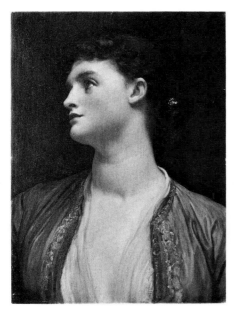

87.15.79 Frederick, Lord Leighton

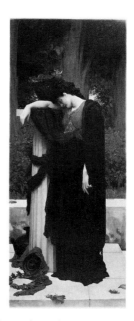

96.28 Frederick, Lord Leighton

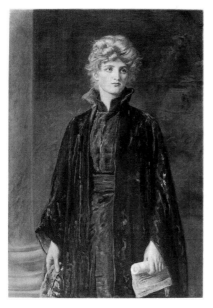

06.1328 Sir John Everett Millais

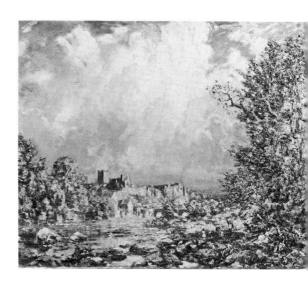

09.1.1 Philip Wilson Steer

282

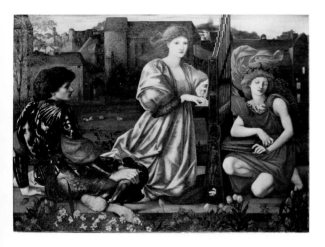

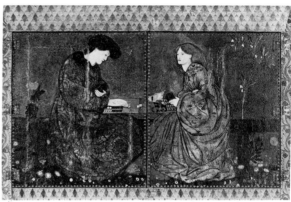

47.26 Sir Edward Coley Burne-Jones

26.54 Sir Edward Coley Burne-Jones

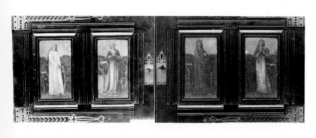

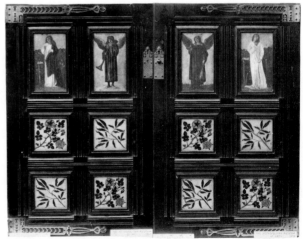

22.177.4, 3 Style of Sir Edward Coley Burne-Jones

22.177.1–2 Style of Sir Edward Coley Burne-Jones

British

92.10.42 Robert Dudley

92.10.43 Robert Dudley

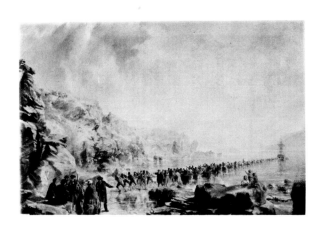

92.10.44 Robert Dudley

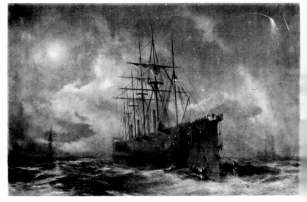

92.10.45 Robert Dudley

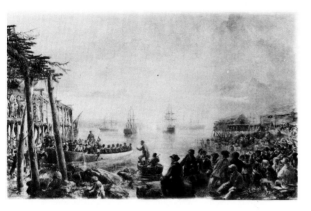

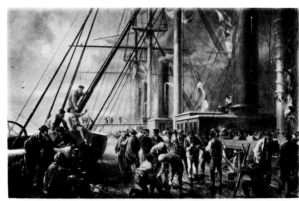

92.10.46 Robert Dudley

92.10.47 Robert Dudley

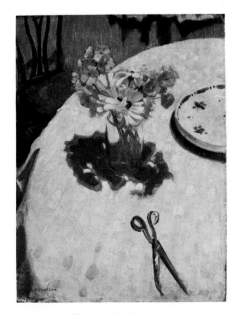

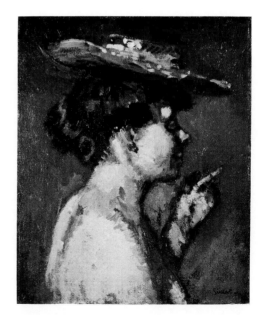

1979.135.15 Sir William Nicholson

1979.135.17 Walter Sickert

British

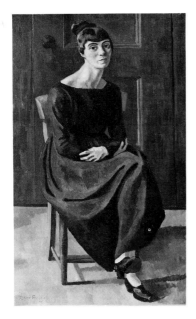

59.132 Roger Eliot Fry

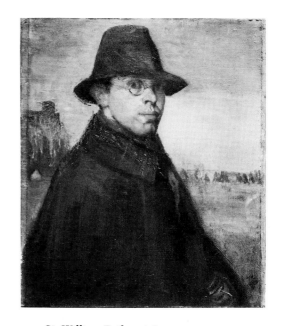

09.179 Sir William Rothenstein

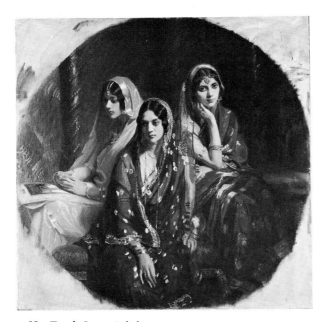

54.68 Frank Owen Salisbury

GERMAN PAINTINGS

including Austrian, Czechoslovakian, Danish, Hungarian, and Swedish

XV-XIX CENTURY

German

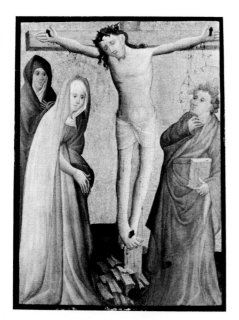

43.161 Master of the Berswordt Altar

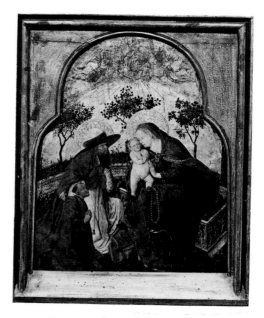

1975.1.133 Bavarian, about 1450

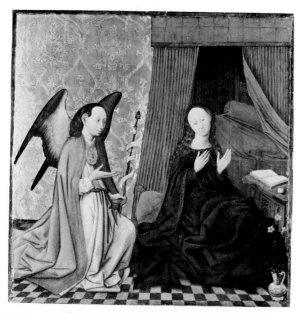

32.100.38 Rhenish, about 1450

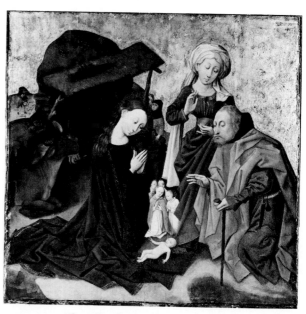

32.100.39 Rhenish, about 1450

German

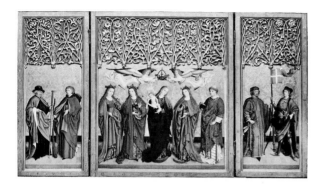

53.21 Master of the Burg Weiler Altar

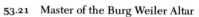
53.21 Master of the Burg Weiler Altar

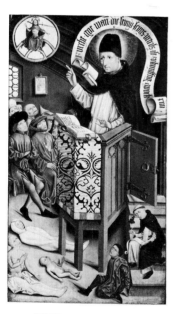

64.215 Friedrich Walther

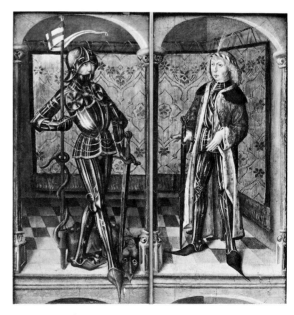

29.158.743 Rhenish, about 1480

290

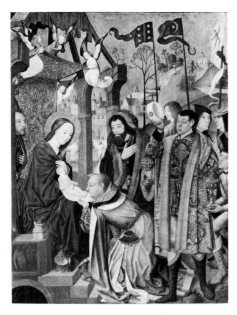

26.52a Master of the Holy Kinship

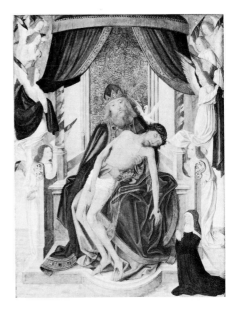

26.52b Master of the Holy Kinship

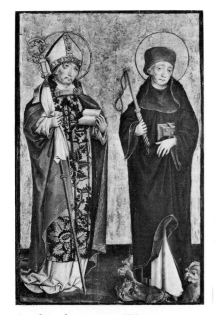

44.147.1 Tyrolese, last quarter XV century

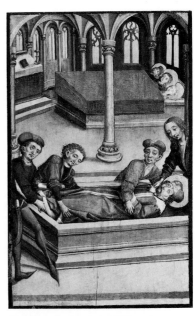

44.147.2 Tyrolese, last quarter XV century

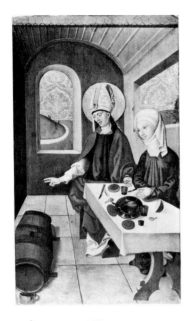

71.33a Swiss, last quarter XV century

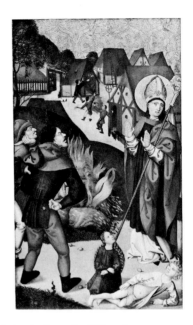

71.33b Swiss, last quarter XV century

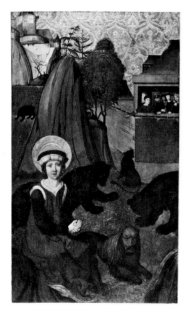

71.40a Swiss, last quarter XV century

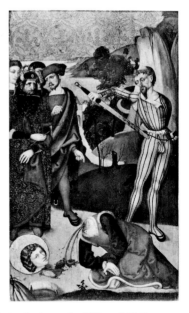

71.40b Swiss, last quarter XV century

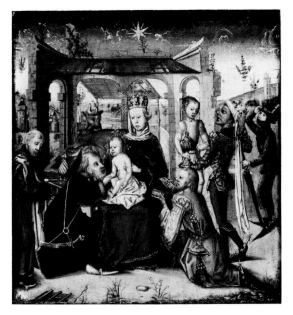

1975.1.134　Westphalian, XV century

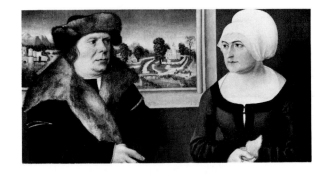

12.115　Ulrich Apt the Elder

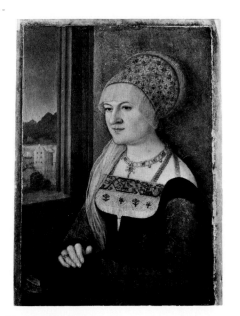

71.34　Bernhard Strigel

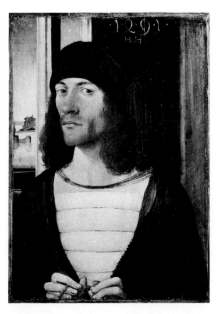

23.255　Upper Rhenish, last quarter XV century

German

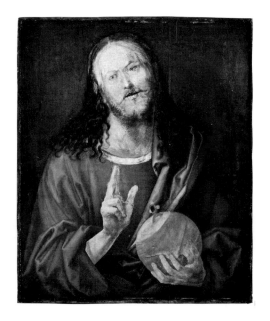

32.100.64 Dürer

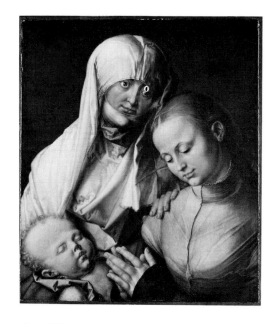

14.40.633 Dürer

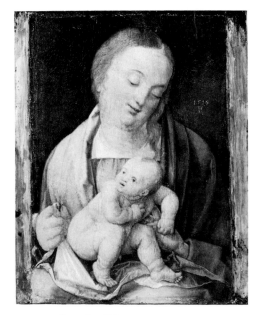

17.190.5 Attributed to Dürer

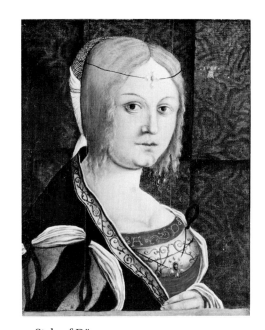

49.7.27 Style of Dürer

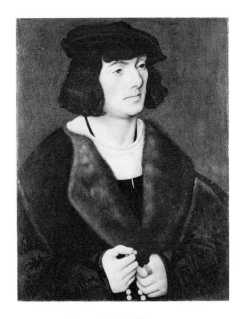

29.100.24 Lucas Cranach the Elder

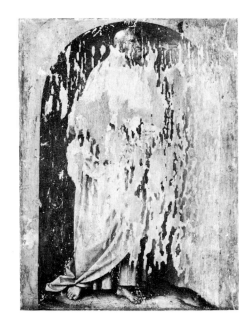

29.100.24 Lucas Cranach the Elder

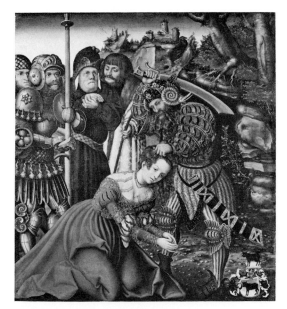

57.22 Lucas Cranach the Elder

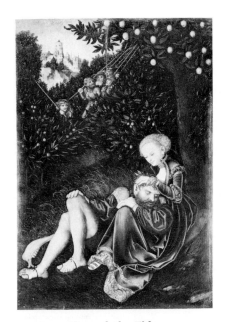

1976.201.11 Lucas Cranach the Elder

295

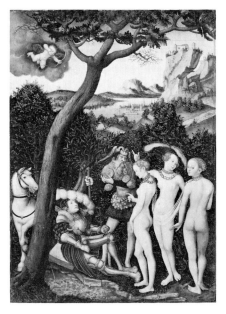

28.221 Lucas Cranach the Elder

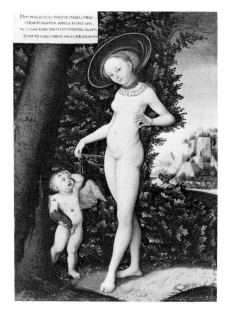

1975.1.135 Lucas Cranach the Elder

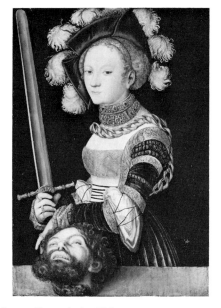

11.15 Lucas Cranach the Elder

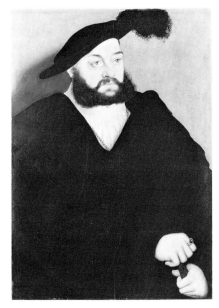

08.19 Lucas Cranach the Elder

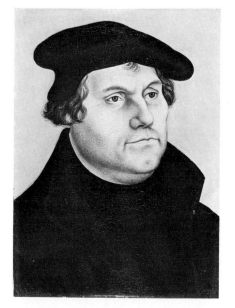

1975.1.136 Lucas Cranach the Elder

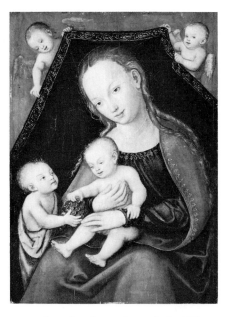

60.71.27 Attributed to Lucas Cranach the Elder

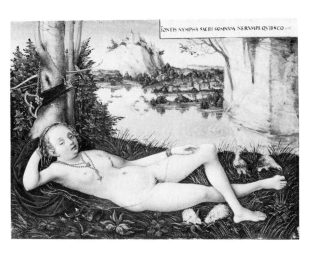

55.220.2 Workshop of Lucas Cranach the Elder

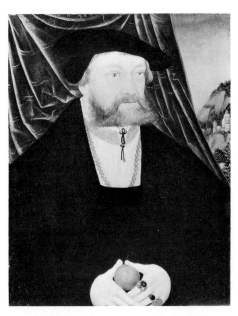

32.100.61 Workshop of Lucas Cranach the Elder

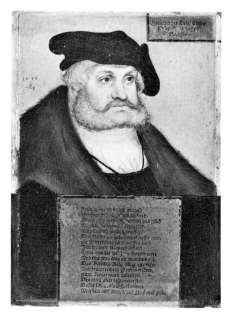

46.179.1 Workshop of Lucas Cranach the Elder

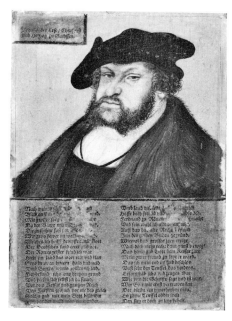

46.179.2 Workshop of Lucas Cranach the Elder

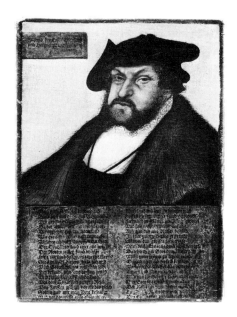

71.128 Workshop of Lucas Cranach the Elder

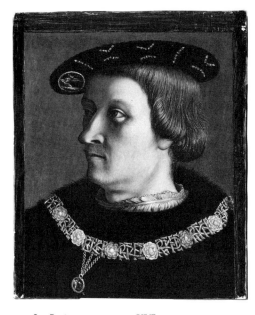

32.100.116 Swiss, 1st quarter XVI century

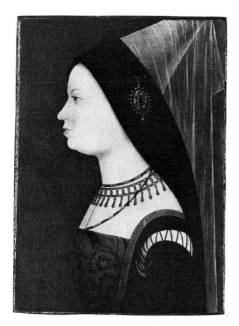

1975.1.137 Hans Maler

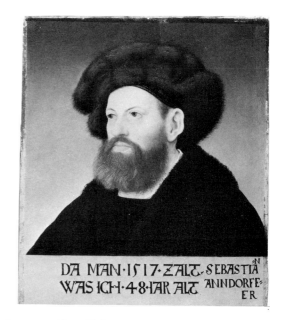

32.100.33 Hans Maler

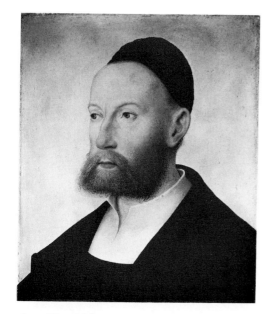

14.40.630 Hans Maler

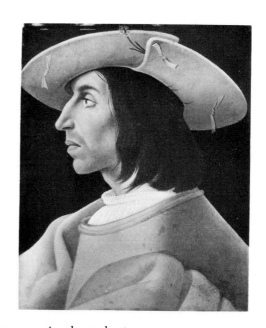

32.100.99 Augsburg, about 1525

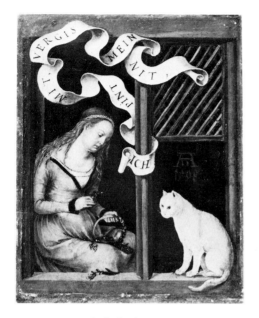

17.190.21 Hans von Kulmbach

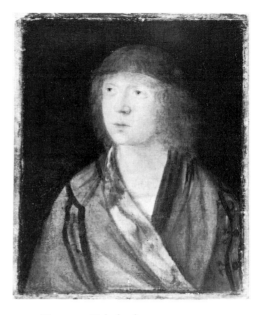

17.190.21 Hans von Kulmbach

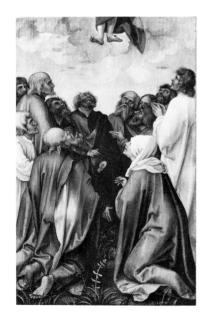

21.84 Hans von Kulmbach

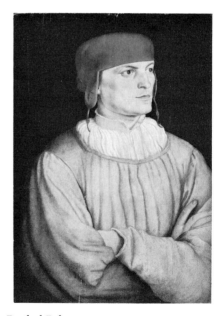

12.194 Barthel Beham

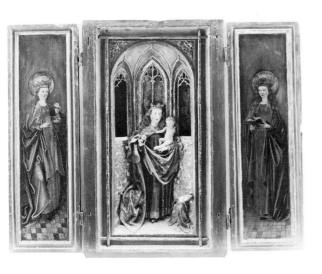

12.103 Ulm, 1st quarter XVI century

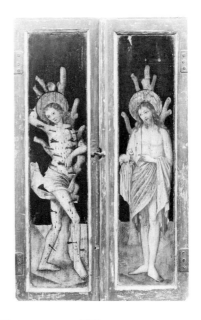

12.103 Ulm, 1st quarter XVI century

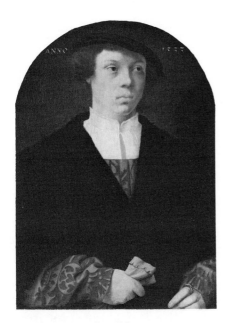

62.267.1 Barthel Bruyn the Elder

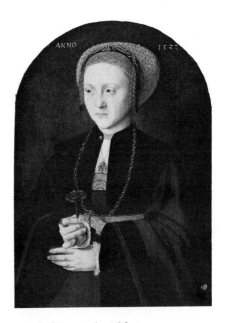

62.267.2 Barthel Bruyn the Elder

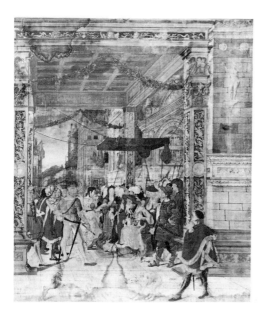

89.15.20 Attributed to Jörg Breu the Younger

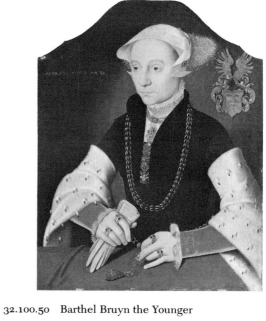

32.100.50 Barthel Bruyn the Younger

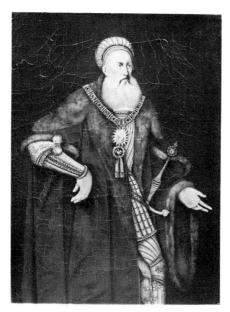

07.245.1 Copy after a German Painter, middle XVI
century, XIX century

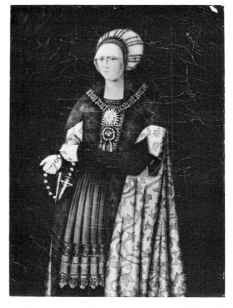

07.245.2 Copy after a German Painter, middle XVI
century, XIX century

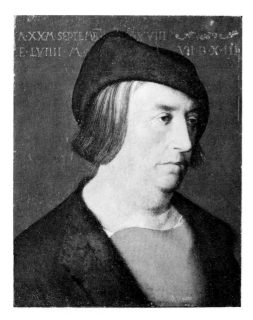

50.145.23 Hans Holbein the Elder

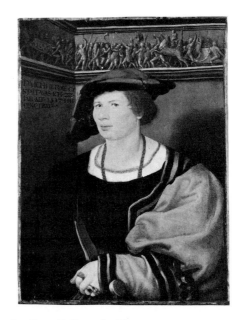

06.1038 Hans Holbein the Younger

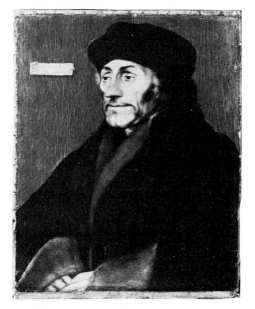

1975.1.138 Hans Holbein the Younger

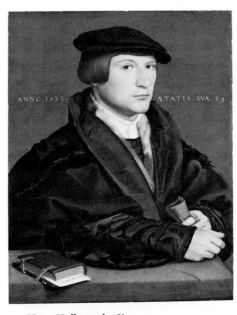

50.135.4 Hans Holbein the Younger

German

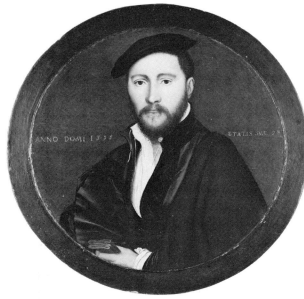

50.145.24 Hans Holbein the Younger

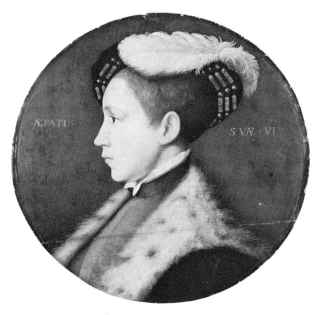

49.7.28 Hans Holbein the Younger

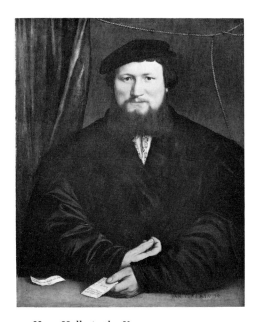

49.7.29 Hans Holbein the Younger

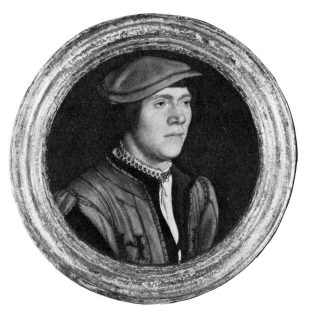

49.7.31 Hans Holbein the Younger

304

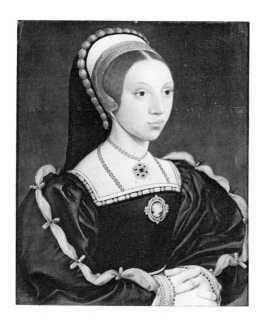

49.7.30 Workshop of Hans Holbein the Younger

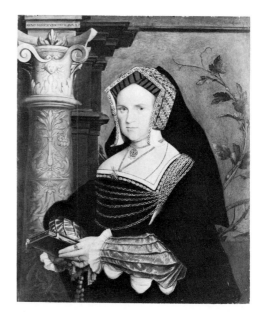

20.155.4 Copy after Hans Holbein the Younger

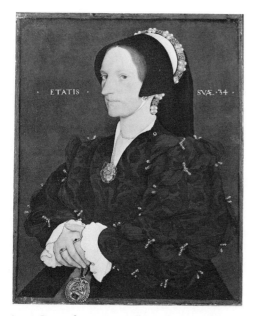

14.40.637 Copy after Hans Holbein the Younger

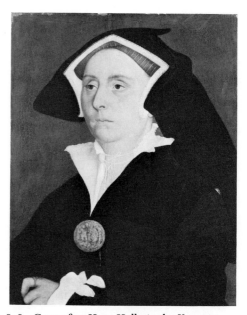

14.40.646 Copy after Hans Holbein the Younger

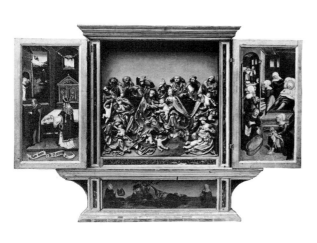

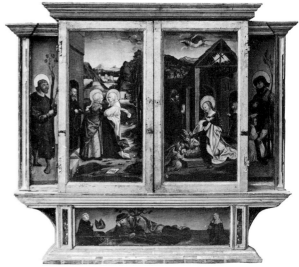

90.3.5 Franconian, dated 1548

90.3.5 Franconian, dated 1548

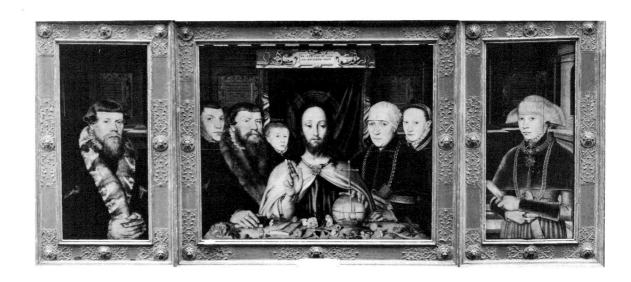

17.190.13–15 Attributed to Ludger Tom Ring the Younger

306

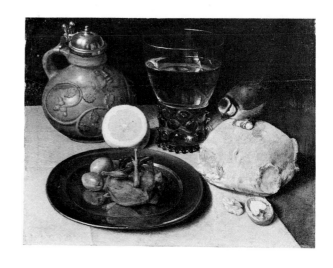

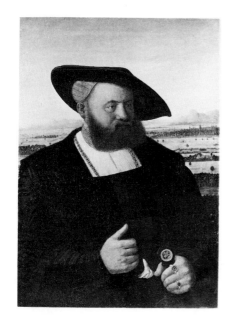

12.75 Conrad Faber

21.152.1 Georg Flegel

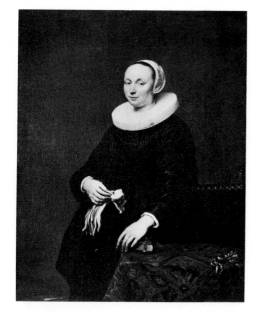

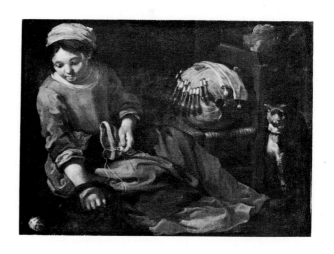

89.15.28 Jürgen Ovens

1971.115.2 Bernhard Keil

German

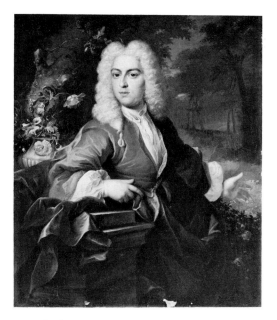

68.190 Abraham Mignon

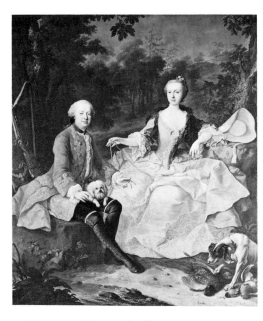

50.50 Marten van Mytens the Younger

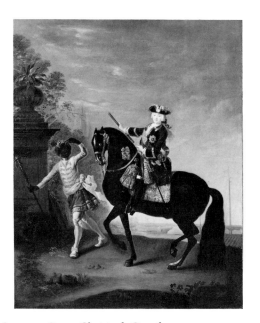

1978.554.2 Georg Christoph Grooth

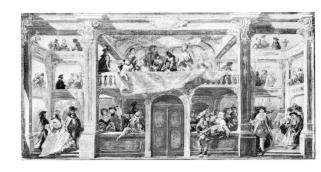

34.83.2 Johann Georg Lederer

308

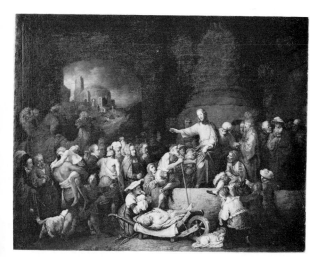

85.9 Christian Wilhelm Ernst Dietrich

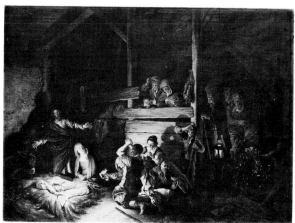

71.162 Christian Wilhelm Ernst Dietrich

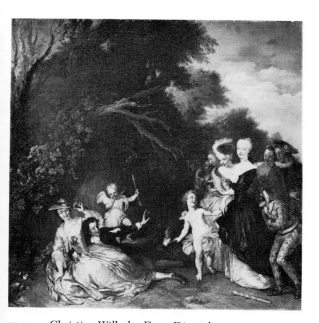

71.142 Christian Wilhelm Ernst Dietrich

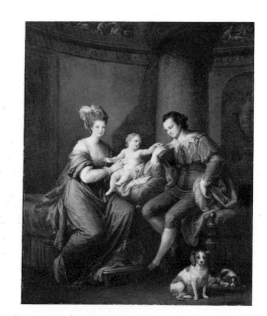

59.189.2 Angelica Kauffmann

German

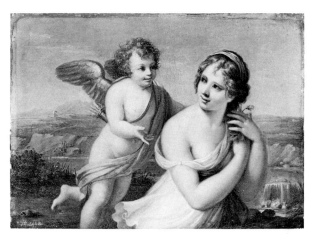

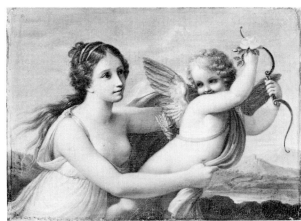

39.184.18 Angelica Kauffmann

39.184.19 Angelica Kauffmann

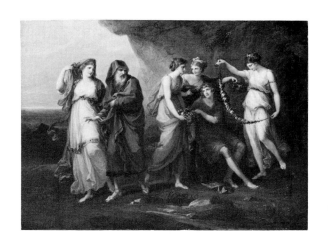

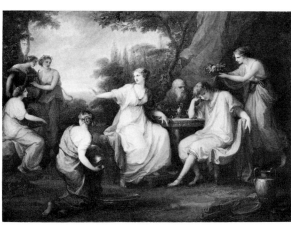

25.110.188 Angelica Kauffmann

25.110.187 Angelica Kauffmann

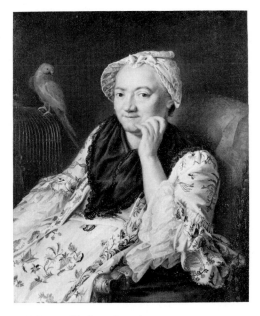

22.174 Johann Nikolaus Grooth

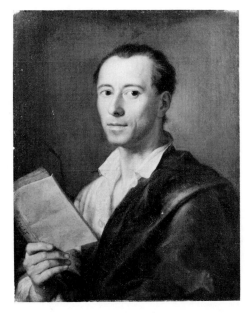

48.141 Anton Raphael Mengs

89.4.2741 German, early XVIII century

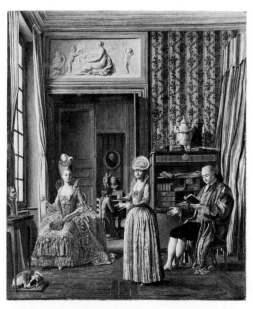

1971.115.6 Johann Eleasar Zeizig Schenau

311

German

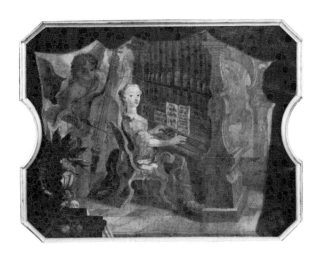

89.4.3516　Franz Casppar Hofer

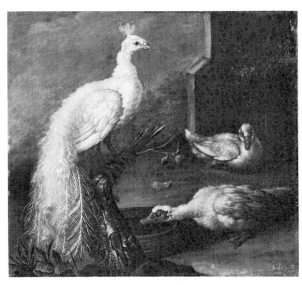

67.187.193　Attributed to Jacob Grooth

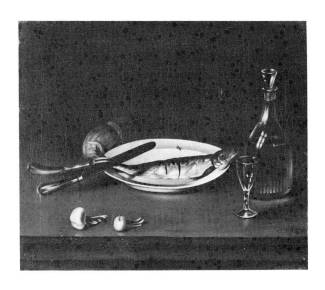

67.187.192　German, XVIII/XIX century

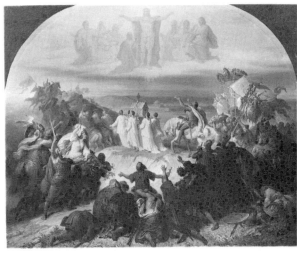

87.15.110　Wilhelm von Kaulbach

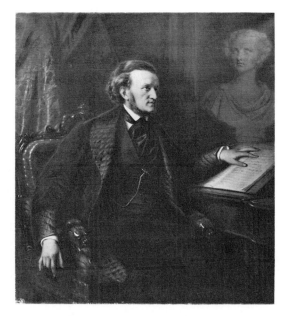

89.8 August Friedrich Pecht

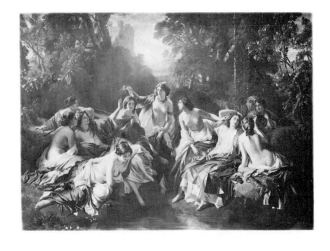

01.21 Franz Xaver Winterhalter

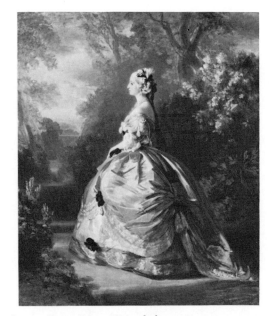

1978.403 Franz Xaver Winterhalter

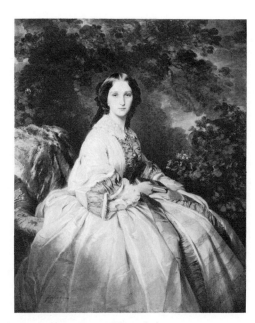

67.187.119 Franz Xaver Winterhalter

German

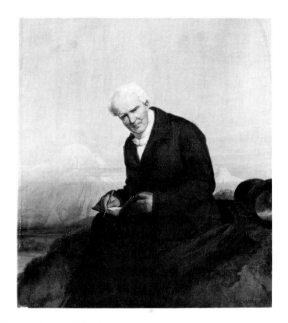

89.20 Julius Schrader

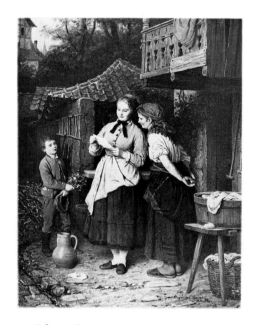

87.15.65 Johann Georg Meyer

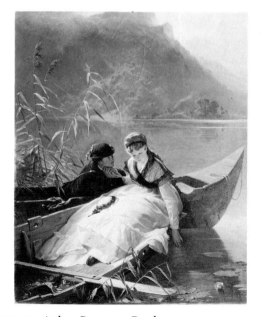

87.15.132 Arthur Georg von Ramberg

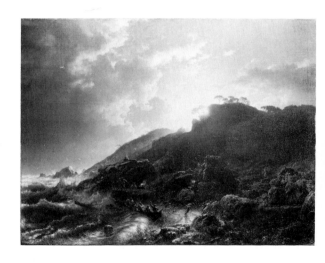

87.15.23 Andreas Achenbach

314

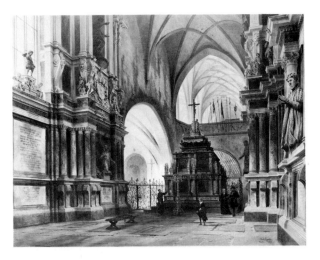

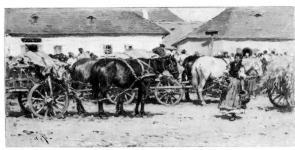

87.15.33 Carl Georg Anton Graeb

23.103.3 August Xaver Carl von Pettenkofen

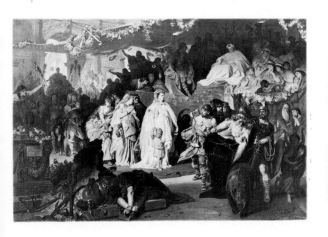

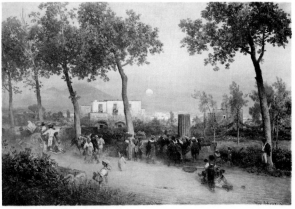

87.2 Carl Theodor von Piloty

87.15.105 Oswald Achenbach

German

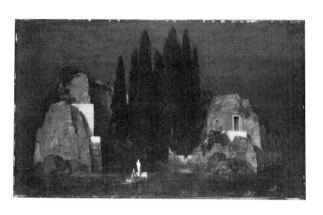

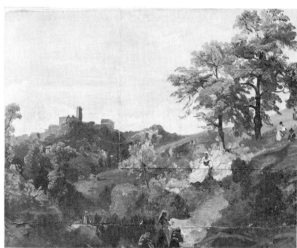

26.90 Arnold Böcklin

26.100 Attributed to Arnold Böcklin

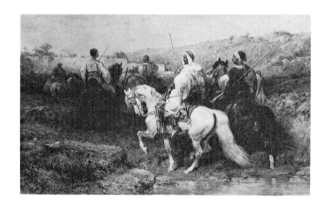

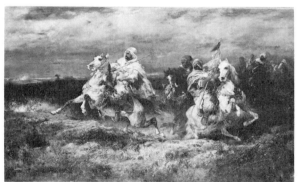

87.15.127 Adolf Schreyer

94.24.2 Adolf Schreyer

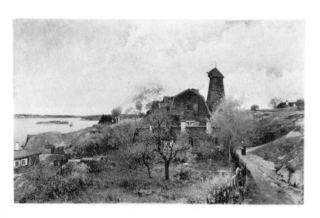

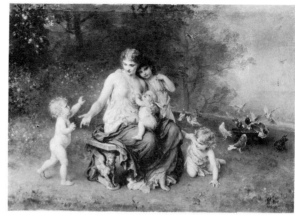

87.15.99 Alfred Wahlberg

25.110.68 Ludwig Knaus

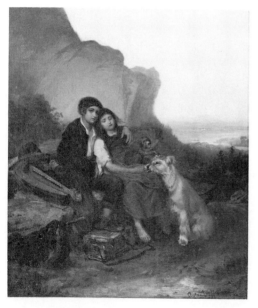

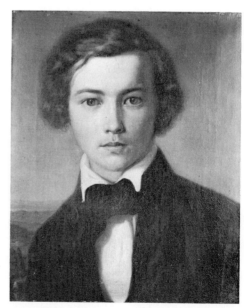

64.151 Anton Dieffenbach

46.104.1 H. Hamm

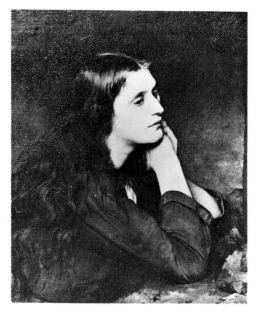

87.22.1 Ferdinand Schaus

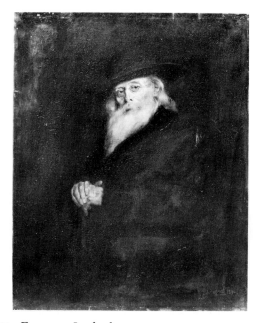

11.52 Franz von Lenbach

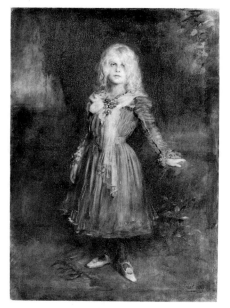

25.110.46 Franz von Lenbach

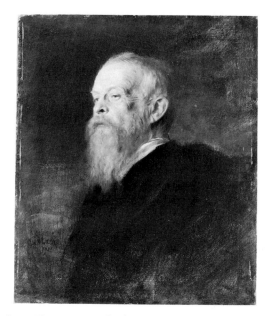

39.65.4 Franz von Lenbach

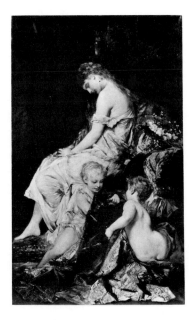

87.15.133 Hans Makart

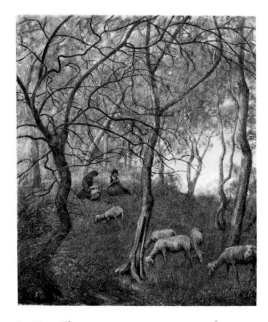

09.48 Hans Thoma

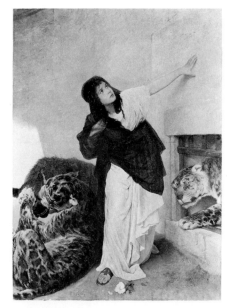

87.15.58 Gabriel Max

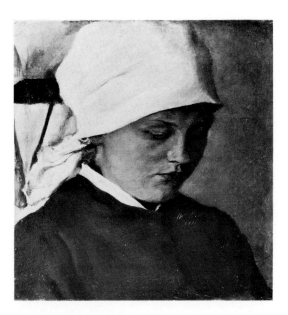

16.148.1 Wilhelm Leibl

319

German

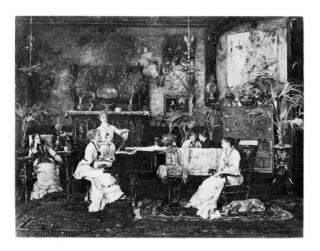

08.136.11 Mihály de Munkácsy

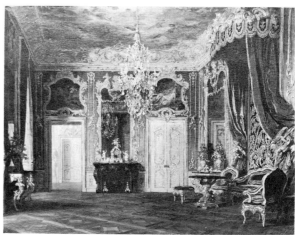

90.30 Gyula Benczúr

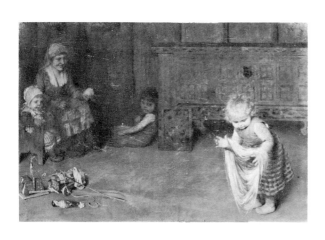

25.110.40 Hermann Kaulbach

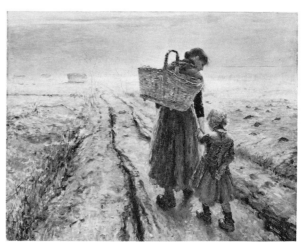

17.120.203 Karl Hermann Fritz von Uhde

320

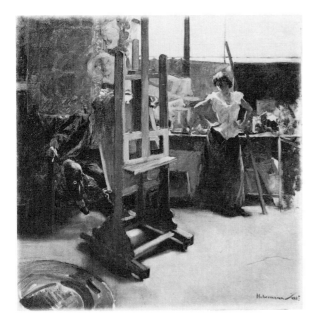

16.16 Hugo von Habermann

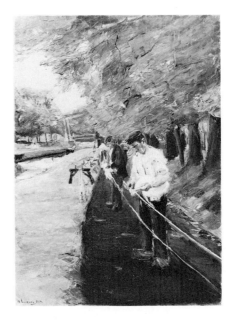

16.148.2 Max Liebermann

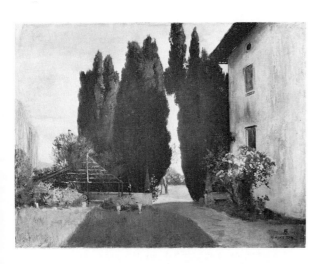

16.148.3 Friedrich August von Kaulbach

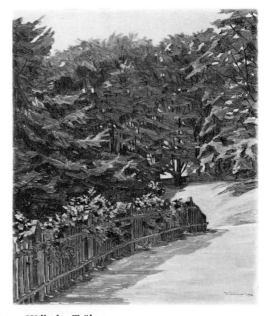

16.15 Wilhelm Trübner

German

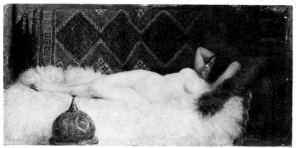

1975.280.9 Fritz Steinmetz-Norris

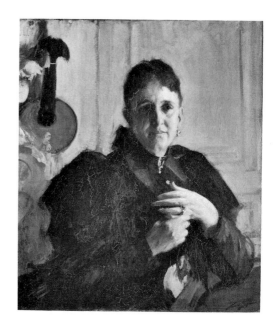

17.204 Anders Zorn

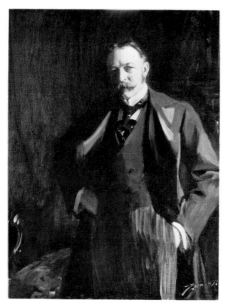

19.112 Anders Zorn

60.85 Anders Zorn

322

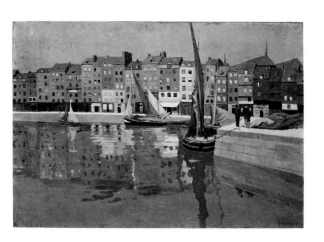

67.187.116 Félix Vallotton

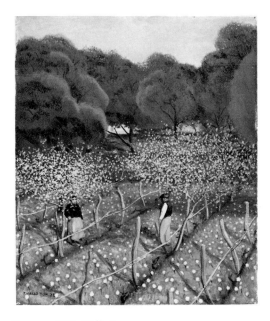

67.187.114 Félix Vallotton

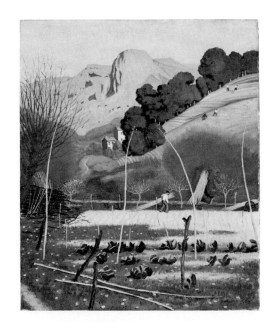

67.187.115 Félix Vallotton

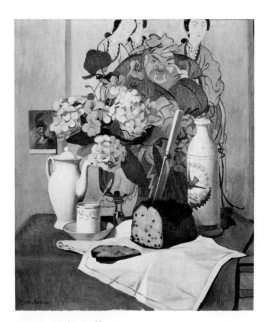

67.187.117 Félix Vallotton

German

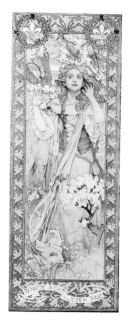

20.33 Alphonse Mucha

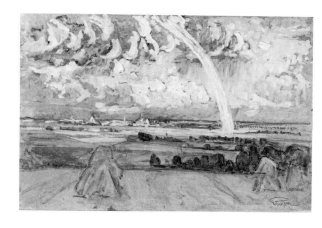

54.33 Prince Eugen of Sweden